Praise for Ann C. Barbour and
Learning at Home Prek–3: Homework Activities That Engage Children and Families

"This book has so many rich choices for families to work together at home. The activities are categorized by academic subject and will be extremely easy for teachers or even an entire elementary school to incorporate as homework practices."

—Stephanie Malin
Instructional Coach, Beaverton School District, Beaverton, OR

"This book is a great resource for educators and families and is filled with practical ideas to engage everyone in the fun of learning."

—Susan Stewart
Curriculum Consultant, Supervisor, Adjunct Instructor,
Stark County Education Service Center, Ashland University, Hartville, OH

"I love this book. What a great resource, full of activities and directions for those activities that parents and other caregivers can easily do at home."

—Nadia Mykysey
Educator, Temple University, Philadelphia, PA

"Wonderful! The author has done an excellent job of providing a wealth of materials for the educator and/or parent, as well as answering some tough questions about home learning for young children. It has been done with the utmost care and in a very professional manner."

—Ken Klopack
Art and Gifted Educational Consultant, Chicago Public Schools, Chicago, IL

"This book is stuffed full of very valuable material for the classroom teacher who wants to encourage student engagement in meaningful learning activities at home. I am going to use this book and these wonderful ideas in writing my own professional goals for next year. The research, ideas, and materials are all very appropriate for me as I continue to grow as an experienced teacher who is interested in getting better every year!"

—Carol Forrest
Primary Teacher (K–1), Nyssa Elementary School, Nyssa, OR

"There is no doubt that connecting with family members is of great benefit to a student's learning. Dr. Barbour presents clear and easy to implement strategies for successfully making this connection, with an emphasis on building positive home-school relationships and promoting learning together as an enjoyable experience for everyone involved. This work shows a clear commitment to exploring all subjects with children, including the often neglected science and art. This publication is clearly a valuable resource for educators and administrators alike at all stages of their career. Dr. Barbour clearly recognizes the importance of community resources, outdoor spaces and informal learning sites such as museums as valuable places for children and their families to learn together and provides clear guidance for how to tap into these resources."

—Leah M. Melber
Director of Student and Teacher Programs, Lincoln Park Zoo, Chicago, IL

"For young children (and their parents), homework is often a painful, empty experience. Barbour rethinks this age-old task with meaningful and powerful ways parents can joyfully connect with their children and build the skills they need for school."

—Steven Hicks
Teacher, The Accelerated School, Los Angeles, CA

"At this critical time in early childhood education, Ann's book provides a valuable resource for programs seeking to strengthen ties between home and school. Grounded in the research on play and the benefits of family involvement in the learning process, this book provides a rich menu of ideas and resources that can be easily implemented in any early childhood setting."

—Blanche Desjean-Perrotta
Associate Dean for Teacher Education and
Associate Professor of Early Childhood Education, University of Texas at San Antonio

Learning at Home PreK-3

Homework Activities That Engage Children and Families

Ann C. Barbour

Skyhorse Publishing

Skyhorse Publishing books may be purchased in bulk at special discounts for sales promotion, corporate gifts, fund-raising, or educational purposes. Special editions can also be created to specifications. For details, contact the Special Sales Department, Skyhorse Publishing, 307 West 36th Street, 11th Floor, New York, NY 10018 or info@skyhorsepublishing.com.

Skyhorse® and Skyhorse Publishing® are registered trademarks of Skyhorse Publishing, Inc.®, a Delaware corporation.

Visit our website at www.skyhorsepublishing.com.

10 9 8 7 6 5 4 3 2 1

Library of Congress Cataloging-in-Publication Data

Barbour, Ann.
 Learning at Home Prek-3 : homework activities that engage children and families / Ann C. Barbour.
 p. cm.
 Includes bibliographical references.
 ISBN 978-1-61608-548-3 (pbk. : alk. paper)
 1. Homework. 2. Early childhood education--Activity programs. 3. Motivation in education. I. Title.
 LB1139.35.P37B37 2012
 371.3028'1--dc23
 2011040818

Printed in Canada

Contents

Acknowledgments

Many people have shaped this work. I learned about the power of informal and interactive activities to involve parents in children's learning while teaching a course in family and community resources at the University of Texas at San Antonio (UTSA) many years ago. Three early childhood teachers in Alamo Heights Independent School District in San Antonio—Susan Peery, Susan Wilson, and Liz Mendenhall—generously allowed me to track the first year of their classroom-based literacy bag projects. In the process of reading children's and parents' enthusiastic journal responses to the materials these dedicated teachers sent home, I became convinced that interactive homework of this sort benefited parents and teachers along with the children.

In California, I worked with the Academic English Mastery Program (AEMP) in Los Angeles Unified School District. AEMP is a multischool program that supports standard English learners, most of whom are African American and Mexican American, in acquiring school language and literacy. With the goal of increasing the involvement of their families, I helped design literacy backpack projects in these schools. This project gave me a better understanding of the importance of culturally relevant materials in engaging family members. I also saw how eager parents were to help their children learn and how conscientious young children were in caring for materials. I am particularly grateful to Lilly Alexander, the Parent Representative at one of the AEMP schools, for exemplifying how parents, and indeed grandparents, can be the most valuable resources in implementing projects of this type.

Many of my students at California State University, Los Angeles, created interactive homework activities as an assignment for a school-family partnerships course. They donated these activities to stock AEMP backpacks for first and second graders. This assignment collectively helped us focus on ways to create sturdy materials inexpensively and efficiently. A number of these students—themselves classroom teachers—subsequently developed learning-at-home projects in their own classrooms. They witnessed the positive impact of interactive homework materials on family involvement and children's eagerness to learn.

A number of my students' creativity and resourcefulness provided inspiration for this book, but I want particularly to thank several talented Los Angeles-area teachers for permission to share their ideas in this book. Saray Fregoso, a second-grade teacher, created the "Making Progress" and "Trail to Freedom" games. Saray also developed "Life's Ups and Downs" and "My Weekly Schedule." Steven Hicks, a kindergarten and first-grade teacher and recent Washington Teaching Ambassador Fellow, made the "Cakewalk" game. Karen Gilbaugh, a primary-grade teacher and assistant principal, designed the "Poetry Awards" cards. Sevan Yagyazan, an early intervention preschool teacher, had the idea of making puppets out of sponges. Phung Ballot, an Early Start teacher, created the "Win a Chair for Mom" file folder

game. Second-grade teacher, Helen Hsu, made the "Retelling Stage." Another second-grade teacher, Catalina Munguia, sewed the hand puppets and made the story sequencing folder activity. Natalie Palma, a curriculum resource teacher, devised the "Fact or Fiction" sorting activity. Evan Barbour, a science illustrator and museum-based science educator, painted the "Bird Puzzle" and made the craft stick puzzles.

Finally, and most of all, special gratitude to my own family: to Alan for his steadfast encouragement and to our sons, Nathan and Evan, who led the way when they were young children and made learning at home fun for us all.

Additionally, the Publisher would like to thank the following peer reviewers for their editorial insight and guidance:

Ken Klopack
Art and Gifted Educational Consultant
Chicago Public Schools
Chicago, IL

Julee Loorya
Kindergarten Teacher
Birney Elementary
Redondo Beach, CA

Stephanie Malin
Instructional Coach
Beaverton School District
Beaverton, OR

Nadia Mykysey
Educator
Temple University
Philadelphia, PA

Susan Stewart, EdD
Curriculum Consultant, Supervisor, Adjunct Instructor
Stark County Education Service Center, Ashland University
Hartville, OH

Linda K. Taylor
Assistant Professor
Ball State University
Muncie, IN

Sonia Trehan Kelly, MEd
Director
Blue River Montessori School
Duxbury, MA

About the Author

 Ann C. Barbour, PhD, is Professor Emerita of Early Childhood Education at California State University, Los Angeles (CSULA). A former preschool and elementary teacher, she has over 30 years' experience in the field of early education. At CSULA, she teaches courses in best practices and trends and issues in early education, the role of play in learning, and school-family partnerships. She has coauthored two books: *Prop Box Play: 50 Themes to Inspire Dramatic Play* and *Portfolio Assessment: A Handbook for Preschool and Elementary Teachers,* as well as numerous articles on early childhood education.

Ann has worked with teachers, district administrators, parent representatives, and her own students in learning-at-home projects based on materials children take home from school. She also helped develop the Peabody Award-winning television series, *A Place of Our Own* and *Los Niños en Su Casa,* and she was content advisor for each of the 325 episodes produced in English and in Spanish. These series are designed to help parents and caregivers nurture the development and enrich the learning experiences of preschool-age children. They are broadcast daily on public television stations throughout the nation.

Introduction

If you have picked up this book, you are probably concerned about supporting children's learning both inside and outside the classroom. As a classroom teacher, your main focus is or will be on effective curriculum practices during school hours. But you know that teachers are not the only influences on children's knowledge, skills, and dispositions, or even the most important influence. You may wish that parents and other family members would be more involved in helping children learn, and you may have tried different strategies to encourage their participation. Maybe you have talked to parents about what they can do with their children at home. Perhaps you assign homework to extend classroom-based lessons and expect families to supervise it or at least make sure children complete and return it. But if you are like most teachers, you probably have experienced less parent participation than you would like.

This book is about encouraging learning at home and engaging family members, especially parents and others who have primary responsibility for childcare, in helping children develop academic knowledge and skills and intellectual dispositions, so they will do well in school and beyond. It contains research-based information about why and how to support children's learning at home. It also includes a large collection of developmentally appropriate activities to make it easier for you to enlist family support in complementing and enhancing classroom instruction.

You can think of these activities as homework, but they are not of the traditional type. Rather than relying on pencil-and-paper assignments, which many children—and families for that matter—find dreary or stressful, the activities encourage children and family members to spend time together in informal, play-based interactions that reinforce and augment classroom instruction. They constitute what has sometimes been called *interactive homework*.

The first three chapters provide the research background and rationale for learning-at-home activities. Chapter 1 describes what we know about how children learn. Chapter 2 summarizes what have learned about effective strategies to overcome barriers to family involvement. Chapter 3 addresses issues and research findings related to homework, particularly for young children. In Chapter 4, there is a nuts-and-bolts description of how to apply this information through specific strategies to support learning at home.

Chapters 5, 6, and 7 are "make-and-take" chapters consisting of thematic school-to-home "kits" to encourage informal family interactions that complement, deepen, or enhance classroom instruction in language and literacy (Chapter 5), mathematics or science (Chapter 6), and the expressive arts (Chapter 7). While the activities are organized according to these subjects, most integrate developmental and content areas, including the social sciences.

Each kit in these chapters includes several activities appropriate for children in designated grade levels along with directions about how to make or assemble the necessary materials. However, because it's as important to differentiate learning activities at home as it is in the

classroom, you may find activities suited to your own students' needs in any of the kits. There is also a list of children's books that are related to the theme of the kit. Whenever possible, the lists identify literature that is especially relevant to particular cultural groups, ones with characters or situations with which families from those groups can identify. Each kit also includes ideas for additional ways families can encourage children's learning. These suggestions do not depend on any items provided by the school. Because of their interactive nature, they enable families to use everyday experiences as educational opportunities.

In addition to the thematic kits in Chapters 5, 6 and 7, Chapter 8 has even more learning-at-home activities to share with families. These activities either require no materials at all or are based on materials that families commonly have on hand. But unlike the suggestions in the Chapters 5–7, they are not thematic. They are particularly appropriate for inclusion in school newsletters, Web sites, or vacation calendars. Chapter 9 expands interactive homework possibilities though suggestions for longer-term family projects that result in some sort of product that highlights each child's or each family's unique characteristics.

The Resources includes several games and activities that are ready for duplication. It also includes samples of letters and forms you can send home. There is a list of online resources through which you will find additional ideas for home-school activities as well as parent- and child-friendly Web sites you can recommend to families. As with other learning experiences, the educational value of electronic media for children can be enhanced when parents and other care providers participate and/or extend the lessons provided.

A characteristic of teaching effectiveness is resourcefulness. The materials in this book are intended to guide you in selecting and adapting activities to suit your own situation and accommodate the characteristics of the children you teach and their family circumstances. In the process, you may be inspired to modify activities you already use in your classroom to cultivate family participation in strengthening children's learning at home.

As a result of the drumbeat for early academics, teachers, parents, and children alike are feeling the pressure of higher academic expectations at earlier ages. Certainly, we want all children to acquire the academic skills needed to succeed in school but to do so without sacrificing their eagerness to learn or confidence in their own abilities. Homework—learning-at-home activities—should be considered in relationship to these goals. What if homework turned children on, rather than turned them off? What if it was something to look forward to, rather than a chore? What if it bridged home and school cultures? What if it encouraged, rather than discouraged, family togetherness? I have seen these things happen through the kinds of learning-at-home activities you will find in this book—ones that are based on children's real-world experiences with concrete materials and with others who can capitalize on interactions as teaching and learning opportunities. I hope it will help you make these things possible in your own classroom.

What We Know About Children's Learning 1

I didn't know how interested my son is in reading and learning new things until we played those games you sent home with him.

—Parent's note to her son's kindergarten teacher

What are the best ways to encourage children's learning at home? Answers to this question depend on what we know about how children learn in general and the integral role that families play in that process. Our understanding of learning is based on decades of research. While there are numerous approaches to curriculum, there is widespread agreement about principles and practices that underlie the best of them. Regardless of setting—whether formal or informal, school or home—these principles apply.

Any steps you take to encourage children's learning at home involve the family. Your efforts will be magnified if families, too, understand how children learn best. To this end, you have a unique opportunity to help them do so even though that may not be the reason you became a teacher. You may agree with a veteran teacher who said, "When I first started teaching I wasn't altogether prepared for how much I would be involved in parent education!" Even so, while the approaches you use to facilitate learning at home are designed to benefit children, they can also help family members better understand children's learning, so they are able to support it now and in the future.

LEARNING PRINCIPLES

Children Are Active Learners

Whether or not learning theorists have influenced your views, if you have worked with young children, you know they learn best when they are actively engaged. Just like the ancient Chinese proverb "I hear and I forget. I see and I remember. I do and I understand," children learn by doing. From birth on, they are intent on finding out about the world around them. They actively construct understanding through their own endeavors during first-hand experiences with materials and with others in their homes, communities, and classrooms. They need abundant opportunities to figure out how things work in both the physical and social worlds.

3

Good learning experiences enable them to do just that. Good learning experiences are authentic—connected to the real world as children know it—and for that reason they are memorable and satisfying. No amount of telling children that $2 + 3 = 5$ can replace actual experiences with concrete materials they can use to make this and other numerical relationships meaningful.

Parents and other adult family members may not fully understand young children's need for the kinds of first-hand experiences that best support their learning. They may hold the view that true learning is "book learning"—formal instruction by trained teachers—and that it entails the kinds of systematic instructional practices prevalent in classrooms for older students. But just like their children, parents also learn by doing. They are better able to understand the power of active learning by experiencing it themselves. *Telling* them that children learn through authentic experiences is likely to be less effective than *enabling* them—say—to play a game with their child that entails using academic and intellectual skills, so they experience the benefit of active learning first-hand.

Children Learn Through Interactions With Others

Learning is in large part a social activity. Children are social beings and social interaction has great power to encourage the expansion of their thinking and their language skills. Communication with others enables children to connect their experiences to the language symbols—the words—that represent them. As they become more proficient language users, their ability to talk about their understandings improves. At the same time, other people can use language to provoke children's thinking. Interaction in all forms—both verbal and nonverbal—is mediated by the cultural context with all its richness and nuance. What children see and hear and how others respond to them impacts their learning in both subtle and dramatic ways.

Children's *potential* to learn also hinges on social interaction. They are primed to learn when the level of challenge is just outside the realm of what they are able to do independently. Adults and more-capable siblings and peers can provide the necessary guidance and scaffolding for children to take that next step, so that subsequently, they can take it by themselves. The image of a scaffold as a temporary framework that supports learning is an apt one in helping us understand our roles as teachers. While curiosity and a sense of competence are the main reasons children are eager to learn, social interactions enable other people to cultivate that desire, reinforce children's efforts, and motivate them still further.

When adults—teachers and parents alike—show they value learning and include children in activities that naturally include academic skills like reading and using numbers, they are encouraging children's interest in and enthusiasm for learning those skills. Teachers can help parents understand the power of participating in informal activities with their children. Every day activities like cooking, building, making repairs, or playing a game *together* are powerful and satisfying learning opportunities for children and positively influence their motivation to learn.

Children Learn Holistically

It's customary to describe children's development and learning in separate areas: social/emotional, cognitive, language, physical. But this is an artificial division because development in one area influences and is influenced by development in other areas. For example, in the same way that children's language and intellectual development are intertwined—each supporting the other—so too are their conceptual understandings. Children perceive the world as an integrated whole, not divided into bits of information in discrete categories like reading, writing, or mathematics. As children engage in activities, they naturally seek out connections

between new information and what they already know. This not only makes learning more meaningful, it makes it easier.

Integrated learning activities approximate real-world experiences because they help children make connections across content areas and construct knowledge that is relevant on a personal level. They also help children apply skills and concepts in meaningful ways. For example, the ability to differentiate attributes of objects is important in every subject area. It aids in recognizing differences in quantity, size, shape, pattern, and letters, and it enables children to compare and contrast characteristics of organisms and other natural phenomena. While integrated approaches can help children acquire basic academic skills, such as letter recognition, their value in addressing intellectual dispositions or "habits of mind" (Katz, 1993) should not be underestimated. These dispositions include a desire to make sense of their experiences, to theorize about cause and effect, and to think critically. They are also motivating factors in children's continued eagerness to learn.

The general public is accustomed to thinking of learning in specific content areas. As a result, parents may think that basic skills are best taught through direct instruction apart from a context that makes these skills meaningful. For example, parents may encourage their children to recite the alphabet, count to 10, or name colors under the assumption that their ability to do so means they understand these concepts and can apply them in other situations. They may not understand that children will be more likely to learn how to spell a word if they need it to use it to write an important message than if the word is part of a list of unrelated spelling words. Once again, teachers can help parents understand that experiences and activities through which children make connections across developmental and content areas make learning easier and more meaningful.

Each Child's Learning Style Is Unique

Every child is naturally good at certain things and has preferred ways of learning. The key for teachers and parents is to recognize and respect each child's unique talents and to provide learning opportunities that best match his or her learning style. Howard Gardner's (1993) descriptions of nine intelligences (linguistic, logical-mathematical, musical, spatial, bodily-kinesthetic, intrapersonal, interpersonal, and existential) provide insight into the various avenues through which we all can learn. Each child possesses these competencies to a varying degree but finds learning through some channels easier. For instance, some children are sensitive to the meaning and order of words (linguistic intelligence), others to the complexity of logical systems (logical-mathematical intelligence). Some children naturally think in pictures (spatial intelligence), while still others are skilled at using their bodies (bodily-kinesthetic). When we accommodate differences in how children best learn and display knowledge, we are helping them to be successful and feel more capable as learners.

Helping parents accept and appreciate their child's unique abilities and learning styles is another way teachers can support children's learning at home. Teachers can also encourage parents to engage children in experiences that enable them to use their natural talents. And, as a result of their understanding of each child's strengths, teachers can further support parents in this process by recommending or assigning particular kinds of learning-at-home activities.

Children Learn Through Play

Play is a catalyst for learning. Through play, children have opportunities to make sense of their experiences. Play enables them to learn and practice concepts and skills, express their

ideas and emotions, and develop symbolic capabilities. It also helps children build relationships and solve problems. Play is often described by its characteristics. It is self-initiated, spontaneous, actively engaging, intrinsically motivating, carried on for its own sake, and pleasurable. When adults provide activities and experiences that embody at least some of the characteristics of play, they are capitalizing on the power of play to encourage learning. This means that an activity that is inherently motivating, individually relevant, and engaging is a great learning activity. Playful activities can be used to build academic skills such as vocabulary and print recognition, number sense, measurement and geometry concepts, and other skills that are encapsulated in most states' curriculum standards. Of equal or greater importance, playful activities that absorb children's interest and encourage their curiosity strengthen intellectual dispositions and contribute to their eagerness to learn. And when adults play *with* children, they can take advantage of teachable moments and see child development in action.

This is perhaps *the* key to encouraging family members to participate in educational activities at home with their children. The power of play to promote learning is widely misunderstood. Teachers who enable parents and other family members to engage in playful activities with children are supporting learning and at the same time helping families better understand the role of play as a medium and context for learning. Play also encourages family togetherness, which has emotional benefits including children's feelings of self-worth and family and cultural identification.

EARLY LEARNING PRACTICES

Besides considering how and why to encourage learning at home, you will need to plan for *what* children will learn. Understanding age-related and individual characteristics and needs are important factors in the process of recommending to family members how they can best support children's learning. In addition, you are or will be charged with organizing and planning curriculum relative to grade-level learning outcomes. These considerations will determine the kinds of home activities and concrete learning materials from which children are most likely to benefit.

Curriculum Guidelines

State and school district standards define small units of knowledge and skills that make up academic program goals and desired learning outcomes. Whether termed guidelines, frameworks, foundations, or standards, they share many similarities in outlining grade-level expectations for learning in language, literacy, mathematics, science, and other academic domains. It should be noted, however, that academic goals are often different from the foundational skills (e.g., using language to express oneself or focusing attention on purposeful activities) and intellectual dispositions (e.g., curiosity or persistence) that support learning in both the short and long term. These underlying skills are more likely to be included in early learning standards in preschool than in kindergarten or primary-grade standards.

Ideally, children's experiences in—as well as outside of—school should help them reach both intellectual and academic goals. Many curriculum frameworks mention the importance of family involvement and schools' support for parents as partners in the education and development of children. The notion that schools and families should work collaboratively to ensure that children engage in optimal learning experiences is one supported by the No Child Left Behind Act of 2001. While guidelines may mention the importance of engaging families in school curriculum, specific strategies to help children reach desired outcomes or ways to involve families in the process are left up to each district, school, and teacher.

As a teacher, you are guided to some extent by grade-level standards that usually describe outcomes in each content area. Understanding curriculum approaches in each of these areas can aid you in applying learning principles to help each child progress relative to these standards. Appropriate curriculum encourages active learning, is child-centered, and promotes intellectual dispositions as well as academic knowledge. It often integrates content areas. Addressing curriculum standards appropriately requires intentionality. Part of intentionality is conveying to others how child-centered learning experiences are compatible with standards. What we know about child-centered learning and best practice in each curriculum field is informed by research and supported by professional organizations. With sensitivity to family characteristics and advanced planning, you can directly involve family members in fostering children's knowledge and skills in all areas of the curriculum. And in the process, you are helping families become more aware of appropriate approaches that encourage children to be engaged and enthusiastic learners.

Language and Literacy

Children are made readers on the laps of their parents.

—Emilie Buchwald

Language and literacy acquisition go hand-in-hand and continue to develop as children grow. Experiences with oral language lay the foundation for later literacy learning. For children to learn to read and write, both communication and literacy skills need to come together. The more children hear and use language to communicate, the greater their understanding of the phonological (sound), syntactic (rules), semantic (meaning), and pragmatic (usage) aspects of language. The more experiences they have with print in their environments and with books, the better they understand that print conveys messages and relies on basic conventions. Appropriate experiences with print also encourage such literacy specific skills as letter recognition, sound-symbol correspondence, encoding, decoding, and phonemic awareness.

One-on-one conversations, storybook reading, and activities that include words in spoken or written forms provide opportunities for children to deepen their language and literacy development. Activities such as these are also fundamental to children's concept development and motivation to learn. Interaction is key. A joint position statement entitled "Learning to Read and Write," published by the International Reading Association (IRA;1998) and the National Association for the Education of Young Children (NAEYC) describes appropriate experiences and teaching to support literacy learning from preschool through the primary grades. In preschool, these approaches are

⟨ Positive, nurturing relationships with adults who engage in responsive conversations with individual children, model reading and writing behavior, and foster children's interest in and enjoyment of reading and writing;

⟨ Print-rich environments that provide opportunities and tools for children to see and use written language for a variety of purposes, with teachers drawing children's attention to specific letters and words;

⟨ Adults' daily reading of high-quality books to individual children or small groups, including books that positively reflect children's identity, home language, and culture;

⟨ Opportunities for children to talk about what is read and to focus on the sounds and parts of language as well as the meaning;

⟨ Teaching strategies and experiences that develop phonemic awareness, such as songs, fingerplays, games, poems, and stories in which phonemic patterns such as rhyme and alliteration are salient;

⟨ Opportunities to engage in play that incorporates literacy tools, such as writing grocery lists in dramatic play, making signs in block building, and using icons and words in exploring a computer game; and

⟨ Firsthand experiences that expand children's vocabulary, such as trips in the community and exposure to various tools, objects, and materials.

In addition to those listed above, some of the appropriate experiences in kindergarten and the primary grades include

⟨ Daily experiences of being read to and independently reading meaningful and engaging stories and informational texts;

⟨ Daily opportunities and teacher support to write many kinds of texts for different purposes, including stories, lists, messages to others, poems, reports, and responses to literature;

⟨ Writing experiences that allow the flexibility to use nonconventional forms of writing at first (invented or phonic spelling) and over time move to conventional forms;

⟨ An intellectually engaging and challenging curriculum that expands knowledge of the world and vocabulary; and

⟨ Adaptation of instructional strategies or more individualized instruction if the child fails to make expected progress in reading or when literacy skills are advanced.

Language and Literacy Learning at Home

Child development experts and educators understand that children's language and literacy skills begin at birth, long before they are enrolled in formal educational settings. Parents and other family members may not have that same level of understanding or know just how important they are in encouraging children's language and literacy. However, with your support and guidance, they too can use the approaches listed above to engage in interactive experiences that enhance the skills their children already possess. Without family involvement, children's potential progress is likely to be diminished.

Specifically, this means helping families understand that exposure to language- and print-rich environments is key. They may not know that children need multiple experiences encountering and using language and literacy in a variety of meaningful contexts if they are to become proficient readers and writers. Or that interactions within their family provide an important context—if not *the* most important context—for children to learn to use spoken and written language to communicate effectively.

You can help parents and others understand that the single best way to encourage children's literacy is to ensure they have daily experiences with high-quality books and opportunities to talk with responsive adults about what they hear and see in the books. This process begins with access to books, something that varies from family to family and community to community. While all children benefit from taking high-quality books home from school, it's especially important for disadvantaged children who may not otherwise have age-appropriate books available. When children listen to stories and interact with books, their understandings of the functions, forms, and conventions of print are enhanced. Shared book reading can also encourage natural and spontaneous exchanges that increase children's understanding of the story, stimulate their language and vocabulary, and develop their abstract and critical thinking skills.

Activities that enable family members to extend book reading encourage children to focus on the ideas presented in the book as well as specific language and literacy skills, such as

sound-symbol relationships and story narrative. Both books and activities are natural conversation starters and can motivate adults to talk with children about things that are personally meaningful and culturally relevant.

Parent-child interactions during daily routines also provide rich context for language and literacy development. The simple act of talking about experiences and activities together enables parents to use those experiences to positively influence children's learning in general and as a springboard to informally teach specific language and literacy skills.

Mathematics and Science

I had my eyes opened to look for science and math in everything.

—Parent who used parent kits in a library-based
science and mathematics program that addressed
many early-education standards in mathematics,
science, and literacy

Conceptual development in mathematics and science share several similarities. Both rely on first-hand encounters with the environment and active engagement with concrete or manipulative materials that enable children to explore, see relationships, and problem solve. Both involve classification, comparisons of similarities and differences, and some form of representation or communication of these relationships. Measurement is used in both to capture observations. Children's understanding is enhanced when mathematics and science are integrated with activities in other content areas. For instance, cooking and gardening encourage children to count, measure, observe, and compare. In addition to similarities shared by these two disciplines, guidelines from professional organizations describe how adults can foster children's learning in each area.

Early Childhood Mathematics: Promoting Good Beginnings is a joint position statement published by National Association for the Education of Young Children (NAEYC) and the National Council for Teachers of Mathematics (NCTM; 2002). It describes high-quality mathematics education for young children and includes 10 research-based recommendations:

1. Enhance children's natural interest in mathematics and their disposition to use it to make sense of their physical and social worlds.

2. Build on children's experience and knowledge, including their family, linguistic, cultural, and community backgrounds; their individual approaches to learning; and their informal knowledge.

3. Base mathematics curriculum and teaching practices on current knowledge of young children's cognitive, linguistic, physical, and social-emotional development.

4. Use curriculum and teaching practices that strengthen children's problem-solving and reasoning processes as well as representing, communicating, and connecting mathematical ideas.

5. Ensure that the curriculum is coherent and compatible with known relationships and sequences of important mathematical ideas.

6. Provide for children's deep and sustained interaction with key mathematical ideas.

7. Integrate mathematics with other activities and other activities with mathematics.

8. Provide ample time, materials, and teacher support for children to engage in play, a context in which they explore and manipulate mathematical ideas with keen interest.

9. Actively introduce mathematical concepts, methods, and language through a range of appropriate experiences and teaching strategies.

10. Support children's learning by thoughtfully and continually assessing all children's mathematical knowledge, skills, and strategies.

There are three main dimensions of science. The first aspect, and the one that most often comes to mind, is content or scientific knowledge. Science curriculum is often structured by areas within science (physical science, life science, earth and space science, science and technology) to provide experiences through which children can acquire content knowledge. And, indeed, the National Science Education Standards organize science content standards in this fashion for K–4 (National Committee on Science Education Standards and Assessment, 1996). While content knowledge is important, the other two dimensions of science may be even more significant in early childhood. They are science processes—the foundation of the scientific method—and attitudes and dispositions about science. Without curiosity, a sense of wonder, and a feeling of capability to learn about science, children may lack the motivation to acquire science content knowledge. Helping them develop the intellectual dispositions to do science can be more difficult in the upper grades than it is in early childhood. The early years provide that opportunity.

It has been said that young children are natural born scientists. They are innately interested in the world around them and eager to learn about it. Just like scientists, they naturally use the science processes of inquiry and investigation as they build their own theories of how things work. Effective instructional practice in science provides time, space, and equipment for children to conduct investigations. It also encourages children's systematic use of basic science process skills. These include observing, classifying and comparing information, measuring, communicating observations and information collected, inferring cause and effect relationships, predicting outcomes, and experimenting by manipulating variables.

However curriculum and instruction are organized, the main goal in early childhood should be to build on the processes children are already predisposed to using to figure things out so that they begin to think like scientists. To this end, it is more appropriate for children to investigate fewer topics in depth, so they have opportunities to use science process skills systematically, to learn to think critically, and to gain confidence in their abilities as problem solvers, than it is to tackle too many topics. It is better to enable children to "uncover" a topic than to cover the curriculum in a superficial fashion (Helm & Katz, 2001).

Mathematics and Science Learning at Home

Families play a central role in children's mathematical development and science understandings, one that is analogous to their role in children's literacy development. Children's early experiences at home and in the community shape their later abilities and interests and can build a sound mathematical and science foundation.

Several of the NAEYC-NCTM (2002) recommendations highlight the importance of families in children's acquisition of mathematical knowledge. One way you can encourage children's in-depth and sustained involvement in math activities is to help families extend and develop math experiences outside of school. Furnishing families with information about everyday mathematics experiences as well as supplying hands-on resources in the form of games and manipulative materials enables them to engage children in mathematical learning experiences tailored to their interests, languages, and home cultures (Edge, 2000). Playful activities that encourage counting, measuring, block constructions, and that include board and card games can also help children and families develop positive attitudes toward math.

You can also help families see the many opportunities for science experiences within their homes and communities. Kitchens and back yards are wonderful science labs, full of hands-on opportunities for children to learn about science. Encouraging children's engagement in inquiry and investigations at home, where time constraints are likely to be fewer than they are within daily classroom schedules, allows for the kind of sustained involvement that leads to in-depth understanding. It also increases parent involvement and interest. When parents have information and materials to engage children in learning about natural phenomena, they are able to extend those experiences in ways not always possible within the classroom. They can seize the moment and follow children's lead and in the process reinforce positive attitudes about science and children's belief in their own capabilities.

Many child-development experts have voiced concerns about children's disconnection from the natural world (Kahn & Kellert, 2002). Children seem to be increasingly plugged into television and electronic games when inside and engaged in organized sports when outside. You can encourage families and children to become involved in nature-based science experiences that inspire a sense of wonder and curiosity, the driving forces behind science. Moreover, personal contact with nature makes it more likely that children will become conscientious stewards of the earth. Science content related to ecology or the environment cannot replace the attitudes children develop from first-hand experiences in the natural world. So, when you help families understand the learning that can come from watching a spider build a web, following an ant trail, or observing pigeon or sparrow behavior, you are helping to empower the next generation in caring for the planet and instilling scientific habits of mind.

Given appropriate support from the school, most children will use science process skills (observing, communicating, classifying, measuring, inferring, and predicting) at home to understand science concepts at a deeper level. Likewise, they can explore mathematical relationships, engage in problem-solving activities, and document mathematical information. When you enable families to engage together in appropriate home-based math and science activities, you are enhancing the quality of classroom math and science instruction. With your support, family members can reinforce basic concepts and skills as they engage with children in informal activities and investigations. At the same time, you are enabling families to help children gain confidence in their own abilities as budding scientists and mathematicians. The power of family members' interest and participation should not be underestimated as a motivating force to encourage learning in these areas.

The Creative Arts

Many educators and parents still differentiate between a time for learning and a time for play without seeing the vital connection between them.

—Leo Buscaglia, *Love in the Classroom*

As you and your school struggle to meet the requirements of No Child Left Behind with its focus on reading and mathematics, there is often little time for children to engage in creative arts activities. Nonetheless, the creative arts—music, movement, dance, creative dramatics, and the visual arts of drawing, painting, and sculpting—play a central role in early childhood education and should be part of children's daily experiences. They invite children to experiment, invent, and express their thoughts and feelings as they interpret and represent their experiences in unique ways. In the process, the arts promote children's positive attitudes about inquiry, problem solving, and confidence in their capacity to learn. In addition, children with a variety of talents and learning styles can enhance and demonstrate their understanding through the arts.

The arts help children make their thinking visible. For example, the visual arts enable children to use "graphic languages" (Katz, 1993) to represent their experiences and ideas in ways they are not yet able to articulate in words. Creating something new through any of these art forms is exciting for children. No matter what their creations appear to be to others, the process of expressing themselves in their own unique ways helps them make sense of their experiences and is intensely engaging and personally satisfying.

The arts also provide many avenues for engaging children in literacy, math, science, and technology. Take drawing for example. Children draw stories and create shapes and patterns. Drawing is both a scientific tool requiring careful observation, and it is a means of communication; it is both a science process and literacy skill. And, of course, it helps refine hand-eye coordination and fine motor skills.

With increasingly crowded classroom curricula and growing pressures on teachers to devote more time to reading and mathematics instruction, the creative arts along with opportunities for creative thinking and physical activity are frequently pushed aside. In response, professionals from many disciplines are alarmed that children have diminished opportunities to engage in the kinds of creative expression and learning that the arts make possible. One way to compensate for these limited opportunities is to help families provide them outside of school.

Creative Arts Learning at Home

You can help families recognize the essential value of creative expression not only as a means of representation but also as a way to facilitate development and learning in other areas of the curriculum. With your support, families can make it possible for children to engage in the kinds of creative arts activities that were more likely to be part of the school day in the past. To leverage the learning opportunities the arts provide, you can help families understand the importance of

⟨ Giving children extended, unhurried periods of time to explore materials and use them in their own ways;
⟨ Providing space where children can leave unfinished work and come back to it later;
⟨ Experimenting with movement, sound, dramatics, and other artistic media;
⟨ Encouraging imagination, creativity, and problem solving;
⟨ Participating with their children in joint projects to reinforce family identity; and
⟨ Helping children gain appreciation for how their own and other cultures are reflected in the arts.

When you provide families with materials and ideas for activities through which they can make music, dance, draw, tell stories, and play active games together you are helping families recognize the value of the arts as a means to enhance children's learning. In the process, you can also reinforce the idea that a few basic materials combined with common household items are all that are needed to encourage creative problem solving and expression.

Even when your classroom teaching practices are based on sound principles of learning informed by professional organizations' guidelines, they can be enhanced through family involvement. Given current curriculum mandates and the overemphasis on test scores as evidence of students' achievement, it is likely your class schedule is more crowded than ever. It is also likely there is limited time for playful or creative activities or for the kinds of one-on-one interactions that so effectively support children's learning in all areas. Enlisting the participation of family members is one way to compensate indirectly for the pressures imposed by curriculum mandates and by the challenges you face in meeting individual needs within a group of children with diverse characteristics. With your support, families can become directly involved in children's learning in all areas of the curriculum and can extend and enhance the school-based experiences you provide. The result is a positive impact on students' success.

Involving Families 2

I have learned how important the role of a parent is in encouraging a child's interest in something.

—Journal entry from a mother who did family
homework with her five-year-old

The fact that family involvement from birth on has long-lasting influences on children's social, emotional, and cognitive development is probably not new information to you. The understanding that home is the first classroom and parents are children's first and most essential teachers is widely accepted. While teachers usually have children in their classrooms for one academic year, the family continues to be the main force in a child's education from birth to adulthood. This makes it clear that any and all school initiatives that support families in their roles as teachers have the potential to magnify school-based efforts.

Before turning to how to encourage family involvement, it's important to look more closely at issues related to it and to understand that the most successful strategies address the challenges parents and schools face in working together.

FAMILY INVOLVEMENT MATTERS

The importance of family involvement has been well documented. Numerous studies show that children whose parents are involved perform better academically and have fewer behavior problems (Henderson & Mapp, 2002; Izzo, Weissberg, Kasprow, & Fendrich, 1999; Jimerson, Egeland, & Teo, 1999). Family involvement results in children's language growth and development, higher reading scores, motivation to achieve, quality work habits, and prosocial behavior (Caspe, Lopez, & Wolos, 2007). In fact, the most accurate predictor of students' success in school is not socioeconomic status, ethnic or racial background, or the parents' level of education. It is the extent to which the family is involved in creating a home environment that encourages learning, communicates high, yet reasonable, expectations for success, and becomes involved with the child's school-based education (National PTA, 2000, p. 12). In addition to school success, family involvement is also associated with long-term social benefits such as high levels of high school completion and less substance abuse, antisocial behavior, and teenage pregnancy.

Becoming involved in children's education has value for parents as well. Involved parents tend to be more accepting of their children, more attuned to their needs, and more likely to provide positive reinforcement. They also tend to use more complex language and to encour-

age their children's exploration and verbalization. Plus, they are more likely to utilize community-based services effectively to help meet their families' needs (Henderson & Berla, 1995). Participation can also be a gateway for parents' personal growth. Involvement in school programs contributes to parents' feelings of self-worth and competence, especially among low-income and ethnic minority populations. Involved parents feel invested in what happens at school and that their contributions make a difference. This sense of empowerment can lead to self-development and engagement in other social institutions.

Schools with high levels of family involvement usually outperform similar programs with low levels of family involvement. Teachers and principals in these schools more often experience high job satisfaction and feel more respected in their positions (Henderson & Berla, 1995). Family members' support also enhances the instruction teachers are able to deliver and the kinds of activities they can provide for their students.

The benefits of family involvement persist over time. Parents who are involved during the early years are likely to continue their involvement as their children progress through elementary school, with resulting positive outcomes for their children in high school (Ou, 2005). When schools encourage parent participation in early childhood, they are helping parents establish a pattern of continued support for their children's learning. For example, one parent whose kindergarten child brought home a literacy backpack containing books and related activities said that because of these materials, she realized how she could establish a regular reading routine with her child: "It's very important for us to do this all the time" (Barbour, 1998). Nonetheless, it is never too late for families to get involved. No matter when they do, their children's performance improves.

MAKING CONNECTIONS

Family involvement takes various forms (Epstein, 1995). Many of the ways families can support their children's learning are rooted in the connections they have with educational settings. The type and frequency of these connections, whether formal or informal, set the tone and determine the nature of the home-school relationship and the extent to which it is a true partnership. At one extreme, this relationship can be respectful and supportive. At the other, it can be antagonistic and uncooperative. Or it can be indifferent and of little benefit to anyone. Few parents take a leading role in establishing this relationship. They take their cues from the school. It is up to school personnel, particularly the classroom teacher, to initiate the kinds of school-family connections on which mutually beneficial partnerships can be built.

Connections can be made at the school site when parents are invited to attend parent-teacher conferences and other school-based events or to help with school activities. Many teachers consider parent participation to consist mainly of these types of at-school connections, and, indeed, hope to make many of them with each new group of students' families. However, making connections with some families at school can be easier than with other families. Middle-class families, in particular, may be particularly responsive to involvement opportunities of this kind (Coleman & Churchill, 1997). Other families, however, may be unable or unwilling to participate in this way because they work two jobs, rely on public transportation, or require childcare for younger children. In addition, their understandings and feelings about school may impact their responsiveness to these kinds of invitations. They may be unfamiliar with the educational system in the United States, distrust school officials because of their own negative experiences in school, or have limited English proficiency. For these and other reasons, it is important to use a variety of approaches to connect with families. Teachers and administrators who are aware of potential barriers to family involvement are better able to initiate and cultivate fruitful connections. School practices to

inform and involve families set the tone of the school-family relationship and determine the extent to which parents will be involved in their children's education.

WHY FAMILIES DON'T GET INVOLVED

The major factor limiting family involvement is lack of time, especially when events are scheduled during the day. In a 1992 survey of 3,000 National PTA leaders, 89% of respondents identified time constraints as the main reason parents do not get involved. This finding coincides with elementary schools' perceptions that lack of time on the part of parents is the main barrier to family involvement (U.S. Department of Education, National Center for Education Statistics, 1996). Other barriers identified in the PTA survey are that parents

⟨ Feel they have nothing to contribute (32%);
⟨ Don't understand the planning process or the service system (32%);
⟨ Don't know how to become involved in a meaningful way (32%);
⟨ Lack child care (28%);
⟨ Feel intimidated (25%);
⟨ Are not available during the time school functions are scheduled (18%);
⟨ Have language and cultural differences (15%);
⟨ Lack transportation (11%); and
⟨ Don't feel welcome at the school (9%).

Even though these survey results are based on a one-dimensional definition of parent participation as attendance at meetings or other school functions, they nonetheless reveal a realistic picture of the challenges families face in interfacing with schools and the obstacles teachers and schools need to overcome if they are to form meaningful connections with all families. They make it clear that involving families requires understanding their unique circumstances and perceptions and responding accordingly.

Schools can address the more tangible barriers through scheduling and helping to arrange childcare and transportation when attendance at school-based events is necessary. But the less tangible barriers—those related to parents' feelings of being valued, competent, and accepted—require different approaches. Overcoming these barriers requires careful consideration of the underlying messages families receive from the school as well as alternative opportunities to become involved in their children's education.

TEACHERS' AND PARENTS' VIEWPOINTS AND EXPECTATIONS

School personnel and parents view family involvement through different lenses. Teachers' attitudes about family participation in their classrooms are tied to their comfort level with parents witnessing their teaching styles and influencing the classroom climate (Carlisle, Stanley, & Kemple, 2005). Some teachers seek out and rely on parents' classroom participation, finding it a necessary source of support. Others would just as soon not have parents in their rooms but value their involvement in other ways. Teachers' attitudes are also colored by their perceptions of how effective parents are in providing instructional support at home. While 90% of teachers believe family involvement is a vital component of a good school,

73% believe that most parents don't know how to help their children (Jones, White, Aeby, & Benson, 1997). Whether or not teachers request parents' help with homework, most do expect that parents will see that children complete assignments and bring them back to school on time.

Parents' perceptions of their involvement are somewhat different than those of teachers. Regardless of their level of income, ethnic and racial background, or level of education, parents recognize the value of being involved in their child's education. Parents consider themselves to be deeply involved in their children's education at home, and they regard their involvement at home as more important than their involvement in activities at their child's school. They tend to become most involved in school efforts when the link between their participation and its benefit to their child is clear and direct (Institute for Educational Leadership in Washington, D.C., 1995). However, many parents are uncertain about how to participate in school-based activities. About one third of parents indicate that not knowing how to help their children limits their involvement (U.S. Department of Education, National Center for Education Statistics, 1996).

A MULTIDIMENSIONAL VIEW OF FAMILY INVOLVEMENT

A commonly held view of family involvement is that it entails coming to school-based functions, attending parent-teacher conferences, serving on school-related committees, or volunteering in the classroom. Parents' participation *at* school directly supports a school's instructional programs and is a vital component of successful schools. However, other types of involvement are also extremely important. Family support for children's learning *outside* of school, particularly at home, is likely to have an even more significant impact. The home environment, family resources, and interrelationships influence how effective this support is. Parents who frequently talk, read, and play with their children are helping them learn. Similarly, those who provide a variety of activities and experiences or teach specific skills are doing so as well. Parent participation in child-centered activities is directly associated with social, emotional, language, and literacy development.

A multidimensional view of family involvement has been integrated into the parent involvement component of the No Child Left Behind (NCLB) legislation (U.S. Department of Education, 2005). The law requires that schools develop ways to get parents more involved in their child's education both at school and at home. Joyce Epstein (1995) from the Center on School, Family and Community Partnerships at Johns Hopkins University provided a useful framework that is the basis for the National Parent Teachers Association (NPTA) program standards and can be used as a basic blueprint for developing parent involvement programs as well as evaluating existing practices. It acknowledges that there is no one formula or pathway for creating partnerships with families because local needs and circumstances differ. This framework includes six types of family involvement: (1) parenting—helping all families establish home environments that support children as learners; (2) communicating—establishing two-way exchanges about school programs and children's progress; (3) volunteering—recruiting and organizing parent help at school, home, or other locations; (4) learning at home—providing information and ideas to families about how to help children with homework and other learning experiences; (5) decision making—including parents from all backgrounds as representatives and leaders on school committees; and (6) collaborating with the community—identifying and integrating community-based resources and services to strengthen school programs (Epstein, 1995).

Three types of involvement in this framework—parenting, learning at home, and communicating—affirm the centrality of family contributions outside of school. The key role of families is illus-

trated by an instructional coach's comment that she often hears teachers say that their students would do better "if they just got more help at home." With this understanding, school efforts aimed at reinforcing parents as educators and homes as learning environments have great potential for positively influencing children's learning. Regular and direct home-school connections are likely to magnify the effectiveness of both parents' and teachers' efforts and the value of both home and school as learning environments. However, to be most effective, strategies aimed at encouraging family involvement at home need to make it possible, even convenient, for families. They should be planned with awareness of the common barriers mentioned above, especially parents' lack of time or knowing how to help their children. In addition, they should also consider cultural relevance and families' funds of knowledge as an additional motivator.

THE IMPORTANCE OF HOME-CULTURE CONNECTIONS

One factor that contributes to discontinuity between school and home is dissimilarity in cultures. Schools and families may hold contrasting perspectives about teachers' and parents' roles in promoting children's learning skills, and their expectations for children's behavior may differ. They may also primarily rely on different ways of communicating. Cultural differences such as these tend to be the greatest for children of color, with ramifications for their academic achievement. When schools help children to bridge home and school cultures, they increase the likelihood of their success.

In addition to potential cultural differences, children from minority populations are disproportionately enrolled in schools with insufficient parent involvement and support for the school curriculum (Los Angeles Unified School District, 1998). Parents and teachers can also misinterpret each other's actions or lack of action. For example, teachers may think that some parents do not care about their children's education if they are unresponsive to written information sent home. However, these parents may be marginalized by school practices that rely on impersonal forms of communication or assume family members are proficient in English. In reality, parents care deeply about their children and are by no means indifferent to what happens in school. Nonetheless, their prior experiences with schools and their cultural backgrounds influence how they manage their children's education. For instance, despite less direct involvement with the school, immigrant Latino families tend to stress the importance of education and provide nonverbal support by excusing children from chores and other obligations so they can attend to their homework (Caspe et al., 2007).

Schools that recognize and use families' preferred ways of communicating and interacting take an important step toward building school-family partnerships. Schools that include opportunities for families to be involved in culturally responsive curriculum increase the likelihood they will participate. One way to do this is to integrate families' funds of knowledge (Moll, Amanti, Neff, & Gonzalez, 1992) into the curriculum, for example, through storytelling or drawing on family members' skills. Another approach is to share culturally relevant children's literature and activities with families. This can be especially effective in lessening cultural discontinuity and creating a bridge between school and home. Instructional materials that include portrayals of individuals with whom families can identify or images and practices that are familiar help them feel included and motivate their participation. For example, children's books with African American characters or historical themes are likely to be particularly relevant to African American families. Similarly, English-Spanish bilingual books or those that represent the cultural experiences of various Hispanic and/or Latino groups are likely to be of

interest to families from those ethnic communities. Culturally responsive materials validate cultural identities and can help to bridge home and school. They also help to educate all children and families about the diversity around them and to connect them to the pluralistic communities in which they live (Allen & Boykin, 1992).

WHAT WORKS

Schools and individual teachers have used a variety of approaches and instituted many different kinds of programs to encourage family partnerships. Some of these are more effective than others. Those that are most successful follow a few basic rules.

⟨ They reach out to parents (Berger, 2008).

⟨ They make it easy for parents to participate (Morton, 1992).

⟨ They give parents specific information about what they can do to be involved (Hoover-Dempsey et al., 2005).

⟨ They enable parents to experience a direct connection between their efforts and their children's learning (Institute for Educational Leadership in Washington, D.C., 1995).

⟨ They are embedded in instructional practices, rather than "added on" to school activities (Caspe et al., 2007).

⟨ They rely on family strengths, recognize cultural differences, and respect diversity (Weiss, Caspe, & Lopez, 2006).

If thoughtfully planned, learning-at-home activities that encourage family interaction can incorporate each of these guiding principles. These types of activities are sometimes called *interactive homework* or even *family homework*. They enable parents to better understand their children as learners and to experience the direct effect of their own involvement—factors that encourage their continued participation. Teachers support this process by providing specific guidelines and most of the necessary materials. Interactive homework that is designed with cultural sensitivity and consideration for families' characteristics can be especially effective in reinforcing family participation.

Research confirms the effectiveness of interactive homework as a means of involving families and as a strategy to improve children's learning. An examination of more than 300 school-family partnership programs in over 20 states found that schools that implemented interactive homework tended to have high-quality programs (Sheldon & Van Voorhis, 2004). Another study revealed that students whose teachers regularly assigned interactive homework had significantly higher levels of academic achievement than students who completed traditional homework assignments (Van Voorhis, 2003).

In addition to its effectiveness in supporting parents' engagement in children's learning, interactive homework requires that schools expend relatively few monetary or human resources. It is a cost-effective strategy that benefits children, families, and teachers alike. If schools expect more parents to take an active role in their children's education, they must support them in the process. Family homework provides direct and ongoing support.

As highlighted by the effective practices described above, the approaches you use to involve families in children's learning will be enhanced when you enable parents to be teachers of their own children. The activities you recommend or assign and the materials you send home can encourage interaction and bridge home and school expectations and cultures. Your investment in designing interactive homework will pay big dividends for children and their families. The success you are likely to experience for your efforts will be an added bonus.

What About Homework? 3

Right by the copy machine there is an article that says that homework sometimes creates a negative effect on students' outlook on school and learning. I think that's the appropriate place to post the article because if you make homework packets, that's where you will be spending a lot of time!

—Second-grade teacher

Homework should not be taken out altogether. It is just a matter of knowing how to adjust to the needs of students.

—First-grade teacher

For young and old alike, the word *homework* conjures up strong images and feelings. Whether we are teachers, parents, or students, our views of homework are shaped by our conceptions of what homework is, can, or should be, as well as by our personal experiences with it. Homework has gotten a good deal of attention recently, both in professional literature and the popular press where the "battle over homework" is akin in some ways to the similarly unfortunately named "reading wars" in its polarization of issues related to homework. At the most elemental levels, controversies about homework revolve around to what extent the benefits to learning are related to the costs as measured by time and the extent to which they influence children's and families' lives after school. Related controversies surround homework and young children.

Broadly speaking, *homework* is a teacher-assigned task that students are expected to complete outside of school hours. These tasks vary from school to school, from grade level to grade level, and from classroom to classroom. The most common type of homework for younger children is assigned to help them practice specific skills by repeating them through some sort of exercise, usually on worksheets. Other kinds of homework can lay the groundwork for a lesson or unit at school by asking children to gather information ahead of classroom instruction, or it can extend learning by asking children to apply what they've learned to other contexts. Projects that involve families usually encourage children's application of skills and concepts. Cooper (2007) described goals for assigning homework in these terms: (1) to boost children's learning and achievement; (2) to instill attitudes, dispositions, and habits to positively affect long-term academic achievement; (3) to encourage greater independence, self-reliance, and curiosity, and (4) to involve families in schooling.

Much of the controversy about homework stems from the degree to which it accomplishes these goals. Despite policy makers', teachers', and parents' perceptions of the benefits and drawbacks of homework, research reveals mixed results. Some studies indicate positive effects, especially for students in middle and high school, while others highlight the negative impact homework has on children's feelings and attitudes about school and their lives outside of school. A major difficulty in assessing the effects of homework is the dissimilarity of variables related to it. The kind, quantity, quality, and frequency of homework differ as do expectations about the extent of family involvement in it. Whether or not assignments are personalized for individual students or what the home environment is like are additional factors not accounted for in most studies of the effectiveness of homework. It should also be noted that reported benefits and drawbacks of homework are largely based on *traditional* homework assignments—paper-and-pencil assignments that are hand checked or graded by teachers—rather than on family-based learning activities. This alone may account for many of the results reported below.

BENEFITS AND DRAWBACKS

Cooper's (2007) summary of the value of homework for kindergarten through high school students is based on his synthesis of homework research conducted over the last 20 years. It reveals that in general homework can improve students' academic achievement as measured by scores on unit tests. However, grade level significantly affects the effectiveness of homework. Students in grades 7 through 12 are likely to benefit most as are children with learning disabilities who are given assignments tailored to their individual skills, attention span, motivational level, and that successfully involve their parents. However, *the link between homework, as traditionally conceived, and achievement for young children is "trivial."*

With the understanding that family involvement is strongly connected to children's success in school, homework is seen by teachers as a tangible means to encourage parent participation. It can create a bridge between school and home through

(a) letting parents and other adults know what the child is learning, (b) giving children and parents a reason to talk about what's going on at school, and (c) giving teachers an opportunity to hear from parents about children's learning. (Walker, Hoover-Dempsey, Whetsel, & Green, 2004)

Epstein (2001) confirmed this perspective—by listing in her 10-point typology of reasons teachers assign homework—with two points that are related to parent-child relations and parent-teacher communications. First, homework can provide

opportunity for students and parents to develop positive communication on the importance of learning, exchange information, facts, attitudes and expectations about school; it can show how aspects of school work apply to real-life situations, as well as encouraging positive feedback from the parents. (p. 37)

Second, homework can also allow "teachers to communicate with parents, to involve them in the learning process and inform them about what and how the students are learning and how their skills are progressing" (p. 37).

The negative effects of homework have gotten a good deal of play in the popular press

within the last decade. Take for example, *Time* magazine's 1999 cover headline "Too Much Homework! How it's hurting our kids, and what parents should do about it." The lead article arrestingly titled "The Homework Ate My Family" (Ratnesar, 1999) claims that "the sheer quantity of nightly homework and the difficulty of the assignments can . . . leave kids in tears and parents with migraines and generally transform the placid refuge of home life into a tense war zone" (p. 56). The suggestions that too much homework can overwhelm families and can lead to children's emotional and physical fatigue and loss of time for other worthwhile activities is echoed by educational experts as well. At stake are children's interest in what they're learning and positive attitudes toward school. Echoing this view, Kohn (2007) said, "Most children dread homework, or at best see it as something to be gotten through. Thus, even if it did provide other benefits, they would have to be weighed against its likely effect on kids' love of learning" (p. 36).

Other arguments against homework stem from the lack of or an inappropriate type of family involvement (Cooper, 2007). On one hand, homework assignments can accentuate existing socioeconomic inequities and widen the achievement gap. Children from more affluent homes may be more likely to have greater parental support and live in home environments more conducive to doing homework, whereas low-income children may have more difficulty completing assignments. On the other hand, family involvement can cross the line between coaching children and completing assignments for them, thereby inadvertently undermining their self-reliance—one of the purported goals of homework. Additionally, some parents may exert excessive pressure on children to perform well.

Again, it is important to remember that in researching and writing about homework, critics and proponents of homework are most often referring to traditional homework assignments.

TRENDS AND ISSUES

Even though there may be widespread perceptions that students are burdened with more homework now than in the past, research indicates this is not necessarily the case in all age groups. Gill and Schlossman (2004) traced trends in the amount of time students spent on homework over the past 50 years. They found the only increase in the last two decades was in the lower elementary grades. Six- to eight-year-olds *are* spending more time on homework than they did in the past. This is not surprising given the push for earlier academic achievement and greater accountability for young children's learning as measured by standardized test scores. The irony in this trend is that researchers believe traditional homework has the least if any impact on academic achievement during these years.

Much of the increased homework for young children is in the form of worksheets intended to provide practice in basic skills. For example, kindergartners in an urban Los Angeles school district bring home daily homework folders filled with worksheets. Representative examples of these worksheets direct children to practice vowel or initial consonant sounds by cutting and pasting pictures of objects, to recognize similarities by circling pictures of objects that are the same color, and to sort by color by marking an X through a picture of an item that is not like the others in the row. The mother of one of these kindergartners said her child spent at least one hour per day completing them, despite the National Education Association and the National PTA (n.d.) recommendation that children should spend no more than 10 minutes per day per grade level (beginning in first grade) on homework.

A 2007 poll of 1,000 teachers, 501 parents and 2,101 K–12 students conducted by Harris Interactive revealed that many parents were concerned about the quality of their children's homework assignments. Forty percept of parents said a great deal of their children's homework

is "busywork," and one-third rated the quality of their children's assignments as fair or poor (Viadero, 2008). However, not all parents have negative reactions to this type of work. In the words of a mother of a kindergartner enrolled in that Los Angeles area school district whose daughter's homework consisted mainly of worksheets:

> Personally I love the idea of her having homework from school. It teaches her to have patience, that you don't turn in sloppy work, how to understand directions, and the consequences if you don't do your work or don't do it right. The most important aspects of homework at this age are to let them know there is work after school so that it won't be a surprise when they reach the next grade, how to prioritize their time, and the communication between the child and parent because as a parent you get to see what is going on in class and how they are progressing in terms of understanding the assignment. (Personal correspondence)

Opposite sentiments about the value of homework are reflected in this anonymous parent's weblog posting:

> I hate homework, in part because I do know some of the research behind its effectiveness or lack thereof. Much of the homework my kids bring home is busywork. It's homework for the sake of doing homework. I wouldn't mind longer term projects that require 1/2 hour or so each evening to work on. Homework is especially hard to manage when both parents work full time. When you don't get home until 6 p.m., there's not much time to do anything but homework and dinner (http://weblogs.swarthmore.edu/burke/?p=289).

Even preschool-age children are assigned worksheets as homework despite education researchers' recommendations for other more developmentally appropriate types of learning experiences. In the face of this trend, the Association for Childhood Education International (ACEI) published a brochure for families entitled "Worksheets in Preschool: Too Much, Too Soon" (Miller & Cantor, 2008). Its underlying message is that children need to be actively involved in authentic problem-solving situations to build a foundation for reading, writing, and math. Worksheets decontextualize skills and concepts and even when completed correctly, do not necessarily indicate that children understand the meaning behind what they have done.

Even parents with young children may view homework as an indication of school commitment to academic achievement and thus assume their children will be given work to bring home. In the face of this pressure, teachers may assign homework, even though they harbor doubts about its value (Kohn, 2007). A recommendation made by one kindergarten teacher in an urban Los Angeles public school to her teaching partner illustrates this expectation: "Throw them a bone! Parents think that if their children are not given homework, they are not learning." However, parents may not fully understand the great variations in homework assignments and that some are more conducive than others to children's learning.

Much of the public debate about homework revolves around the *quantity* of homework rather than about the *quality* of what children are asked to do outside of school and whether or not the time spent on it is commensurate with its value. According to Gill and Schlossman (2003) writing in the *Los Angeles Times*:

> In our view, homework is the prime window into the school for parents to see, understand and connect with the academic mission of the teachers. It is the primary area in which children, parents and schools interact daily. Yet it gets less systematic thought

and attention than any other key component of education. Other than the admonition that kids should do more of it, we pay almost no attention to how to improve its design and content. (December 11, 2003, Part B, p. 17)

With the view that homework *can* be a means to cultivate collaboration with families to support children's learning, it behooves schools and teachers to try to overcome issues that make homework a challenge for many families. These issues include parents' uncertainty about school homework policies and practices, how they can best help their children, and whether the amount, quality, or level of difficulty in assignments is appropriate for their children. Another issue reflected in one parent's comment above is competing demands on their time and energy after they get home from work. Some families also lack appropriate or necessary resources at home for children to complete assignments (Epstein, 2001). Added to these potential sources of tensions are those created by demographic changes in the United States. Parents whose own schooling experiences were dissimilar to those of their children, who are unfamiliar with schooling practices in the United States, or who have limited proficiency in English often leave children to complete homework on their own. As one master's degree candidate in early childhood education and first generation Chinese-American put it:

My own parents were not able to help me [with homework] because they did not understand it themselves and there was also the language barrier. They did not speak English very well so whenever I did not understand, I had to wait until the next day to ask the teacher. I know what it feels like to not understand the homework and have to turn it in unfinished. (Personal correspondence)

Parents such as hers can also feel powerless and frustrated by their inability to help their children. Delgado-Gaitan's (1990) ethnographic study of low-income Latino families' interactions with the school their second- and third-grade children attended revealed that the majority of parents were confused by unclear school expectations and the vagueness about the meaning of homework:

Feelings of incompetence in their ability to help their children perpetuated a sense of isolation among the families. They felt responsible for their children's failure. The feeling of shame about being poor and lacking formal educational skills restricted their use of school and community resources. (p. 115)

RESPONDING TO CHALLENGES

Given these challenges, teachers must carefully consider how they design homework to improve young children's learning, increase communication with families, and improve parent-child relations (Epstein & Van Voorhis, 2001). Coupled with these considerations are ones related to young children's developmental characteristics, which differ significantly from those of older children. Homework, or learning-at-home activities, should reflect young children's need to be actively engaged with concrete materials and with others in experiences that are connected to the real world as they know it. Real-world experiences enable children to learn holistically; through authentic experiences children build, connect, and apply concepts and skills in ways that make the most sense to them. First-hand experiences are also important because preschool and kindergarten children are still developing abilities to think symbolically, and primary-grade children's abilities to think abstractly are limited. This means that authen-

tic experiences support learning that is meaningful and memorable in a manner that more abstract tasks, such as traditional homework, are unable to do. Young children also greatly benefit from interactions where communication and the guidance of others can help sustain and encourage their learning.

Play-based activities are exceptionally powerful contexts for learning. During play, children's brains are particularly receptive to learning. Play is absorbing and motivating and usually stress free. Play with others magnifies its power as a medium for learning. Informal play-based activities create optimal conditions through which young children can build foundations for later, more abstract, and more independent learning. With teacher support, children's homes are especially appropriate environments for playful learning to occur. Playful activities that encourage family interaction are mutually beneficial to parents and children alike because family relationships are at their core. These types of activities also provide models of appropriate learning experiences for families and, hence, indirect parent education.

PROMISING PRACTICES

Play-based activities are one kind of what has been termed *interactive homework*. Interactive homework assignments based on parent-child interactions encourage conversations related to learning activities. They tend to be more authentic—connected to children's experiences in the real world—than traditional homework assignments, and, for this reason, are more engaging. They can also increase parents' interest in homework, a factor positively related to homework completion (Cooper, 2007).

Interactive homework encourages positive attitudes about learning at home for children and family members alike when

⟨ Assignments are tailored to children's interests and needs;
⟨ Activities are linked to home experiences;
⟨ Activities are culturally relevant;
⟨ Directions are clear;
⟨ Family members are given a means to provide input;
⟨ Assignments make it easy for families to participate (e.g., supplying all necessary materials);
⟨ Flexibility is built in (e.g., assignments include choice or a time frame within which to complete them); and
⟨ Family participation is recognized and reinforced through positive feedback.

Interactive homework is gaining traction within the educational community. One group of researchers and educators who have taken great strides to disseminate information about interactive homework is the National Network of Partnership Schools (NNPS) at Johns Hopkins University (2009). Founded and directed by Joyce Epstein, its objective is to provide leadership to schools in developing family and community involvement programs that meet No Child Left Behind requirements for parent involvement.

NNPS has established a school-family partnership process called Teachers Involve Parents in Schoolwork (TIPS) Interactive Homework. The purpose of TIPS is to support teachers in involving family partners in learning-at-home activities at the elementary, middle, and high school levels and to address some of the problems associated with traditional homework. Goals for TIPS interactive homework are to

⟨ Build students' confidence by requiring them to show their work, share ideas, gather

reactions, interview parents, or conduct other interactions with a family partner;
⟨ Link schoolwork with real-life situations;
⟨ Help parents understand more about what their children are learning in school;
⟨ Encourage parents and children to talk regularly about schoolwork and progress; and
⟨ Enable parents and teachers to frequently communicate about children's work, progress, or problems. (Adapted from National Network of Partnership Schools, 2009)

TIPS provides guidelines for designing interactive homework assignments at any grade level and in any content area and includes prototype activities and templates on its Web site: www.csos.jhu.edu/P2000.

Research indicates positive effects of weekly interactive homework on student achievement, family involvement, and attitudes about homework. For example, interactive homework given to low-income second-grade students improved their ability to draw inferences, as measured by scores on reading inference tests, and also increased parent participation (Bailey, Silvern, Brabham, & Ross, 2004). Older students not only experienced higher levels of family involvement, they completed more assignments, turned in more accurate assignments, and earned higher report card grades (Van Voorhis, 2003).

Other programs designed to involve families, particularly in children's literacy acquisition, are also becoming more prevalent. One example is Read With Me/Lea Conmigo, a program that engages families of infants through first-grade children in reading activities. Sponsored by Families In Schools, it provides backpacks filled with sets of children's books in English and Spanish and related family literacy activities. Even educational supply companies have capitalized on schools' desire to involve families in children learning by marketing generic sets of take-home backpacks filled with books and write-and-wipe activity cards.

In addition to ensuring interactive homework is aligned with the special characteristics and interests of families and promotes dialogue and discussion, it should encourage children's logical thinking skills and enable them to construct understandings that are personally meaningful to them. Activities that promote reasoning tend to be more authentic and provide opportunities for adults to scaffold children learning.

THE BOTTOM LINE

Homework policies and practices differ widely as do families' and children's experiences with homework and feelings about it. Nonetheless, when homework is assigned to young children, it should be used to best advantage to foster their learning. Understanding how children learn best enables teachers to design learning-at-home activities that make good use of children's time out of school and within the context of their families. Teachers play critical roles in encouraging families to nurture children' learning. They must carefully consider how homework is conceptualized, how appropriate it is for each child, and how procedures related to it are structured. Carefully designed homework can encourage more than skill and concept development. It can foster quality interactions, productive work habits, home-school communication, and positive attitudes about school. In other words, it can meet all four goals (Cooper, 2007) listed at the beginning of this chapter.

Appropriately designed homework for young children

⟨ Enables children to learn through first-hand concrete experiences;
⟨ Includes interaction with others;
⟨ Makes it easy for parents to participate;

⟨ Allows children to apply what they know in a variety of contexts;
⟨ Differs according to children's individual characteristics, abilities, and needs;
⟨ Accommodates variations in home environments;
⟨ Has clear directions and guidelines for families;
⟨ Is connected to and enriches classroom learning;
⟨ Provides feedback to children and means for parents to give feedback to teachers; and
⟨ Is short in length (or meant to be accomplished over several days).

Equally important, well-designed learning-at-home activities can sustain young children's eagerness to learn, which is a critical component of their future success.

Encouraging Learning at Home 4

The role of parents in the education of their children cannot be overestimated.

—Mexican American Legal Defense Fund

A kindergarten teacher in a low-income, urban school wrote in his journal, "I know I can influence the care my students receive at home by encouraging more interaction, more book reading in lieu of watching television and playing video games, and stimulating child-parent activities and experiences." Insights of this kind are foundational to school efforts to support children's learning at home.

Planning ways for family partners to be meaningfully involved in children's education requires that curriculum goals are aligned with children's needs and interests and family characteristics. Respecting family strengths and accommodating their needs will encourage family participation and make it more effective. Failing to do so is a missed opportunity and distances families from their children's experiences in school. Effective support of family members as teachers of their own children depends on several considerations.

WHAT TO CONSIDER

Children's Interests and Needs

Knowing children well is key to providing learning experiences that are most appropriate for them. The centrality of each child in the learning process underscores the importance of authentic learning activities, ones based on individual characteristics and learning styles. Good teachers continually help children activate their prior knowledge, make connections to the real world, and think strategically. Just as in-class activities should be tailored to individual children, so too should activities that encourage learning at home. A one-size-fits-all approach is suitable in neither context. Bridging in-school and at-home learning also requires that teachers understand the families and homes from which children come. With this knowledge, teachers can encourage home-based activities that are most relevant within the context of a family.

Family Characteristics and Circumstances

A tenet in early childhood education is to take children from where they are and move them along from there. "Where children are" is firmly rooted in their home environments and family cultures. The nature of their experiences within their homes and communities determine the kinds of learning opportunities they have. Knowing as much as possible about children's backgrounds and environmental circumstances is key in effectively meeting their needs within the classroom. It is also a critical consideration in bridging the home and school spheres of influence.

As classrooms become increasingly diverse, teachers need to make conscious efforts to understand their students' out-of-school experiences and to consider how these influence and can be used to support children's learning at home. Two teachers' comments illustrate this point:

I was conscious of different family structures, but it wasn't until I became a preschool teacher that I realized that every child comes with his own unique history. It's very easy to jump to conclusions about a child and their family based on one's own personal ethnocentrism. (An experienced preschool teacher, personal correspondence)

My own parents had to work all the time and so, as the oldest, I was left to take care of my siblings. I had to walk them home from school, feed them, and help them with their homework. I even attended parent-teacher conferences. (A newly certified substitute teacher, personal correspondence)

The following questions are starting points in understanding family characteristics and determining how best to involve family members in that children's learning.

⟨ What language or languages are spoken at home?

Knowing the home language can determine the best ways to communicate with families. It can also inform decisions about the types of activities and materials that will be most relevant and engaging to families. Families whose home language is not English will benefit from bilingual materials and are likely to experience a greater sense of empowerment and feeling of value than if materials and activities are in English only.

⟨ Is the child cared for after school by a parent, grandparent or other relative, or home- or center-based childcare provider?

Children's afterschool care arrangements may determine who is most likely to participate with the child in learning-at-home activities. These arrangements may also necessitate communication with others outside the family circle.

⟨ Does the child live with one or two parents, or is there a joint custody arrangement?

Children, parents, and teachers benefit when there is two-way communication and collaboration among all adults who care for a child. This may mean making a conscious effort to support both parents individually in encouraging children's learning at home.

⟨ Are there older or younger siblings at home?

Family composition can be a factor in determining the types of home-learning activities that are most appropriate for particular children and families. Older and younger siblings often are eager participants in family homework, especially if it involves concrete materials. Older siblings can help to scaffold learning. Younger siblings benefit as well. Information about family composition also influences decisions about the kinds of concrete materials teachers send

home. For example, paper rather than plastic bingo chips are safer when there are infants or young toddlers in the family.

⟨ Is the child eligible for free or reduced lunch—an indication of family income?

Expectations about family involvement should be realistic. The degree to which families can provide resources and the amount of time an adult family member can spend with a child are often directly related to income. Teacher sensitivity to these factors can enhance school-home communication and inform decisions about how best to support learning at home.

⟨ Is the child enrolled in afterschool activities or lessons?

Children's afterschool activities provide additional information about family circumstances and children's interests. They may also determine when and how to communicate with families or to send activities home with children.

Beyond this type of factual information, teachers should also be aware of family attitudes and expectations, many of which are culturally embedded.

Home Language and Culture

As U.S. schools become increasingly diverse, children from different cultural and language backgrounds are learning together in the same classroom. The more teachers know about the cultures from which their students come, the easier it is to plan appropriate curriculum and provide learning-at-home activities. The great majority of English learners in the United States come from Spanish-speaking homes. According to a 2000–2001 survey initiated by the U.S. Department of Education, nearly 80% of students with limited proficiency in English were from Spanish-language backgrounds (Kindler, 2002). However, they represent only one of many language groups. In port cities and large metropolitan areas, it is common to have children from a variety of language backgrounds in the same classroom. In Los Angeles Unified School District, for example, approximately 90 different languages are spoken. Rural communities are also becoming increasingly diverse. Nevertheless, while students may share a language and some traditions, their backgrounds can be quite different. For instance, Spanish-speakers may be Mexican immigrants or third-generation Mexican Americans. Their families may have come from Central America, South America, or the Caribbean, bringing with them distinct cultural heritages.

One way to respond to family characteristics is to provide culturally relevant books, those that include characters, situations, and even languages with which children and families can identify. Culturally relevant materials can counter negative self-concept and poor cultural grounding—both barriers to academic achievement in minority populations (Ladson-Billings, 2001)—and increase levels of parent involvement. Culturally relevant books validate personal experiences, help family members talk with and tell stories to their children, and encourage other self-affirming interactions.

Family Strengths and Challenges

Every family has strengths and challenges. These are influenced by social, economic, cultural, and demographic characteristics and can determine the degree of continuity between children's at-school and at-home experiences. For example, economic resources affect parents' energy levels and the learning opportunities they provide to their children. Children's daily routines and home environments can be predictable and organized or chaotic. Some families participate in activities together; others pursue their interests separately. Families differ in their levels of literacy in English or in their primary language. If several generations are living under

the same roof or there are older siblings, children are likely to have several learning partners at home. If they are living in single-parent families, their parents may be more likely to rely on others to provide out-of-school learning experiences. Families vary in their familiarity with the school system or expectations for parental involvement. This in turn influences their participation in learning activities at home.

While it's important to respect family privacy, knowing something about these factors will help teachers plan accordingly. One way to do this is to send home a family survey at the beginning of the year. Depending on a school's population, it might be necessary to translate this survey into more than one language. A sample of a family survey is included in the Resources at the end of the book.

Understanding family strengths and challenges enables teachers to tailor activities to be of most benefit to individual children. It also serves as the basis for knowing how to communicate most effectively with families about learning-at-home activities.

Parent Education

Parents and schools have essentially the same goals: They want children to be successful in school and prepared for the future. Conflicts sometimes arise when parents lack understanding of appropriate ways for children to learn and master particular skills. For example, parents may not know that children need daily experiences with books and that opportunities to "write" in their own way or see stories they have told written down encourage literacy and can be more effective in motivating a desire to read and write than repeated practice writing letters and numbers. It is the responsibility of teachers, as professional educators, to help parents recognize how children learn both in school and at home. When they do so, parents are much more likely to appreciate the learning inherent in first-hand experiences, responsive interactions with others, and playful activities like games and dramatic play.

Any connection with families provides an opportunity for parent education, either expressly or indirectly. Open houses, parent conferences, and school literature usually inform families about ways to support children's learning. But, nothing is more powerful than modeling appropriate activities and interactions and giving parents first-hand opportunities to experience the positive effects of their own involvement. Many schools plan onsite events like family math or literacy nights to great effect. These can help parents use particular instructional strategies at home. However, these types of events require parents and children to be at school on particular days and times, something that is not possible for or attractive to all families. An alternative that reaches all families, even those that are physically or culturally isolated, is to send home interactive learning activities. This type of *interactive homework* models the kinds of experiences that most appropriately support children's learning. When materials encourage interaction, they enable parents to experience directly the power of their own abilities as teachers.

The effectiveness of providing interactive materials to families is illustrated in parents' responses to two different home literacy projects. Children in these schools took home bags or backpacks containing books and related learning activities based on a particular theme or topic. One project in a public early-childhood center served a diverse group of preschool and kindergarten children, many of whom were Title I students (Barbour, 1998). Parents commented on questionnaires about their experiences with the materials:

⟨ "There are pretty neat books out there for five-year-olds. Reading and vocabulary can be greatly enhanced with related activities."

⟨ The materials show "how to interact with books and games."

⟨ The bags "gave me many ideas to encourage my children to read."

⟨ My son "learned most from the more interactive activities."

Another school-to-home project was based in a large urban elementary school that enrolled 90% African American students. First and second graders and special education students took home literacy backpacks that included culturally responsive children's books, activities, and response journals (Barbour, 2002). Samples of parents' journal entries included

⟨ Playing a game "made reading more interesting," and retelling a story together using puppets "was a great reading comprehension lesson."

⟨ The backpacks "gave me a lot of great ideas" for helping my child.

⟨ "I loved to see my child *excited* about reading."

Adults as well as children learn best through active engagement. These projects encouraged parental interest and support, as parents learned more about their children as learners. They also modeled good learning activities and enabled parents to experience the positive influence of their own participation. Parents felt empowered as teachers of their own children (Barbour, 1998, 2002).

Curriculum Goals and Standards

An increasingly crowded curriculum and the pressure to help children meet standards and perform well on tests make it even more important to promote children's learning at home. Critics of homework make valid points about the detrimental effects of too much or inappropriate homework that results in family conflict, children's stress, and negative attitudes about school. However, if we expand the definition of *homework* to include informal, interactive, and playful activities that families and children can enjoy together, we can encourage learning at home that augments and supplements classroom curricula *and* addresses critics' concerns. Building flexibility and choice into interactive homework (e.g., providing open-ended activities or an extended time frame for their completion) also encourages the kinds of meaningful and sustained engagement that promotes intellectual understanding in addition to academic skill development.

For example, if the goal for children is to make accurate estimations, a plastic jar filled with an assortment of items to estimate becomes a family guessing game. If the goal is that children produce simple narratives, puppets and story prompts will help families scaffold children's storytelling. If the goal is for children to demonstrate an understanding of time, a blank daily or weekly schedule chart and a set of labeled clothespins will enable families to reinforce time concepts as they help children make connections between time and family activities.

HOW TO MAKE IT HAPPEN

Most learning-at-home activities are based on materials that teachers send home with children. Creating these materials and building support for this type of family homework is an up-front investment. It requires planning and organization, but it pays big dividends. These nuts-and-bolts strategies will help you in this process.

Building Support for Learning at Home

1. Send a letter to families at the beginning of the year explaining how home learning activities contribute to children's education. Outline homework procedures, and invite their participation. Describe the types of activities children will bring home, how often they will bring them, what kinds of family participation is most appropriate and beneficial, how much time typical activities will take to complete, and what families should do if they have questions about an assignment. Emphasize the important role family partners play and the opportunities they will have during these activities to help their children learn.

2. If you plan to send home learning activities on a regular basis, consider using a catchy name for your homework projects. This helps to establish them as integral to the curriculum and creates anticipation. Some teachers have called learning packets Buddy Bags, Discovery Kits, Friday Backpacks, and B.E.A.R. Bags (for Be Excited About Reading).

3. Host a parent meeting, or use back-to-school night, to review the information in the letter. Demonstrate several of the activities you will send home. Show how they are connected to curriculum goals and grade-level standards.

4. Create an agreement or "contract" that outlines participants' roles. Ask everyone to sign the agreement, promising to do his or her part. For example, teachers agree to send home appropriate activities and follow up when they are returned, children agree to spend time doing the activities, and family partners agree to participate in them too and to make sure children return materials to school. An example of an agreement is included in the Resources. Some schools require everyone's signature on this type of agreement before children are permitted to take materials home. This reinforces that learning is a true partnership and that sharing teaching resources is a joint responsibility. When children see the learning materials they will be able to take home, there's an excellent chance they will motivate their parents to sign the agreement.

5. Recognize children's and family members' efforts. Be enthusiastic. Talk with children about their learning experiences at home, and encourage them to talk with their peers about them. Show parents you appreciate their contributions by sending notes home and sharing children's comments about home activities during informal conversations. Broadcast successes. Post photos of family projects in the hall. Recognize family contributions in the school newsletter. Ongoing reinforcement ensures that home learning projects don't lose steam.

Practical Considerations

Containers

Choose containers that protect activities and are easy for children to carry back and forth to school. Containers should close completely, be durable, and be readily managed by children. They should also be easy to replace without much expense. Whatever you put inside the container is the main thing, but if you choose the container first you won't be surprised when either the activities you create or the container itself is too big. A case in point: A standard file folder game will not fit in some inexpensive child-size backpacks. Options include

⟨ Manila folders or recloseable plastic bags that fit in children's own backpacks;
⟨ Small tote bags or cloth grocery bags;
⟨ Nylon gym bags;
⟨ Inexpensive child-sized backpacks; and
⟨ Child-size suitcases.

If you don't care whether all containers are alike, shop thrift stores for bags and backpacks where you can often find them for pennies. New but inexpensive child-size backpacks are available through teacher supply companies and some big box stores. If you plan to purchase bags or backpacks in bulk, investigate the cost of printing your school's or program's name and address on them. Alternatively, you can use a fabric or permanent marker to write this information yourself. This makes for easier return of any misplaced bags.

Making Activities

A major consideration in creating activities that engage children and families is the time and expense involved. Much can be done to minimize both of these. Just about any strategy you use to make classroom materials will work to create home learning materials, but here are ideas you may not have considered.

Use electronic resources—copy machines, computer technology, and Internet images and templates. They are your allies in this process. Use software programs to create file folder games. Download public domain photos. Use them to create cards for memory or concentration games. Make board games using templates available on the Internet, many of which are accessible without charge. Photocopy book illustrations to make puzzles, matching, or sequencing activities. (Remember to credit your source.)

Create more than one copy of an activity. It takes proportionally more time to create the first activity than it does to make the second. The first time includes planning; the second and third times you are simply duplicating what you've already done and can be more efficient in the process. For example, if you make a file folder game, print or photocopy several of them. If you make multiple copies of an activity, you can send it home with more than one child, share it with colleagues, or use it in your own classroom.

Use published pencil-and-paper worksheets as inspirations for interactive games where players take turns, rather than sending them home for children to complete alone. For example, a worksheet that asks children to cut and paste picture of objects that begin with a certain letter or have particular characteristics can be the basis for a more appropriate and interactive sorting game. Each player takes a turn drawing a picture card, naming the object, and placing it in one category or another. Better yet, children can go on a scavenger hunt to find real items with certain characteristics.

Combine teacher-made materials with selected commercially produced ones. The important thing is that *you* decide which activities will best encourage authentic learning at home for the children you teach.

Enlist parent volunteers to help you create activities. Most classrooms have at least one or two parents who are happy to respond to teacher requests. Some may not be able to volunteer in the classroom or contribute in other ways but are willing to make materials at home. Give them guidance or directions and supplies to make activities or to assemble materials. They can be wonderful resources.

Work with other teachers on activities. Bounce ideas off each other. Trade duplicate copies of activities you have created. Consider presenting a proposal at a grade-level meeting that everyone in the group contributes to a collection of activities. Tapping each other's experience and resources is mutually beneficial. (See Figure 4.1.)

Make activities sturdy, so they withstand multiple uses. Laminate materials or cover them with clear contact paper or strips of clear packing tape. This protects both the materials themselves and the time you invested to make them.

Keep a copy of any activity you make so that it will be quick and easy to reproduce in the event it is lost or damaged. Having a copy on hand also allows parent volunteers to do this for you.

| Figure 4.1 | Creating Activities With Others |

Other Considerations

❬ Provide guidance to families when you send home books with or without activities. They may not know whether you expect them to read to their child or that their child should be able to read the book to you. You can include a brief note in any book or activity packet describing how you hope they will participate. Or, you can simply tuck a bookmark in the book that says, "Please read this book to me," or, "Let's read this book together," or, "Please listen to me read this book!" Bookmarks can be color coded for easy identification.

❬ Include print on activity materials as often as you can. Not only will this encourage children's literacy and numeracy acquisition, it will enable family partners to help children practice and solidify the skills they already have learned. If children's home language is not English, include both languages whenever possible.

❬ Write directions that are clear, concise, understandable, and written in large print. Lengthy or complicated instructions can be daunting and reduce the attractiveness of an activity. Include bilingual directions when necessary. (See Figure 4.2.)

❬ Stick directions directly onto the activity. An instruction sheet that is separate from the activity adds one more item for families and you to keep track of. It's better to bundle activity materials and directions together.

❬ Bag all activity materials together. Zip-and-seal storage bags work well, particularly freezer bags. They are inexpensive, transparent, and can be labeled.

❬ Small items (e.g., counters and dice) can be kept in film canisters, drawstring bags, plastic boxes, potato chip cans (check for sharp edges and cover with contact paper), or pencil cases.

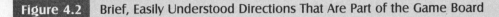

Figure 4.2 Brief, Easily Understood Directions That Are Part of the Game Board

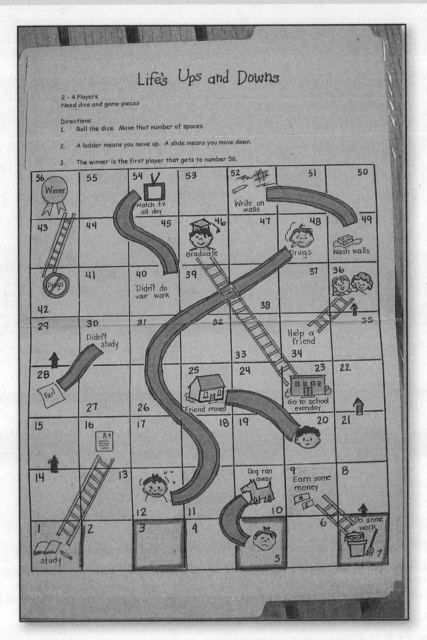

⟨ Consider including electronic components. A taped story reading of a book you send home is particularly helpful to families with low levels of literacy or who have limited proficiency in English. (If families do not have a tape player, consider letting them check one out from school.) A videotape or DVD of you or another teacher reading a story is an effective way to model oral fluency and techniques to make the story come alive. It can also model strategies to encourage children's active engagement in the reading experience.

⟨ Supplement concrete items with a sheet of ideas for informal learning experiences that require no materials or that use materials most families already have. These might include a recipe, a poem, guessing game directions, or what to look for on a neighborhood walk or car trip. Ideas for these types of activities are included as "Other ways to help your child learn" in Chapters 5, 6, and 7. Chapter 8 is entirely comprised of family activities that do not depend on materials sent home from school.

Figure 4.3 An Easy-To-Duplicate File Folder Game

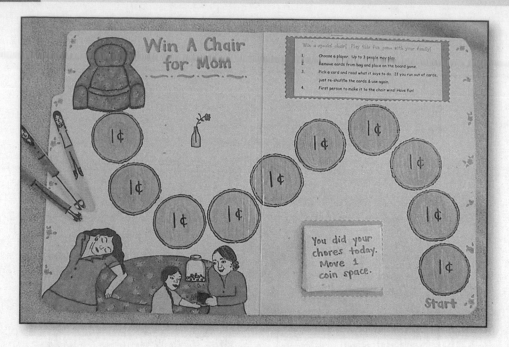

Inexpensive Activities That Can Be Mass Produced

To benefit the greatest number of children, plan activities that are inexpensive and easy to duplicate. (See Figures 4.3–4.6.) The following types of activities work well.

- 〈 Folder-based activities
 - Board games
 - Felt boards with felt pieces
 - Sequencing, matching, categorizing activities
 - Puzzles made from card stock
 - Photocopied book illustration cut in pieces
 - Jumbo craft sticks (tape together, draw on both sides, and then remove tape)
 - Dye cut templates (draw on before cutting apart)
- 〈 Dramatic play props
 - Thrift store shirts customized with fabric makers
 - Props similar to ones depicted in the books sent home
 - Gardening glove puppets for fingerplays (use Velcro, pipe cleaners, yarn, pompoms, or markers to turn each finger into a character)
 - Jumbo craft stick puppets
 - Finger puppets
 - Sock puppets
- 〈 Others
 - Laminated card stock board and dry-erase marker
 - Concentration-type games
 - Bingo games
 - Domino games
 - "Feelie" bags

Figure 4.4 A File Folder Sequencing Activity

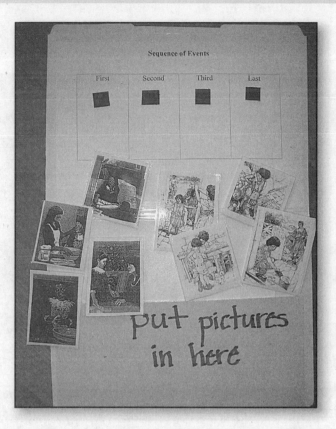

Figure 4.5 Versatile Props for Encouraging Interactions

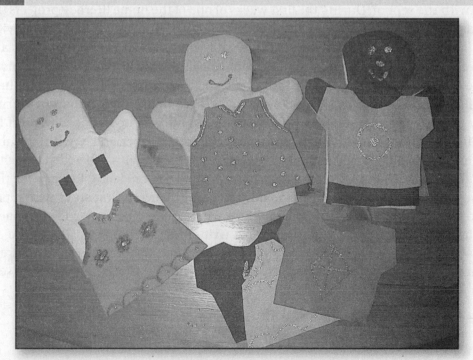

| Figure 4.6 | Sponge Puppets With Elastic Bandage Hand Straps Sewn On Back |

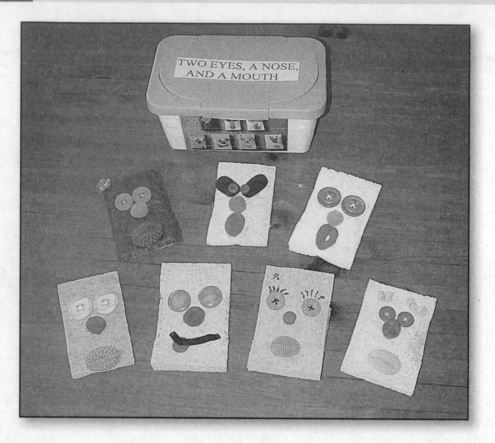

Encouraging Family Feedback

To ensure you are providing activities that best support learning at home, invite parents and other family partners to give you feedback. This will enable you to adjust the materials or reconfigure an activity. Soliciting feedback from parents also reinforces their role as true partners with the school. During the first weeks of one of the home literacy projects described above, parent comments indicated there were too few activities and that some activities were too easy for their children. Parents said they wanted to do both more activities and more complex activities with their children (Barbour, 2002). This feedback was immensely helpful in fine tuning materials that were sent home and in improving the success of the project.

An efficient way to ask for feedback is to include a response sheet or parent journal along with any activities you send home. Either can include a brief, open-ended request that parents write a comment about their and their children's experiences with the materials. Alternatively, you can ask specific questions related to the activity. An added benefit of inviting parents to write comments is that by doing so they are modeling literacy for their children. One factor to consider, prior to including a parent journal that stays with a particular activity or activity kit, is whether some parents will be reluctant to provide feedback if they know other parents will read what they have written. If you judge this to be the case, use individual response sheets instead. Another consideration is home language. Parents with limited proficiency in English will be more likely to respond if they are invited to use the language in which they are most proficient.

More formal questionnaires given to families after they have been involved for a period of time in family activities are also useful in assessing learning-at-home projects.

How to Acquire Books and Materials

⟨ Use classroom book club bonus points.

⟨ Shop yard sales and thrift shops.

⟨ Place an "ad" in a school or district newsletter requesting donations of gently used books older children have outgrown.

⟨ Send families a wish list of materials that can be used to create games and activities.

⟨ Present a proposal to the PTA or PTO requesting targeted support for a project or that a portion of proceeds from fund-raising efforts be allocated to purchasing books and materials.

⟨ Write a letter to local civic or service club. Those that are active in mentoring endeavors or that have participated in other education service projects may be particularly receptive to an appeal.

⟨ Canvass local businesses to request they "sponsor a bag" by donating funds to cover the cost of books and materials for one learning-at-home bag or backpack. Ensure their contributions are broadcast to families in the community and that the bag carries an acknowledgment of their contribution. Consider other ways to recognize their support for your school.

⟨ Investigate organizations that provide grants to buy books and other materials. Local and regional foundations and some professional organizations offer small grants to teachers to create and implement projects that improve student learning and larger collaborative grants to support teams of professionals. For example, the National Education Association's Foundation for Improvement of Education offers numerous small grants, as do the American Library Association and the National Kindergarten Alliance. Use the Internet to find potential funders. DonorsChoose (www.DonorsChoose.org) enables teachers to submit electronic proposals for needed resources and allows donors to browse and grant requests. In return, donors receive thank-you letters and photos from students and a teacher impact letter. Grant Wrangler (www.grantwrangler.com) is a free, searchable listing service for classroom and teacher grants to K–12 schools.

Versatile Purchased Items

Basic educational and office supplies can be used in many ways to create materials for learning-at-home activities. The items listed below are particularly versatile.

⟨ Dice or plain wooden cubes to make dice
⟨ Game spinners
⟨ Blank dye-cut puzzles
⟨ Jumbo craft sticks or tongue depressors
⟨ File folders (colored ones are most attractive)
⟨ Blank cassette tapes or CDs
⟨ Small dry-erase boards with dry-erase makers
⟨ Stencils (shapes, letters)

〈 Card stock

〈 Colored 3" ↔ 5" cards (for 1/2-and-1/2 matching cards, story sequence cards, game cards, domino-like cards)

〈 Felt sheets for roll-up felt boards and felt characters

〈 Zip-and-seal food storage bags

〈 Ring fasteners or shower curtain rings

〈 Clear contact paper or packing tape if laminating machine is not available

〈 Long shoe laces for lacing cards

〈 Game pieces or markers (e.g., counting bears)

〈 Clothespins

〈 Velcro "buttons"

〈 Assorted dye cut shapes

〈 Composition books or small notebooks for journals

Managing a Learning at Home Project

Projects in which children routinely take activity packs home from school benefit from systematic management. Whatever system you develop should be as efficient and easy for you and for families as possible. Teachers who have successfully developed learning-at-home projects use management procedures that you can adapt in your own classroom or school.

〈 As described above, begin the project with a notice to families describing the project and their roles as participants. This usually is in the form of a letter. If children will bring home books and other learning materials, this letter can be accompanied by a consent form that outlines all stakeholders' responsibilities. Parents must sign it before materials are sent home. An example of a consent form is in the Resources. This "Sample Literacy Bag Agreement" requires parents', children's, and the teacher's signatures.

〈 The types and number of learning-at-home activities you plan determine how often they can be sent home. For example, if you have one bag or backpack with activities that children can keep for a week, it could take the better part of the school year for every child to have a turn. On the other hand, if the number of packets is equivalent to the number of children in your class, every child can take one home. And if each packet or bag is different, children can take one home on a rotating basis every week.

〈 Give children and families a window of time to do the activities together. As described earlier, children benefit from sustained engagement in meaningful learning experiences, and home environments are especially conducive to in-depth or repeated interactions. Allowing families to use materials over the course of a week or weekend or giving them a longer period of time to complete family projects allows for extended interactions and accommodates variations in family schedules. Make whatever routine you decide upon as predictable as possible, so children and families know what to expect.

〈 Distribute take-home materials to children individually, or let them check them out using a library-like system. Pocket charts work well for this purpose. Children place cards with the name of the packet or bag they check out in pockets with their names.

〈 Use parent volunteers to help with checking out and checking in materials. In large-scale projects where several classrooms share materials, the school librarian or a parent representative in a parent resource center may be able to assume this responsibility.

⟨ Check to make sure children have returned all items sent home with the exception of expendable materials. Send a reminder to parents if any items are missing. Under most circumstances, children should not be permitted to take home additional materials if they have not returned previous ones.

⟨ Schedule time after activities or projects are returned for children to talk about their experiences and to display their creations. This sharing time reinforces the importance of learning at home and builds other children's eagerness to use similar materials.

⟨ Read parent and child response forms or journal entries to learn more about each child and family's experiences with the materials and to make any necessary adjustments. Respond accordingly.

A Literacy Backpack Program

Literacy backpacks (Figure 4.7) contain collections of books and related activities that children take home from school on a rotating basis. They provide direct access to age-appropriate books, an important aspect of home literacy environments that supports children's developing ability to read and write (Strickland, 2002). They have been used effectively to promote family involvement in children's literacy acquisition (Cohen, 1997; Richgels & Wold, 1998). Literacy backpacks encourage family involvement in several ways: (1) They reach all families, including those who tend not to be involved in classroom or school-based activities; (2) they encourage family-school partnerships and communication that promote children's learning; (3) they model appropriate, interactive means through which family members can support children's language, literacy, and learning; and (4) they reinforce the importance of parents' roles as teachers of their own children (Barbour, 1998). In addition, with appropriate contents, literacy backpacks can support children's (and other family members') cultural grounding and provide positive role models, important considerations in nurturing the language and literacy development of minority students (Walters, 2002).

A study in an urban elementary school serving a predominantly African American population revealed the multiple benefits of literacy backpacks. The backpacks were distributed on a regular basis to all first and second graders as well as special education students. Each contained at least two culturally relevant books unified by a theme and activities that were either based on the theme or on individual books. Parent and child response journals were also included to further encourage literacy. Study results indicated that the backpacks (1) provided direct access to high-quality, culturally relevant books; (2) extended and augmented school-based curriculum; (3) positively influenced children's literacy and attitudes; and (4) dramatically increased meaningful family involvement (Barbour, 2002). Parent journal responses highlighted the desire and ability of families to be involved in their children's learning, a factor that is often underestimated. Parents indicated that they not only wanted more materials to use with their children, they wanted their children to bring home backpacks more often. Some parents even asked to purchase backpacks. Both parents and teachers underestimated the degree to which young children can assume responsibility, given the proper support. Children were entrusted with books and activities and, with very few exceptions, brought them back to school intact and on time.

Sample responses from children's journals included

⟨ "I like bringing the backpack home and reading the books with my mother." (Preschool child's dictated comment)

| Figure 4.7 | Academic English Mastery Program Literacy Backpack |

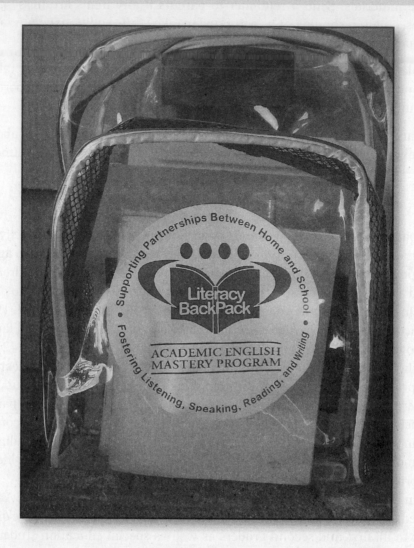

⟨ "The game is fun. We have to roll the dice and we move that number to the one and if you get on the slide you have to go down the ladder. If you get on the ladder you get to go up." (Kindergarten child's dictated comment)

⟨ "The backpack is grate. I showed the backpake to my grannie. I tuk good kar uv my backpake. I did my journal." (First-grade child)

To be of most benefit to children, learning-at-home activities should be tailored to their needs, interests, and characteristics, and to those of their families. Strategies that others have found to be effective in involving families, creating learning activities or kits, and managing learning-at-home projects will help you provide continuity between school and home and enlist family partners in encouraging children's academic success.

The comments of two teachers who created take-home bags for children in their classes sum up the benefit of a project of this type:

⟨ "Parents' responses were the most affirming event of my year." (Kindergarten teacher)

⟨ "I feel I've truly touched lives and made families feel closer with this project." (Preschool teacher)

Tips for Developing a Backpack Program

✓ Tailor backpack contents (books and activities) to the characteristics of the children and their families who will use them.

✓ Select books, materials, and themes that are culturally appropriate—ones with which children and their families can identify—in addition to ones that are relevant to the interests and language and literacy levels of the children.

✓ Include play-based, interactive activities.

✓ Provide all the materials.

✓ Access resources for free and inexpensive items (book clubs, donations, thrift shops).

✓ Bag all materials and directions for each activity together.

✓ Avoid making bags filled with lots of small things.

✓ Make sure materials are sturdy.

✓ When assembling backpacks on a large scale, make similar activities at the same time.

✓ Partner with others to plan and assemble backpacks to avoid duplicating efforts.

✓ Avoid materials that are consumable or can't be replaced.

✓ Laminate everything.

✓ Keep a master list of all backpack themes, their contents, directions for making activities, and copies of any parts of the activities that can be duplicated, or photos of activities, so that someone else can reproduce them.

✓ Consider using parent volunteers (fund raising, assembling materials, making activities, handling check-in and check-out).

✓ Explain the program to family members, and distribute printed information about it that includes a calendar and lists responsibilities of all participants.

✓ Include parents in presenting the project to other parents.

✓ Use several means to keep track of the backpacks' contents.

✓ Start small, make modifications as you go, and build on what works.

Whether you decide to begin with one take-home activity and then build on your successes or you are planning a larger scale project, the following chapters contain ideas to help you get started.

The learning-at-home activities in the next chapters will help you plan the most appropriate and effective ways to engage family members as educational partners. The activities are organized according to broad content areas, but most are integrated. While they are designed for particular purposes, they inherently encourage children's skill and concept development across the curriculum. Once again, use your professional judgment in selecting and/or adapting activities that align your goals with individual child's needs and family characteristics.

5 Language and Literacy Kits

The activities in this chapter are designed to encourage informal family interactions that support children's language and literacy development. While language arts are the focus, many themes and activities integrate social studies and multiculturalism as well as encourage concept and skill development in other areas of the curriculum. Each kit includes several activities and an assortment of suggested children's literature from which to choose. Other books with similar content or themes may be equally appropriate. Select and/or adapt activities to suit your own situation and accommodate the characteristics of the children you teach and their family circumstances.

WRITING SUITCASE

Grade Level: PreK–3

Purposes

Writing Suitcases are appropriate for all young children. They encourage children to engage in writing about familiar objects, events, and experiences and to use writing strategies based on individual levels of development. They can encourage

⟨ Preschool-age children to engage in pretend writing activities or use strings of repeated letter-like symbols;
⟨ Kindergarteners to write words that are legible;
⟨ First graders to write brief narratives describing an experience;
⟨ Second graders to describe setting, characters, objects, and events in a story;
⟨ Third graders to write letters, thank-you notes, and invitations; and
⟨ Family members to share writing experiences with children.

Activities

Stock a small handled container (a lunchbox, plastic portfolio, child-size suitcase or backpack) with a variety of materials that encourage children to write messages, notes or stories, make greeting cards, or design book covers. Materials can include

⟨ ABC puzzle with spell-a-word cards
⟨ Blank greeting cards
⟨ Clip board
⟨ Construction paper
⟨ Crayons
⟨ Dry-erase board with dry-erase marker and eraser
⟨ Envelopes
⟨ Glue stick
⟨ Letter stamps

⟨ Magnetic letters
⟨ Markers
⟨ Message pads
⟨ Nametags
⟨ Paper of different types and sizes
⟨ Parent comment card
⟨ Pencils
⟨ Pictures
⟨ Scissors
⟨ Sticky notes

Variations:

⟨ Add laminated pictures that are interesting and relevant to children.
⟨ Add index cards with thematic story starters or writing prompts such as
 ⊙ Five good reasons to stay up late
 ⊙ A special birthday
 ⊙ Amazing things I know
 ⊙ Best friends
 ⊙ If I were in charge of the world
 ⊙ Jokes I want to remember
 ⊙ Magical things
 ⊙ My favorite things
 ⊙ Things that could be better in my neighborhood
 ⊙ What I will do when I'm 10 years old
⟨ Include a journal and ask children to write a message in it for the next user.

Books

⟨ *Amazing Grace* by Mary Hoffman (African American)
⟨ *Author: A True Story* by Helen Lester
⟨ *Harold and the Purple Crayon* by Crockett Johnson
⟨ *The Jolly Postman: Or Other People's Letters* by Janet and Allan Ahlerg
⟨ *A Letter to Amy* by Ezra Jack Keats (African American)
⟨ *Messages in the Mailbox: How to Write a Letter* by Loreen Leedy

⟨ *The Post Office Book: Mail and How It Moves* by Gail Gibbons
⟨ *The Secret Birthday Message* by Eric Carle
⟨ *What Do Authors Do?* by Eileen Christelow

Other Ways to Help Your Child Learn

⟨ Encourage younger children to draw a picture. Ask them to tell about their picture as you write down word-for-word what they say. Help them "read" their story.

⟨ Sit down and write (a note, recipe, list) with your child so that he or she sees that you are a writer too.

⟨ Leave a secret message for your child, and encourage him or her to write one back to you.

⟨ Remember that learning to write is a developmental process. Children crawl before they walk! Expecting perfection can dampen a child's motivation to write.

BACKPACK BUDDIES

Grade Level: K–2
Purposes

⟨ Identify setting and important events in a story
⟨ Retell familiar stories
⟨ Share information and ideas
⟨ Describe people, places, things, locations, and actions orally and in writing

Activities

⟨ Choose a favorite storybook whose main character is a teddy bear or other animal. Put the book and a stuffed animal that resembles the main character in a child-size backpack or small tote bag. Include a journal or individual sheets of paper with the directions: "Draw, write, or dictate a story about Teddy's (the character's name) adventures in your home."

Variations:

⟨ Include a disposable or inexpensive digital camera with instruction to take one or two photos of the stuffed animal's adventures. Alternatively, ask parents to use their own camera for this purpose. These photos can be captioned and added to the backpack.

⟨ Add items related to the story to encourage children to retell it by acting it out.

⟨ Add a parent or family journal so that other family members can participate in modeling writing for the child.

⟨ Once every child has taken the backpack buddy home, make a laminated "Teddy's Adventures" book from all the journal entries or pictures for the class library.

Books

⟨ *Clifford, the Big Red Dog* by Normal Bridwell
⟨ *Corduroy* by Don Freeman
⟨ *Curious George* by H. A. Rey
⟨ *A Pocket for Corduroy* by Don Freeman
⟨ *The Tale of Peter Rabbit* by Beatrix Potter
⟨ *The Teddy Bears' Picnic* by Jimmy Kennedy
⟨ *The Velveteen Rabbit* by Margery Williams

Other Ways To Help Your Child Learn

⟨ Talk with your child about the stuffed animal's adventures.
⟨ Ask *who, what, when, where, why,* and *how* questions.
⟨ Ask your child to read or tell the story in the book to the stuffed animal.
⟨ Help your child check out books from the library that are related to the one included in the backpack.

PUPPET PACKET

Grade Level: PreK–K

Purposes

⟨ Produce simple narratives
⟨ Act out plays, stories, or songs
⟨ Share information and ideas
⟨ Practice using new vocabulary
⟨ Identify characters, settings, and important events in a story

Activities

Be a Storyteller

Place 4–6 puppets in a tote bag or backpack.

Directions: Encourage your child to tell a story using the puppets. Ask *who, what, why, how,* and *when* questions to help him extend the story. Write down the story or help your child write it in his own way. Help your child read the story and encourage him to reenact it for other family members.

Variation:

⟨ Include craft stick puppets and a file folder with either a generic backdrop or one related to a book you send home so that children can tell their own versions of the story.

Fingerplay Fun

With permanent or fabric markers, draw faces on the fingers of a light-colored garden or rubber glove that represent characters in one or more fingerplays. Include words to the fingerplay or a book based on the rhyme.

Directions: Take turns using the glove puppet to follow along with the poem. Make up your own story for these characters and use the glove puppet to act them out.

Variations:

⟨ Include materials for children to make their own puppets. (For example, socks, gloves or plastic spoons, along with nontoxic markers, fabric scraps, felt, yarn, pipe cleaners, cotton balls, buttons, wiggly eyes, scissors, and glue.)
⟨ Include several story starters written on index cards.

Books

⟨ *Diez Deditos = 10 Little Fingers and Other Play Rhymes and Actions Songs From Latin America* by Jose-Luis Orozco and Elisa Kleven
⟨ *Dreams* by Ezra Jack Keats
⟨ *The Fat Cat* by Jack Kent
⟨ *Five Little Monkeys Jumping on the Bed* by Eileen Christelow
⟨ *Five Little Pumpkins* by Iris Van Rynbach
⟨ *Goldilocks and the Three Bears* by James Marshall
⟨ *This Little Piggy* by Nicholas Heller
⟨ *The Three Billy Goats Gruff* by Paul Galdone
⟨ *The Three Little Pigs* by Paul Galdone
⟨ *Wee Sing Children's Songs and Fingerplays* by Pamela Conn Beall

Other Ways to Help Your Child Learn

⟨ Make a puppet "stage" by turning a coffee table or card table on its side. Children can kneel behind it as they put on puppet shows.
⟨ Help your child to make tickets for the puppet show.
⟨ Be an attentive and appreciative audience.
⟨ Use one of the puppets to tell your child a bedtime story.

RHYTHM AND RHYME

Grade Level: K–1
Purposes

⟨ Listen and respond to poetry
⟨ Identify and produce rhyming words
⟨ Use a variety of comprehension strategies

Activities

Poetry Awards

Duplicate the Poetry Award cards in the Resources, color them if you wish, and laminate them. Alternatively, create your own based on the poems in the book or books you include in the kit.

Directions: Poems can make you feel many different emotions. As you read the poems together, talk about how each one makes you feel. Look at the Award Cards. Decide which poems deserve which awards. Put the award on the page of the poem that you choose. Ask other members of your family if they agree with your choices.

Variation:

⟨ Include blank cards so children can make their own award. They can choose either to keep this award or put it back in the bag so others can use it.

Secret Poems

Include a book of poems, sheets of paper, and pencils. Several books listed below include poems about families and may inspire children to create poems or tell stories about their own families.

Directions: After reading several of the poems in the book, ask your child to choose a favorite and then to write (or tell) a story or poem that is similar to it in some way. It can begin in the same way as the poem he or she likes, or it can be something completely different. Ask your child to read the poem and then bring it to school to share with the class.

Variation:

⟨ If children have individual poetry booklets into which they have copied or pasted favorite poems, send these home instead of blank sheets of paper.

Me, Myself, and I Poem

Directions: After reading "When I Was One" by A. A. Milne, help your child write a poem about him- or herself. Duplicate and laminate the poem form from the next page so your child can use the dry-erase marker to write rhyming words in the blanks. Be sure to read, chant, or sing this new poem with your child.

Variations:

⟨ Include cards with labeled pictures of rhyming words.
⟨ Choose a poem with a simple rhyming scheme from a book you are sending home. Use this poem as the basis for making a fill-in-the-blank sheet so that children and parents can write their own poem.

Poetry Jumble

Write rhyming words on individual strips of card stock as well as common sight words and words children will hear in the books you send home. Include some blank strips and a pencil.

Directions: Take turns lining up the words to make a poem. Use the blank strips to write words that are missing in your poem. Read your poems. Copy your favorite poem into your journal.

Poetry Books

❬ *Arroz Con Leche: Popular Songs and Rhymes From Latin America* by Lulu Delacre (Bilingual—English/Spanish)

❬ *Gathering the Sun: An Alphabet in Spanish and English* by Alma Flor Ada (Bilingual)

❬ *It's Raining Pigs and Noodles* by Jack Prelutsky

❬ *Pass It On: African American Poetry* by Wade Hudson

❬ *Read-Aloud Rhymes for the Very Young* by Jack Prelutsky

❬ *Secrets of a Small Brother* by Richard Margolis

❬ *Tortillitas Para Mama and Other Nursery Rhymes* by Margot Griego, Betsy Bucks, Sharon Gilbert, and Laurel Kimball (Bilingual—English/Spanish)

When I Was One

by A. A. Milne

When I was one,
I just begun.

When I was two,
I was nearly new.

When I was three
I was hardly me.

When I was four
I was not much more.

When I was five
I was just alive.

But now I'm six,
I'm as clever as clever.

So I think I'll be six now,
Forever and ever!

From Now We Are Six (1927)

Me, Myself, and I!

When I was one,
I was _____

When I was two,
I was _____

When I was three,
 was _____

When I was four,
 was _____

When I was five,
 was _____

But now I'm six,
 was _____

Rhyming Books

⟨ *The Beastly Feast* by Bruce Goldstone
⟨ *Chicka Chicka Boom Book* by Bill Martin & John Archambault
⟨ *Miss Bindergarten Gets Ready for Kindergarten* by Joseph Slate
⟨ *Silly Sally* by Audrey Wood

Other Ways to Help Your Child Learn

⟨ Choose a poem you and your child especially like. Write it down and post it in your child's room or on your refrigerator.
⟨ Take turns reading lines or verses of your child's favorite poem. Sing it. Drum it. Dance it together.

ON THE ROAD

Grade Level: K–1

Purposes

⟨ Recall the sequence of events in a story
⟨ Read high-frequency words
⟨ Use a variety of reading comprehension strategies
⟨ Follow written instructions

Activities

On the Road Board Game

Choose a book with a travel theme before making this game. Then draw a curved pathway consisting of 20 or more squares on the inside of a file folder. Draw and label pictures of things the main character in the book encountered on his or her trip inside most of the squares, but write "Draw a card" in several squares. Make about 10 game cards that describe simple obstacles that will prevent progress on the pathway or occurrences that speed it up. These might include a broken down bus (lose one turn), a detour, or short cut. Add one die and four game pieces. If the pathway is relatively short, use a small wooden cube to make a die with one to four spots on it instead of including a purchased one.

Directions: For two to four players. Put the cards face down in a stack. Take turns rolling the die and moving that number of spaces. As you travel on the board, read and tell about what you are seeing and doing on the trip. Continue until every player gets to the destination.

Variation:

⟨ Draw a road map on a small tablecloth. Include street signs, label buildings, and draw other topographical features. Include features in your school's neighborhood. Include a die, game cards, and toy vehicles as game markers.

Ways to Travel Memory Game

Onto pairs of 3" ↔ 5" cards, draw (or glue clip art) pictures of cars, trains, buses, scooters, skateboards, rollerblades, horses, feet, skis, helicopters, and boats. Label each card.

Directions: For two players. Spread cards face down on a table. Take turns flipping over pairs of cards. If the two cards match, the player keeps the cards and takes another turn. If they do not match, the cards are turned back over, and it is the other player's turn. The object is to match the most cards.

Variation:

⟨ Include memory game cards with current and historical methods of transportation.

Books With Travel Themes

⟨ *Bigmama's* by Donald Crews (African American)
⟨ *Going Home* by Eve Bunting (Hispanic American)
⟨ *Going Home, Coming Home/Ve Nha, Tham Que Huong* by Truong Tran (Vietnamese American)
⟨ *Just Us Women* by Jeannette Caines (African American)
⟨ *Not So Fast Songololo* by Niki Daly (African American)
⟨ *Road Trip* by Roger Eschbacher (Poetry)
⟨ *Wow! America!* by Robert Neubecker

Other Ways to Help Your Child Learn

⟨ Talk to your child about a trip you will take together whether the trip is to another town or around the corner. Help your child make a list of what to bring on the trip.
⟨ When you go places with your child, help him or her read the signs. Talk about what they mean.
⟨ Help your child write a letter to a relative or friend who lives somewhere else.
⟨ Take turns finding letters in license plates. In the license plates, try looking for letters in your child's and other family members' names or for sequential letters in the alphabet.

FRIENDS AND NEIGHBORS

Grade Level: PreK–K

Purposes

⟨ Describe people, places, and things in the environment
⟨ Demonstrate familiarity with the local environment
⟨ Recognize other's individual characteristics
⟨ Follow oral directions

Activities

Craft Stick Puzzle (Figure 5.1)

Tape nine jumbo craft sticks together and draw a picture on each side to make two puzzles. Write "something"—one letter per craft stick—on the top end and "beautiful"—one letter per

craft stick—on the bottom end of puzzle. Remove the tape and put the puzzle in a labeled recloseable plastic bag.

Variation:

⟨ Include a set of unused craft sticks and these directions: Help your child make his or her own puzzle of "Something Beautiful." The easiest way to do this is to tape the sticks together before your child draws and writes on them. Your child may keep this puzzle.

Figure 5.1 Craft Stick Puzzle With Hand-Drawn Picture and Words

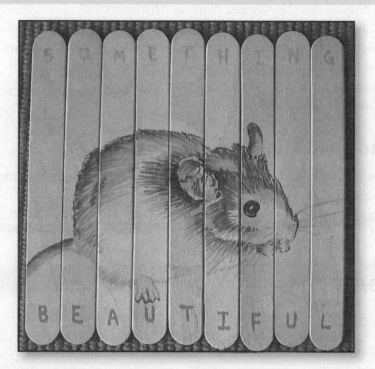

Neighborhood Walk Board Game

Make a copy of the Neighborhood Walk game in the Resources. Glue the game board on the inside of a file folder. Glue the directions on the outside. Write the numbers 1 through 4 on a cube. Place the number cube and four game markers in a zip-and-seal bag. Staple this onto the bag of the file folder.

Directions: For two to four players. Roll the number cube to see who will go first. The player with the highest number begins. Take turns. Roll the number cube and move your marker that many spaces. Read the question in each square you land on out loud and answer it. Continue playing until all players have crossed the finish line.

Friends and Neighbors Storytelling

Provide a small dry-erase board and one or two dry-erase pens. A laminated piece of heavy card stock can be used in place of the dry-erase board.

Directions: Use the dry-erase board and pen to draw or dictate a story about your friends and neighbors. Talk about the story. Use a paper towel or rag to wipe the board clean.

Special Bookmarks

Place several bookmarks made from card stock in an envelope with the directions written on the envelope.

Directions: Do you have a special friend or neighbor? Decorate a bookmark with something you liked in the stories. You can use the bookmark in your book, or give it to your special friend or neighbor.

Books

- 〈 *Barrio: Jose's Neighborhood* by George Ancona (Hispanic)
- 〈 *Eddie's Kingdom* by D. B. Johnson
- 〈 *Little Cliff and the Porch People* by Clifton Taulbert and E. B. Lewis (African American)
- 〈 *Miss Viola and Uncle Ed Lee* by Catherine Stock (African American)
- 〈 *Something Beautiful* by Sharon Wyeth (African American)
- 〈 *The Story of Jumping Mouse* by John Steptoe

Other Ways to Help Your Child Learn

- 〈 Talk with your child about something you can do together to help someone else or to make your neighborhood more beautiful.
- 〈 Take a neighborhood walk to look for things that are similar to those in the stories you read together.

ALL IN A DAY

Grade Level: 1–2

Purposes

- 〈 Recount a sequence of events
- 〈 Demonstrate an understanding of time
- 〈 Sequence ordinals (first, second, etc.)

Activities

My Daily Schedule

On the left side of a 6 × 20-inch strip of card stock write the hours of day (7:00 a.m. to 9:00 p.m.) at equal intervals. Laminate. This daily planner can be folded in half to fit in a bag or backpack. Write children's typical daily activities on individual clothespins. Examples:

〈 Bath	〈 Dinner	〈 Read
〈 Bedtime	〈 Grandma's house	〈 School
〈 Breakfast	〈 Homework	〈 Story time
〈 Chores	〈 Lunch	〈 TV
〈 Clean up	〈 Play	〈 Write
〈 Computer	〈 Play a game	

Directions: Help your child tell time: Plan and keep track of his or her activities during the day by putting clothespins on the My Daily Schedule card. Talk with your child about the order of these activities and how long each takes.

Variations:

⟨ Use card stock divided into seven squares to make a *My Weekly Schedule* board. (Figure 5.2)
⟨ Include appropriately labeled clothespins or a pad of sticky notes on which children can write their own activities.

Jamal's Busy Day

Divide two 8 1/2 ↔ 11-inch sheets of card stock into eight boxes. On one sheet, write the ordinals "first" through "eighth" in each box. On the other sheet, write each of the following in a box:

⟨ We wash up and put on our work clothes.
⟨ We eat a healthy breakfast before we leave for work.
⟨ I work hard with numbers, drawings, experiments, research, and meetings.
⟨ I take the crowded bus home.
⟨ At home, I relax, do my homework, and shoot some hoops.
⟨ We all help get ready for dinner.
⟨ We talk about our busy days.
⟨ We get ready for tomorrow.

Cut them apart to form eight cards.

Directions: Help Jamal put his busy day in order by placing the cards in order from first to eighth.

Figure 5.2 A Weekly Schedule Board That Folds In Half

Variation:

⟨ Make a similar sheet and cards that describe sequential events in another book you send home.

Books

⟨ *All in a Day* by Mitsumasa Anno (Multicultural)
⟨ *The Backward Day* by Ruth Krauss
⟨ *Days With Frog and Toad* by Arnold Lobel
⟨ *A Good Day* by Kevin Henkes
⟨ *Irene and the Big, Fine Nickel* by Irene Smalls (African American)
⟨ *Jamal's Busy Day* by Wade Hudson (African American)
⟨ *Something Beautiful* by Sharon Dennis Wyeth (African American)
⟨ *Sunday Week* by Dinah Johnson
⟨ *What Do People Do All Day?* by Richard Scarry

Other Ways to Help Your Child Learn

⟨ Take turns during or after dinner talking about what you did during the day.
⟨ Encourage your child to start a simple diary or journal by writing about and illustrating events during the day.
⟨ Post a calendar at your child's eye level. Let him or her draw or write something about each day on the calendar. (There is a monthly calendar template in the Resources.)

OPPOSITES

Grade Level: PreK–K

Purposes

⟨ Identify and sort common words into basic categories
⟨ Describe common objects and actions
⟨ Use vocabulary and concepts in context

Activities

Opposites Match

On the inside of a file folder, glue or draw squares with words and/or pictures in them. Make sure these words or pictures have opposites. Make cards of the same size with the opposite words and/or pictures. Select words at the appropriate level of difficulty.

Easier words may include in (out), on (off), first (last), dirty (clean), old (young), easy (hard), short (tall), more (less), heavy (light)

More difficult words may be dark (bright), smooth (rough), shallow (deep), attack (defend), rude (polite), lazy (hardworking)

Directions: Take turns matching each card with its opposite.

Opposite Memory Game

Make cards with matching pictures and/or words of opposites, with one picture and/or word on each card.

Directions: Spread the cards face down on a table. Taking turns, each player flips over one card and says what its opposite is. Then he or she flips over another card. If it is the opposite, he takes both cards and gets one point. If it is not the opposite, he puts both cards face down where they were before.

"Go Fish" for Opposites

The same set of cards used for the Opposite Memory Game can also be used to play Go Fish.

Directions: Shuffle the cards. Deal four to five cards to each player, and place the rest face down in a stack. Each person takes a turn by asking the next player if he or she has a card that is the opposite of one in his hand. If the player has the card asked for, that player must give the card to the person who asked for it, who then places the matched pair face up on the table. If the player does not have the matching card when asked, he or she says, "Go fish," and the asker draws a card from the stack. If he draws a match, he reads each word and puts the match face up. Continue to play until all the cards in the pile have been drawn.

Books

⟨ *Big Dog . . . Little Dog (A Bedtime Story)* by P. D. Eastman
⟨ *Black? White! Day? Night!—A Book of Opposites* by Laura Vaccaro Seeger
⟨ *Eric Carle's Opposites* by Eric Carle
⟨ *Exactly the Opposite* by Tana Hoban
⟨ *Opposites* by Robert Crowther
⟨ *Opposites/Opuestos* by Gladys Rosa-Mendoza (Bilingual)
⟨ *Quinito, Day and Night/Quinito, Día y Noche* by Ina Cumpiano (Bilingual)

Other Ways to Help Your Child Learn

⟨ Say a word that describes a position such as *up, under, forward, left* or an action such as *open* or *push*. Ask your child to act out the opposite of each word. Encourage your child to think of words that have opposites for you to act out.
⟨ Ask your child to imagine living in an opposite world where up is down, backwards is forwards, and little is big. Encourage him to draw a picture of that world and tell you about it.

I LOVE SPIDERS!

Grade Level: PreK–K

Purposes

⟨ Participate in rhymes
⟨ Act out a song
⟨ Develop number sense
⟨ Build concepts about spiders

Figure 5.3	Itsy Bitsy Spider Felt Board Folder

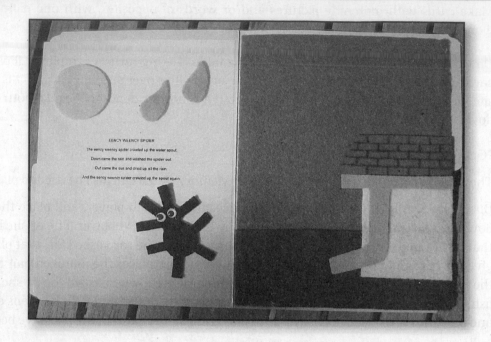

Activities

Itsy Bitsy Spider Felt Board (Figure 5.3 above.)

Write the title and directions on the outside of a file folder. Write the words to the poem inside on the left. Laminate. Glue a sheet of felt on the right side. Glue felt cut outs that represent a side of a building with a downspout. Cut a spider, sun, and several large rain drops out of felt. Place these in a recloseable plastic bag and staple this to the back of the file folder.

Directions: Use the felt pieces to act out the song as you sing it together.

Variation:

⟨ Print "The Itsy Bitsy Spider" poem but leave blank spaces after the words *spider*, *up*, *down*, *sun*, and *rain.* Include labeled picture cards of these words for children to place in the spaces.

"Five Little Spiders" Glove Puppet (See Figure 5.4.)

Use a garden glove or rubber glove to make a hand puppet. Draw a spider on each finger. Alternatively, glue or sew a Velcro spot on the fingertips of the garden glove and make five small spiders from twisted chenille stems with a Velcro spot where their legs intersect. Draw or glue a felt spider web onto the palm of the glove. Include this poem.

Five little spiders crawling all around.

The first one said, "See the bug I found?"

The second one said, "My web is neat."

The third one said, "I have eight feet."

The fourth one said, "We're all so small."

The fifth one said, "Time for autumn leaves to fall."

Then whoosh went the wind and out went the light.

And five little spiders crawled out of sight!

Directions: Take turns using the glove puppet to follow along with the poem.

Figure 5.4 Glove Puppet for Spider Fingerplay

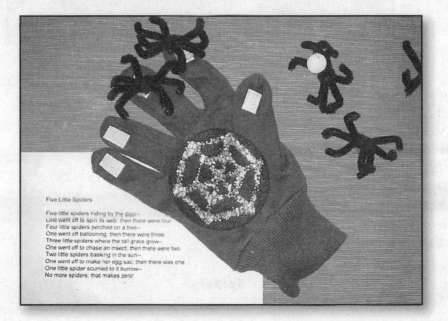

Clothespin Spider Game (See Figure 5.5.)

Make a spider body (about 6" × 9") out of heavyweight, black or brown card stock for each player. Include eight spring-hinge clothespins per body and one die.

Directions: Take turns rolling the die. Pin that number of legs onto the spider. With each subsequent turn, add or subtract the same number of legs as the number you roll. The goal is for every player to make a spider with eight legs.

Variation:

❬ Make cards with an incomplete spider sentence on each. (A spider has _____ legs. A spider spins a _____ to catch its prey. Spider babies hatch from _____. A spider moves by _____.) Take turns drawing the cards and asking each other the question. (You may need to read the card for your child.) If you use the right word to complete the sentence, put a clothespin on your spider. The object is to pin eight legs on your spider.

Figure 5.5 Clothespin Spider Game

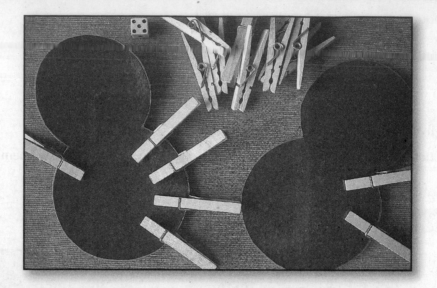

Books

⟨ *Anansi the Spider* by Gerald McDermott (African American)
⟨ *Are You a Spider?* by Judy Allen
⟨ *Be Nice to Spiders* by Margaret Bloy Graham
⟨ *I Love Spiders* by John Parker
⟨ *The Itsy Bitsy Spider* by Iza Trapani
⟨ *Little Miss Spider* by David Kirk
⟨ *Spider's Lunch* by Joanna Cole
⟨ *Spiders* by Carolyn B. Otto
⟨ *The Very Busy Spider* by Eric Carle

Spiders

by Mary Ann Hoberman

Spiders seldom see too well.

Spiders have no sense of smell.

Spiders spin out silken threads.

Spiders don't have separate heads.

Spider bodies are two-part.

Spiderwebs are works of art.

Spiders don't have any wings.

Spiders live on living things.

Spiders always have eight legs.

Spiders hatch straight out of eggs.

Since all these facts are surely so,

Spiders are not insects, no!

Spiders

(Anonymous)

No wonder spiders wear bare feet

To run their cobweb races.

Suppose they had to have eight shoes,

How would they tie their laces?

Other Ways to Help Your Child Learn

⟨ Make edible spiders on circles cut from bread or on round or oval crackers. Spread peanut butter on top, add eight pretzel (or chow mein noodle) legs and eight raisin eyes to make each spider.

⟨ Look around your home or outdoor environment for spiders. Watch them with your child. If you would rather not have a spider indoors, catch it by putting a clear glass over it and sliding a paper underneath it. Release it outdoors. Encourage your child to draw a picture of the spider in its habitat.

⟨ Read the spider poems together.

SHARING STORIES

Grade Level: 1–2

Purposes

⟨ Listen attentively
⟨ Retell stories using basic story grammar
⟨ Act out plot as well as the beginning, middle, and ending of a story
⟨ Recollect important family events and identify with family history

Activities

Act It Out!

Put one or two large pieces of fabric in a zip-and-seal bag along with *Amazing Grace* by Mary Hoffman. Try to use fabric prints that will encourage both boys and girls to participate.

Directions: In the story *Amazing Grace,* Grace used pieces of cloth to help her act out the stories she heard and read. Sometimes, she made hats, scarves, belts, and capes out of scraps of material. Use the material in the bag to act out some of your favorite stories for members of your family.

Variation:

⟨ Draw, write, or dictate the stories you acted out.

Family Quilt

Provide 9 to 12 inch squares of solid colored cloth (muslin or cotton sheeting works well), some colored markers, a hole punch, and some yarn in a zip-and-seal bag.

Directions: Give one or more fabric squares to each member of your family. Draw a favorite or memorable family moment or event on each of the fabric squares. Tell each other the story about your drawing. Punch a hole in the corners of the squares and use

the yarn to tie them together to form a "quilt." Hang the quilt in a prominent place in your home.

Variations:

〈 Invite family members to use squares of cloth from outgrown or special clothing.
〈 Sew the squares together instead of threading yarn through the holes.

When I Was Little

Duplicate several sheets of paper with "When I was little I . . ." on one half and "Now I . . ." on the other.

Directions: Tell your child stories about what he was like when he was younger. Ask him to draw a picture of what he did when he was little and what he can do now that he's older. Put the pictures together to create a "When I Was Little" book.

Books

〈 *All the Way to Lhasa: A Tale From Tibet* by Barbara Berger
〈 *Amazing Grace* by Mary Hoffman
〈 *Big Mama's* by Donald Crews (African American)
〈 *The Happy Hocky Family!* by Lane Smith (Easy reader)
〈 *The Keeping Quilt* by Patricia Polacco
〈 *The Name Quilt* by Phyllis Root
〈 *The Patchwork Quilt* by Valerie Flournoy
〈 *The Quilt* by Ann Jonas
〈 *The Quilt Story* by Tony Johnston and Tomie dePaola

Other Ways to Help Your Child Learn

〈 Look through a family photo album and talk about the occasion when each photo was taken.
〈 Help your child create a scrapbook of family memories by using extra photos, magazine cutouts, drawing, and writing.
〈 Arrange for your child to "interview" an older relative. Questions he could ask might be
 ⊙ Who lived in your home when you were a child?
 ⊙ What was your mother (father, sister, brother) like?
 ⊙ Where did you live?
 ⊙ What was your neighborhood like?
 ⊙ What did you like to eat (play, do), or where did you like to go when you were a child?
 ⊙ What are your favorite memories of growing up?

If you have a tape recorder, this interview will become a special keepsake.

THEN AND NOW

African American History

Grade Level: 1–3

Purposes

⟨ Trace the history of African Americans in the United States
⟨ Understand the sequence of important events
⟨ Explore the lives of people who made a difference
⟨ Compare the lives of African Americans in different times and places
⟨ Follow written directions

Activities

Making Progress Board Game

Copy the Making Progress board game in the Resources. Color it if you wish. Glue it inside a file folder and laminate. Include one die and four game pieces.

Directions: For two to four players. Roll the die. Move your game piece that number of spaces. A ladder means you can move up. A slide means you must move down. Talk about the events or people in the squares you land on. Play until everyone reaches the last square.

Road to Freedom Board Game

Copy the Road to Freedom board game, the spinner, and game markers in the Resources. Color at least the game markers. Glue the game board inside a file folder and laminate. Send the game home with a copy of *Follow the Drinking Gourd* by Jeanette Winter or *The Drinking Gourd* by F. N. Monjo.

Directions: For two to four players. Choose a game marker. Spin to see who goes first. The player who spins the highest number begins. Start on the Cotton Plantation. Spin and move that number of spaces. Follow directions on the road to freedom.

Freedom Train

Cut out and laminate outlines of a train engine and boxcars.

Directions: Put the train pieces in order to form a freight train. When you have finished, tell each other a story you make up about an escape on the Underground Railroad.

Variations:

⟨ Write the names of the states that the Underground Railroad passed through on each of the train pieces. (See *Aunt Harriet's Underground Railroad in the Sky* by Faith Ringgold.)
⟨ Include a blank booklet for students to write their own stories, so others who use the kit can read them too.

African American History Books

⟨ *Aunt Harriet's Underground Railroad in the Sky* by Faith Ringgold
⟨ *Brown Honey in Broomwheat Tea* by Joyce Carol Thomas (Poetry)
⟨ *The Drinking Gourd: A Story of the Underground Railroad* by F. N. Monjo
⟨ *Follow the Drinking Gourd* by Jeanette Winter
⟨ *Freedom Summer* by Deborah Wiles
⟨ *If A Bus Could Talk: The Story of Rosa Parks* by Faith Ringgold
⟨ *Now Let Me Fly* by Dolores Johnson
⟨ *A Picture Book of Martin Luther King, Jr.* by David Adler
⟨ *Smoky Night* by Eve Bunting

Other Ways to Help Your Child Learn

⟨ Tell your child stories of your own life and those of your own parents.
⟨ Choose an African American leader you or your child would like to learn more about. Find out more about this person at your local library or on the Internet.
⟨ Cut photos of African American role models from magazines or download them from the Internet. Make a "Hero Collage" with your child.

FAMILY PICTURES/CUADROS DE FAMILIA

Grade Level: K–1

Purposes

⟨ Develop an appreciation of self, family, and culture as well as the families and cultures of classmates
⟨ Connect information in books to life experiences
⟨ Identify characters, setting, and important events in a story
⟨ Understand and follow directions

Activities

Cakewalk Board Game

This game was inspired by *Family Pictures/Cuadros de Familia* by Carmen Lomas Garza. Cakewalk was a game Mexican Americans played to raise money to send their children to the university. Duplicate the Cakewalk/Endureza la Caminata board game board, two sets of game cards, and directions in the Resources. Color them if you wish. Glue the game board onto the inside of a file folder. Glue the directions onto the outside. Laminate both the file folder game and the game cards. Add one die and four game markers.

Directions: For two to four players. Place your marker anywhere on the cakewalk. Roll the die. Move that number of spaces. If you land on a number space, go forward or back. If you land on a cake, pick a card. The first person to collect three cake cards is the winner!

"Family Pictures" Memory Game

Scan the illustrations in the book *Family Pictures/Cuadros de Familia* by Carmen Lomas Garza. Using PowerPoint software, make them into nine slides per page. Write © *Carmen Lomas Garza* on each slide. Print and laminate two copies to make 18 pairs of cards.

Directions: Turn all the picture cards face down and mix them up. Each player takes turns turning two cards over at a time. If the two match, that player keeps them, and the next player takes a turn. If they do not match, turn them back over again. The player with the most pairs wins!

Variations:

〈 Choose another book with pictures of families to make memory game cards. Be sure to include © credit.
〈 Alternatively, scan family photos of children in your class to make the cards.

Where Does It Belong?

Choose two books about families. Write word cards that describe something in each of the books. Place the word cards in a bag. Create a Venn diagram on card stock or a file folder. Label each side with the name of the book.

Directions: Take turns drawing a card from the bag. Place the card on the side of the diagram that it describes. If the card described something from both stories, place it in the middle. Return the cards to the bag when finished.

Additions

Send home a copy of "What Is a Family" by Mary Ann Hoberman.

Books

〈 *Boundless Grace* by Mary Hoffman (African American)
〈 *Families* by Ann Morris (Multicultural)
〈 *The Family Book* by Todd Parr (Multicultural)
〈 *Family Pictures/Cuadros de Familia* by Carmen Lomas Garza (Bilingual)
〈 *In My Family/En Mi Familia* by Carmen Lomas Garza (Bilingual)
〈 *Ninety-Three in My Family* by Erica S. Perl
〈 *Tanya's Reunion* by Valerie Flournoy (African American)
〈 *Who's in a Family* by Robert Skutch (Multicultural)

Other Ways to Help Your Child Learn

〈 Make a book of family names. Help your child write the names of each person in the family on a different sheet of paper. Your child can add a drawing of each person. Staple them together to make a "Family Name" Book.
〈 Ask each family member to draw a picture and/or write about an important family event or a favorite memory. Put these together in a "Family Memory" Book.

⟨ Collect family photographs of events that are important to you and your child. Make photocopies of them. Allow your child to cut out photocopied pictures to make a collage of your own "Family Pictures."

⟨ Write a favorite family recipe onto the Family Recipe Form in the Resources. Read the recipe with your child. Encourage him to write about and draw a picture on the reverse side of the form. Later, we will put all the recipes together to make a class cookbook.

What Is a Family

by Mary Ann Hoberman

What is a family?

Who is a family?

One and another makes two is a family!

Baby and father and mother: a family!

Parents and sister and brother: a family!

All kinds of people can make up a family

All kinds of mixtures can make up a family

What is a family?

Who is a family?

The children that lived in a shoe is a family!

A pair like a kanga and roo is a family!

A calf and a cow that go moo is a family!

All kinds of creatures can make up a family

All kinds of numbers can make up a family

What is a family?

Who is a family?

Either a lot or a few is a family;

But whether there's ten or there's two in your family,

All of your family plus you is a family!

Source: www.canteach.ca

WHAT'S IN A NAME?

Grade Level: PreK

Purposes

⟨ Develop sense of self

⟨ Recognize letters and identify letter sounds

⟨ Practice writing names

Activities

Name Puzzle

Create a name puzzle for each child by writing it on card stock, laminating, and cutting apart each letter in a squiggly fashion. Write numbers on the backside of the puzzle.

Directions: Help your child put his name puzzle together.

Name Pins

Write individual letters on a set of clothespins. Choose the letters based on the names of children in your class. For example, you may not need to include X but will need several As. Include a list of all the letters included to ensure all are returned.

Directions: Help your child use the clothespins to pin his name and the names of other members of your family to the side of a box or bowl.

Variation:

⟨ Instead of clothespins, use a set of magnetic letters.

Treasure Hunt

Write each letter of a child's name on separate paper lunch bags.

Directions: Help your child line up the bags to spell his name. Then help him look for objects in your home that begin with each of the letters in his name to fill the bags. Ask your child to make up a story using all the items in each letter bag. Write down what he says, let him illustrate the story, and staple them together to make a book (and a keepsake).

Variation:

⟨ Include several extra bags for writing the names of other family members.

Important Names

Send home a set of sentence strips with blanks for parents to write safety information. Families can keep these strips. Alternatively, provide laminated sentence strips and a dry-erase marker that can be returned to school.

⟨ My name is _____. (First and last name)
⟨ My mother's name is _____.
⟨ My father's name is _____.
⟨ My teacher's name is _____.
⟨ I live at _____.
⟨ My telephone number is _____.
⟨ I go to _____ school.

Directions: Finish each sentence, help your child "read" each sentence, and display them in a prominent place in your home.

Name Songs

Duplicate copies of one or more name songs:

> ### Bippity Boppity Name Song
>
> Bippity Boppity Bumble Bee,
>
> Tell me what your name would be!

Directions: Sing or say these two lines, then say your child's first name as you clap the syllables. Next, clap the syllables while only mouthing child's name. The third time, clap and count the syllables. Sing the song adding different names.

> ### Willaby Wallaby Name Song
>
> Willaby Wallaby Woo, an elephant sat on Sue.
>
> Willaby Wallaby Wuan, an elephant sat on Juan.
>
> Willaby Wallaby Wasmine, an elephant sat on Jasmine.
>
> Willaby Wallaby Warry, an elephant sat on Barry

Directions: Encourage your child to rhyme the names of friends the elephant sat on.

Books

⟨ *Andy (That's My Name)* by Tomie dePaola
⟨ *Chrysanthemum* by Kevin Henkes
⟨ *Eleanor, Ellatony, Ellencake, and Me* by Cathy M. Rubin
⟨ *Harry and the Dinosaurs Go to School* by Ian Whybrow
⟨ *My Mommy Doesn't Know My Name* by Suzanne Williams
⟨ *My Name Is Alice* by Jane E. Bayer
⟨ *The Name Jar* by Yangsook Choi (Korean American)
⟨ *A Porcupine Named Fluffy* by Helen Lester

Other Ways to Help Your Child Learn

⟨ Label items in your home that belong to or are special to your child with his name.
⟨ After reading *My Name is Alice* by Jane E. Bayer, help your child use a similar pattern using the beginning sound of his own name.
⟨ Sprinkle a thin layer of salt, cornmeal, or sand into a shallow baking or cookie sheet with sides. Your child can practice using his finger to write the letters of his name in the salt. Alternatively, squirt shaving cream into the pan or directly on a table.
⟨ Use dots to write the letters in your child's name. Start each letters with a bigger or different colored dot so that your child is reminded about where to begin as he traces over the letters.

⟨ Play "post office" with your child. Make a slit in the top of a box. Write your child's name on this "mailbox." You can make a mailbox for each member of your family. Mail notes to your child and encourage him to write or draw messages, sign his name, and "mail" them to someone else.

⟨ Help your child use a computer keyboard to type his name. Show him how to make upper- and lowercase letters.

LEGENDS

Grade Level: 2–3

Purposes

⟨ Restate facts and details in a text
⟨ Compare and contrast plots, settings, and characters presented by different authors
⟨ Compare and contrast different cultural versions of the same story
⟨ Retell stories, including characters, setting, and plot

Activities

Alike or Different?

Make a Venn diagram on the inside of a file folder. Make cards with names of characters, settings, and story events from the books you send home.

Directions: Shuffle the cards and place the deck face down. After you have read the books with someone in your family, take turns drawing a card. Place the card in one section of the Venn diagram and tell why you put it there.

Big Events

Include sheets of paper divided into three sections and labeled first, second, third.

Directions: Write and illustrate three important events in the life of the legendary figure you read about in the order they occurred. Tell someone in your family why you chose those three events.

Variation:

⟨ Include a "prop" from the legend (e.g., John Henry's hammer cut from sturdy cardboard and laminated) for children to use as they retell the story.

Legend Board Game

Create a board game by drawing a curved pathway of squares on the inside of a file folder. Draw or scan pictures from the book (be sure to write the copyright on each illustration you scan) to place on or surrounding the pathway. Write questions about the story on the squares. For example, Where did this story take place? Who was the main character? What was (the character's) problem? What did he or she do that was so special? What was your favorite part of the story? What might have happened if . . . ? Act out . . . Laminate the file folder. Include one die and two to four game pieces.

Directions: Place your marker on "Start." Take turns rolling the die and moving that number of spaces. When you land on a square with a question, answer it. If you are not able to

answer it, go back to the square where you were before. Even if you are not the first player to cross the finish line, keep playing until you get there.

Variation:

⟨ Create the game board on the computer, print and glue onto a file folder. Write questions on game cards, instead of on the squares themselves, for players to draw when they land on a particular square.

The Next Story

Send home a book that you believe will appeal to an individual child.

Directions: Pretend you are the main character in a legend you have read. Make up another story about this character that involves extraordinary courage, skill, or strength. Tell your story to someone in your family.

Books

⟨ *Arrow to the Sun: A Pueblo Indian Tale* by Gerald McDermott (Native American)
⟨ *China's Bravest Girl: The Legend of Hua Mu Lan* by Charlie Chin (Chinese/Chinese American)
⟨ *John Henry* by Julius Lester (African American)
⟨ *Johnny Appleseed* by Rosemary and Stephen Vincent Benet
⟨ *The Legend of John Henry* by Ezra Jack Keats (African American)
⟨ *Magic Dogs of the Volcanos/Los Perros Magicos de los Volcanes* by Manlio Argueta (Bilingual, Hispanic/Latino American)
⟨ *Pie-Biter* by Ruthanne Lum (Chinese/Chinese American) also the Spanish translation *Comepasteles*
⟨ *The Story of Johnny Appleseed or La Hisoria de Johnny Appleseed* by Aliki
⟨ *Two Bear Cubs: A Miwok Legend From California's Yosemite Valley* by Robert San Souci (Native American)

Other Ways to Help Your Child Learn

⟨ Tell your child a legend or folktale from your own culture.
⟨ Take your child to the library to find other legends based on her interests.

GRANDPARENTS

Grade Level: K–3
Purposes

⟨ Use props to tell a story
⟨ Sustain a conversation focused on a particular topic
⟨ Listen critically and respond appropriately to oral communication
⟨ Compare and contrast everyday life in different times
⟨ Express ideas artistically

Activities

Retelling Stage

Make a retelling stage by creating a backdrop on the inside of a file folder. Cut out or draw shapes resembling scenes in one or more of the books you include. For example, make trees, a house, cars, or hills. Using permanent markers, draw simple representations of main characters in the books onto jumbo craft sticks. Write each character's name on the back of the stick. Place these in a zip-and-seal bag, and staple it to the back of the file folder. (See Figure 5.6.)

Directions: Use the retelling stage and the stick puppets to retell the story. Make up a new ending for the story. Create a new story for the main characters.

Keepsake Bookmark

Provide a 2 1/2 ↔ 6-inch piece of construction paper or card stock and markers.

Directions: Make a bookmark for your grandparent or another special older person, and give it to him or her as a keepsake. If you wish, punch a hole near the top and thread a piece of ribbon or yarn through it to make a fancy tassel.

Interview a Grandparent

Include a list of questions children can ask a grandparent or another older person. Laminate for reuse if desired. Choose questions from those listed in the Resources that are most age appropriate. Older children can record responses to the questions they ask.

Directions: Pretend you are a newspaper reporter. Ask your grandparents or other special grand-person questions about their lives when they were younger.

| Figure 5.6 | Retelling Stage With Craft Stick Puppets |

Books

⟨ *Abuela's Weave* by Omar Castaneda (Hispanic)
⟨ *The Always Prayer Shawl* by Sheldon Oberman
⟨ *Bly Mama's* by Donald Crews (African American)
⟨ *A Birthday Basket for Tia* by Pat Mora (Hispanic)
⟨ *Dan and Dan* by Marcia Leonard
⟨ *Grandfather Counts* by Andrea Cheng (Chinese American)
⟨ *Grandfather's Journey* by Allen Say (Japanese American)
⟨ *Grandpa's Face* by Eloise Greenfield (African American)
⟨ *The Gullywasher: El Chaparron Torrencial* by Joyce Rossi (Bilingual)
⟨ *Oliver, Amanda, and Grandmother Pig* by Jean Van Leeuwen
⟨ *Something to Remember Me By* by Susan Bosak
⟨ *The Wednesday Surprise* by Eve Bunting

Other Ways to Help Your Child Learn

⟨ Ask a grandparent or other older family member to show your child a keepsake (e.g., a book, piece of jewelry, medal, quilt) and to tell a story about it.
⟨ Suggest that your child and his grandparent make a "hand-in-hand" keepsake. First, your child should trace her grandparents' hand to make an outline and then place her hand inside it while grandparent traces her hand.
⟨ Help your child plan something special he can do for his grandparent.

YUM! YUM!

Grade Level: 1–3

Purposes

⟨ Sort objects by common attributes and describe the categories
⟨ Use descriptive word
⟨ Follow simple directions
⟨ Ask questions for clarification and understanding

Activities

Favorite Food Bingo

Create four games cards with 16 pictures of nutritious foods. Pictures can be downloaded from the Internet and put into a grid. You can also create either picture or word bingo cards without charge at ESL Activities.com (http://www.eslactivities.com/index.php). Make a matching card for each square. Include enough Bingo chips or paper squares to cover four boards.

Directions: One person takes a card and gives a clue about what kind of food it is (e.g., It is a yellow fruit, It is a liquid dairy product). The other person can ask one additional question. (Is it a banana? Is it a lemon?) If he is correct, he can cover the corresponding square on his Bingo card with a chip or paper square. If more than two people are playing, take turns asking questions, but every player can cover a square if he has a picture of the food on the card. Play until either one person has covered pictures in a straight line or until one person covers his entire board. Bingo!

Food-Word Picture Match and Memory Game

Cut out or download pictures of foods, making sure they represent a balance of food groups. Glue onto 3" ↔ 5" cards. Write the names of each of these foods on a separate set of 3" ↔ 5" cards.

Directions:

⟨ Line up the picture cards. Place the word cards face down in a pile. Take turns drawing a card and matching it to its picture.

⟨ Spread all the cards face down on the table. Take turns drawing two cards at a time. If the word and the picture on the cards match, that player keeps them, and it is the player's turn. If the cards do not match, put them back where they were. The player with the most cards wins.

Variations

Include copies of simple recipes for nutritious snacks. Possibilities include

⟨ Vegetable dip: Blend 1/2 cup mayonnaise, 1/2 cup sour cream. Mix in curry powder or dill weed to taste.

⟨ Yogurt sundae: Add 1 sliced banana or other fruit to 1/2 cup of yogurt. Top with 2 tablespoons honey and wheat germ to taste. Blend.

⟨ Ants on a log: Spread peanut butter onto cut celery pieces. Top with raisins, grated carrots, or coconut.

⟨ Fruit smoothie: Blend 1/2 cup milk, 1/2 cup yogurt, 1 banana, and a handful or two of fruit.

⟨ Trail Mix: 2 cups Chex cereal, 1/4 cup each of raisins, dried fruit, nuts or seeds, and carob bits.

Books

⟨ *The Best Chef in Second Grade* by Katherine Kenah (I Can Read Book)
⟨ *Bread and Jam for Frances* by Russel Hoban and Lillian Hoban
⟨ *Cloudy With a Chance of Meatballs* by Judi Barrett and Ron Barrett
⟨ *Corn Is Maize: The Gift of the Indians* by Aliki
⟨ *Eating the Alphabet: Fruits & Vegetables From A to Z* by Lois Ehlert
⟨ *Everybody Cooks Rice* (Multicultural)
⟨ *Gregory, the Terrible Eater* by Michell Sharmat
⟨ *Growing Vegetable Soup* by Lois Ehlert
⟨ *The Hungry Thing* by Jan Slepian and Ann Seidler
⟨ *I Will Never Not Ever Eat a Tomato* by Lauren Child
⟨ *Too Many Tamales* by Gary Soto (Hispanic)

Other Ways to Help Your Child Learn

⟨ Choose a recipe that you and your child can make together. Let him do as much of the cooking as possible.

⟨ Log onto the U.S. Department of Agriculture's "My Pyramid" Web site (http://www .mypyramid.gov/index.html) for tips for healthy eating, menu planning, and interactive computer games to help your child keep track of his food and exercise.

⟨ Help your child create a shopping list by writing or drawing "My Favorite Foods" from each of these groups: grain, vegetable, fruit, milk, and meat. Post his list on the refrigerator and try to buy the healthy foods your child has listed.

⟨ Help your child keep track of the foods he eats and drinks every day. Children 7 to 10 should have five servings of day from the grain group, four from the vegetable group three from the fruit group, three from the milk group, and two from the meat group.

⟨ Make raisins with your child by placing a basket of green grapes in a warm, sunny spot. Watch them change each day. After a week, you should have raisins!

FACT OR FICTION

Grade Level: K–2

Purposes

⟨ Restate details in a text
⟨ Compare information from fiction and nonfiction texts
⟨ Evaluate information critically
⟨ Categorize information

Activities

Fact or Fiction: What Do Bears Really Do? (See Figure 5.7.)

Send home one fiction and one nonfiction book about bears. Create a file folder game that has two columns, labeled Fact or Fiction, and a set of game cards. Laminate.

⟨ Bears live in dens.
⟨ Bears use their noses to help search for food.
⟨ Bears can climb trees.
⟨ Bears eat mushrooms.
⟨ Bears can swim.
⟨ Bears eat roots.
⟨ Bears sleep a long time in the winter. (They hibernate.)

⟨ Bears need to wear clothing.
⟨ Bears can fly airplanes.
⟨ Bears live in houses.
⟨ Bears fly like birds.
⟨ Bears can understand what people say.
⟨ Bears are safe to pet.
⟨ Bears make friends with other animals (ducks, cats, etc.).

Variations:

⟨ Velcro strips can be attached to the back of the game cards and under each heading.
⟨ Adapt the activity for another animal.

Directions: Read the fiction book with your child. Ask questions about what the bears did in the story, what they looked like, and what they ate. Then read the nonfiction book together and ask similar questions. Take turns drawing one of the game cards and reading the statement on it. Decide if the statement is fact or fiction, and place it in the correct column.

Is That a Fact?

Send home several nonfiction books about animals, several sheets of drawing paper, and markers or crayons.

| Figure 5.7 | Fact or Fiction Sorting |

Directions: Choose an animal from one of the books. Tell someone in your family three facts about your animal. Draw a picture of your animal that includes the correct number of legs, type of skin covering (fur, feathers, or scales), where it lives (desert, forest, jungle, water), and what it eats (plants, insects, other animals). Write the name of the animal on your picture.

Stuffed Animal Adventure

Send home a stuffed animal similar to one in one of the books (e.g., a teddy bear) and a small journal.

Directions: Take the teddy bear with you on a trip. The trip can be to the grocery store or to the Laundromat. After you get home, tell or write a story about an adventure teddy had on the trip. Draw a picture to illustrate your story.

Books

- ❬ *Armies of Ants* by Walter Retan (Nonfiction)
- ❬ *Bear Snores On* by Karma Wilson (Fiction)
- ❬ *Bears: Polar Bears, Black Bears and Grizzly Bears* by Deborah Hodge (Nonfiction)
- ❬ *Do Bears Sleep All Winter?* by Melvin Berger (Nonfiction)
- ❬ *Frog and Toad* (series) by Arnold Lobel (Fiction)
- ❬ *Frogs and Toads* by Bobbie Kalman and Tammy Everts (Nonfiction)
- ❬ *Little Polar Bear* by Hans De Beer (Fiction)
- ❬ *My Friend Rabbit* by Eric Rohmann (Fiction)

⟨ *A Pocket for Corduroy* by Don Freeman (Fiction)
⟨ *Polar Bears* by Ann O. Squire (Nonfiction)
⟨ *Rabbits and Raindrops* by Jim Arnosky (Nonfiction)
⟨ *Two Bad Ants* by Chris Van Allsburg (Fiction)
⟨ *We Are Bears* by Molly Grooms and Lucia Guarnotta (Nonfiction)

Other Ways to Help Your Child Learn

⟨ Help your child use the Internet to find factual information about an animal in one of the stories.
⟨ Ask your child to make up an imaginary story about himself. For example, what he would do if he had superpowers, what would happen if he could fly, or what the family pet would say if it could speak.

Mathematics and Science Kits 6

The take-home activities and kits in this chapter directly support families in augmenting classroom curriculum and engaging children in appropriate mathematics and science experiences. Most are integrated. In addition to emphasizing fundamental understandings and skills in math and science, they also encourage language and literacy development as children use words to ask questions, organize data, and document their discoveries through drawing, writing, and graphing.

Select activities from this chapter and adapt them as necessary to align with your students' and their families' characteristics, interests, and needs.

MATHEMATICS KITS

COUNT UP AND COUNT DOWN

Grade Level: PreK–K

Purposes

⟨ Count, recognize, name, and order a number of objects
⟨ Demonstrate one-to-one correspondence
⟨ Solve simple addition and subtraction problems by counting
⟨ Sort objects by one attribute

Activities

Counting Sticks

Make a set of counting sticks using jumbo craft sticks. Write a numeral at the top of each stick (1–10 or 1–20) and draw a corresponding number of items beneath the numeral. Using a different colored marker, write numerals and the word for each number on the reverse side. Make separate sets of 10 red and 10 blue counting sticks. Provide two plastic cups.

Directions: Help your child line up the numbered counting sticks in order. Ask her to put a certain number red sticks in one of the cups and a different number of blue sticks in the other cup. Ask her which cup has more. Take the sticks from the cups and match them

one-to-one to find out how many more (or how many less). Give her one of the numbered counting sticks and ask her to count that number of colored sticks.

Variation:

⟨ Tape 10 craft sticks together. Draw a picture on this "puzzle" with felt tip pens. Write numerals 1 through 10 at the top. Remove the tape so that children can put the puzzle together.

Nim

Put 15 buttons (or other small items that can be easily counted) in a zip-and-seal bag.

Directions: Spread the buttons out. Take turns removing one or two buttons. The object of the game is to make the other player take the last button. You can make the game more challenging by using a different number of objects or by taking away different numbers of buttons.

Sort and Count

Provide 10 or fewer of each of three items (e.g., buttons, paper clips, and bottle caps) and a laminated sheet or piece of card stock with three circles on it.

Directions: Ask your child to place items that are the same in each of the circles. Help him count how many there are of each item. Ask your child, "Are there more, fewer, or the same number of each item?"

Variation:

⟨ Provide a blank bar graph sheet with a column labeled with the picture and word of each item.

Directions: Ask your child to place each item in the square in the appropriate column to create a bar graph. Ask him to compare the number of items in each column.

Tweezer Math

Include a plastic ice cube tray, at least a dozen small items (colorful erasers, counting bears, shells), and a pair of tweezers.

Directions: Ask your child to use the tweezers to place one item in each of the ice cube tray compartments. Help him count as he does this. Point out any patterns that he creates in the process. He can then remove the items one-by-one.

Altogether Now

Provide a book that has an "add on" pattern where characters are sequentially added to the story, similar to *The Gingerbread Man* (Examples: *May I Bring a Friend* by Beatrice de Regniers or *Rooster's Off to See the World* by Eric Carle), a set of small objects for counting, and a laminated tally sheet and dry-erase marker.

Directions: After reading the book, figure out how many animals there are altogether.

Numbers All Around

Divide a paper plate or a card stock circle into 6 to 10 equal sections. Draw a set of dots from one to six (or 1 to 10) into each section. Write numerals on an equal number of clothespins.

Directions: Take turns choosing a clothespin and pinning it on the matching section of the circle.

Other Items That Can Be Added to the Kit

⟨ A set of dominoes to encourage counting and matching the spots
⟨ A set of magnetic numbers that children can play with

Books

⟨ *Anno's Counting Book* by Mitsumasa Anno
⟨ *Counting Crocodiles* by Judy Sierra
⟨ *Elevator Magic* by Stuart Murphy
⟨ *Five Ugly Monsters* by Tedd Arnold
⟨ *I Spy Two Eyes* by Lucy Micklethwait
⟨ *Just a Minute: A Trickster Tale and Counting Book* by Yuyi Morales (Bilingual)
⟨ *Miss Spider's Tea Party* by David Kirk
⟨ *Moja Means One: Swahili Counting Book* by Muriel Feelings
⟨ *Numbers 1 2 3/Los numeros 1 2 3* by Gladys Rosa-Mendoza (Bilingual)
⟨ *One Gorilla* by Atsuko Morozumi
⟨ *One, Two, Three, Count With Me* by Catherine and Lawrence Anholt
⟨ *Ten, Nine, Eight* by Molly Bang
⟨ *Three Friends/Tres Amigos* by Maria Cristina Brusca and Tona Wilson (Bilingual)

Other Ways to Help Your Child Learn

⟨ Look for opportunities during everyday activities to encourage your child to count—both up and down.
⟨ Point out numbers in the environment: speed limit signs, food packaging, grocery store advertisements, bathroom scale, and so on.
⟨ Ask your child to set the table, counting the number of forks and spoons so that each person has one.
⟨ Sing songs or do fingerplays together that include numbers. An example is "Five Little Monkeys Jumping on the Bed."
⟨ Make your own set of dominoes. Draw a line through the center of 26 three-inch by five-inch index cards. Glue beans or draw spots to make the domino dots. Each half of a card can have zero to six dots, but no two cards should have the same combination of dots. Play dominoes with your child by taking turns matching the spots.

TREASURE BOX MATH

Grade Level: K–1

Purposes

⟨ Make an estimate and verify by counting
⟨ Sort objects by one attribute
⟨ Solve word problems
⟨ Compare quantities
⟨ Use position words
⟨ Organize data on a pictograph or bar graph, and answer questions based on the data

Activity Materials

Fill an interesting box or plastic jar with an assortment of small items that children can count and sort. Make sure the treasure box has a secure lid. Items can include craft store materials (beads, pompoms, colored "gems"), math manipulatives (counting bears, wooden cubes, buttons), or common household objects (clothespins, bottle caps, nuts and bolts).

Sorting Treasures

Include a laminated pictograph onto which children can place these items. Be sure the graph includes a title, labels, and pictures of items in the box. For example, if you make a "Buttons" pictograph, there might be a row of circles onto which children can place two-hole buttons and another row of circles for four-hole buttons.

Variation:

⟨ Include a laminated bar graph with parallel bars for comparing numbers of different items in the jar. (See the Bar Graph Template in the Resources.)

Directions: Ask your child to place the treasures in the right place on the graph. Ask your child to tell what the graph shows:

⟨ How many of one kind are there?
⟨ How many more or fewer of one kind of treasure are there than another kind?
⟨ How are they the same and how are they different?

Math Ring

Use a ring fastener to keep a set of 3" ↔ 5" activity cards together. Depending on grade level, activities can include

⟨ Sort items into categories. How many are in each group?
⟨ Is there another way to group these items?
⟨ How are all the items in each set the same? How are they different?
⟨ How many more beads are there than clothespins?
⟨ If you give each person in your family the same number of buttons, how many will each person have? How many will be left over?
⟨ Estimate the number of treasures in the box.

⟨ How many treasures are there altogether?
⟨ Take turns hiding your favorite treasure. Use position words like *above/below, top/bottom, in front of/behind,* and *over/under* to give each other clues about where the treasure is hidden.
⟨ Use the items to make up a story. Tell your story to someone in your family.

Variation:

⟨ Write story problems about the treasures on the cards.

Books

⟨ *365 Penguins* by Jean-Luc Fromental
⟨ *Bean Thirteen* by Matthew McElligott
⟨ *The Button Box* by Margaret S. Reid
⟨ *The Crayon Counting Book* by Pam Munoz Ryan and Jerry Pallotta
⟨ *Let's Count It Out, Jesse Bear* by Nancy White Carlstrom
⟨ *Sorting (Math Counts)* by Henry Arthur Pluckrose

Other Ways to Help Your Child Learn

⟨ Help your child create her own treasure box.
⟨ Ask your child to help with household chores that include sorting, such as putting away groceries or utensils or organizing a tool kit.
⟨ Make up simple story problems for your child.

MEASUREMENT AND ME

Grade Level: K–1

Purposes

⟨ Use nonstandard units to measure objects
⟨ Compare length and weight of two or more objects using standard or nonstandard units
⟨ Develop sense of self

Activities

Measuring Me

Provide an assortment of nonstandard and standard measurement items: a box of plastic spoons, a box of paper clips, a ball of heavy string or yarn, a standard tape measure, foot-long ruler, a small blank notebook entitled "The Measure of Me" or "From Head to Toe," several markers, and a pair of scissors.

Variations:

⟨ Add a set of Unifix or linking cubes and a stopwatch or timer.
⟨ Include a set of task cards with items to measure instead of or in addition to the directions below.

Directions: Use the string to measure different parts of your child. After you have cut the string, help her find out how many spoons or paper clips equal the length of the string.

Record these numbers together in "The Measure of Me" booklet along with the date. Follow the same process to measure other family members. Ask your child to compare these lengths or numbers. The book is yours to keep and will make a wonderful keepsake.

⟨ Measure your child's height with the string.
⟨ Use the string to measure around her head or stomach, the length of her foot, arm, leg, and so forth. Count with her how many spoons or paper clips these lengths are.
⟨ Use the string to measure how far up a wall she can reach. How far can she reach on tiptoes?
⟨ Trace your child's hand onto one of the pages.
⟨ Trace your child's foot.
⟨ Lay the string on the ground so she can measure how far she can jump.
⟨ How many of her steps does it take to cross a room in your home?
⟨ See how many times she can jump up and down (or do pushups) in one minute.
⟨ Talk about what other things in your home you can measure. Ask your child to estimate ahead of time whether an item will be longer than her foot or her height, and then find out.
⟨ After you have used the nonstandard tools (string, spoons, paper clips) to measure your child, use the tape measure and ruler to measure the same things.

Books

⟨ *Happy Birthday, Sam* by Pat Hutchins
⟨ *How Big Is a Foot?* by Rolf Myller
⟨ *How Far Can You Jump?* by Keith Pigdon and Marilyn Woolley
⟨ *Inch by Inch* by Leo Lionni
⟨ *Length (Math Counts)* by Henry Arthur Pluckrose
⟨ *Me and the Measure of Things* by Joan Sweeney
⟨ *Millions to Measure* by David M. Schwartz
⟨ *Twelve Snails to One Lizard: A Tale of Mischief and Measurement* by Susan Hightower

Other Ways to Help Your Child Learn

⟨ Record the same measurements after several months.
⟨ Periodically, mark your child's height inside a doorframe, so she can see and measure how much she has grown.
⟨ If you have a bathroom scale, let your child weigh herself and then stack items on the scale to equal her weight.
⟨ Add other personal information about your child in the book to make this an even more personal keepsake. For example, you could add her favorite food, color, or game.

Talk with your child about other measuring tools like scales and measuring cups and spoons. Ask for your child's help when you are measuring things.

PATTERNS AND SYMMETRY EVERYWHERE

Grade Level: K–2

Purposes

⟨ Recognize that visual patterns are lines and shapes that repeat

⟨ Extend and create patterns
⟨ Identify and describe shapes in the world (in nature, art, the human body) that show symmetry across a line
⟨ Create shapes that have symmetry

Activities

Quilt Patterns

Provide two sets of eight squares and 16 triangles cut from two different colors of card stock. Make the triangles by cutting some squares on the diagonal.

Directions: Patchwork quilts have repeated patterns. Use one set of squares and triangles to design a quilt pattern. Tell each other how to make a pattern just like yours with the other set. Create other patterns and ask the other person to recreate them.

What Comes Next?

Provide a bag of Unifix cubes, colored buttons, or squares and a set of pattern cards with AB, AAB, ABA, ABB, BABB, ABC (and so forth) patterns drawn on them.

Directions: A pattern is a repeated sequence of numbers, letters, or pictures. Match the cubes to those on the cards. Repeat this sequence to make a pattern.

Mirror Images

Provide a few sheets of construction paper, children's scissors, an unbreakable mirror, and an assortment of items, some that are symmetrical and some that are not. Symmetrical items can include a sand dollar, clamshell, cards with pictures of a butterfly, leaf, or symmetrical letters of the alphabet.

Directions: Symmetry is often called "mirror imagery." Help your child recognize symmetry in the natural world. First, cut out a paper heart for your child. Talk with your child about what he sees when you fold the heart in half. Hold the mirror along the fold so that he can see a whole heart. Ask your child if and why the other items are symmetrical. Is there a place where he can place the mirror (the "line of symmetry") to make each item whole? Encourage him to fold and cut paper shapes to create other symmetrical items. What other items can he find in and around your home that are symmetrical?

Books

⟨ *Eight Hands Round* by Ann Whitford Paul
⟨ *Let's Fly a Kite* by Stuart J. Murphy
⟨ *Lots and Lots of Zebra Stripes: Patterns in Nature* by Stephen R. Swinburne
⟨ *Pattern (Math Counts)* by Henry Arthur Pluckrose
⟨ *Pattern Fish* by Trudy Harri
⟨ *The Sultan's Snakes* by L. Turpin
⟨ *Ten Little Rabbits* by Virginia Grossman (Native American)

Other Ways to Help Your Child Learn

⟨ Use colored Goldfish crackers, carrot and celery sticks, or mixed cereal to build patterns your child can copy and then extend. Talk with her about the sequence and repetition of

colors. She'll then get to eat her patterns!

⟨ Help your child look for patterns in and around your home. Look at clothing, dishes, flowers, leaves, wallpaper, and flooring. Talk about what makes each a pattern.

⟨ Let your child use pages from an old month-by-month calendar. He can color the squares different colors to make patterns.

TIME AND TIME AGAIN

Grade Level: K–2

Purposes

⟨ For kindergarten: Identify time of everyday events to the nearest hour

⟨ For first grade: Tell time to the nearest half hour, and relate time to events (e.g., before/after, shorter/longer)

⟨ For second grade: Tell time to the nearest quarter hour, and identify relationships of time (e.g., minutes in an hour, days in a week)

Activities

Clocks Tell Time

Include a handmade or purchased clock face with moveable hour and minute hands.

Directions: Show your child how to set the hands on the clock to match a real clock in your home. Help him read the time the clock displays. Move the hands to indicate when a particular activity will occur (dinner, bedtime). Help your child compare this time to that shown on the real clock. Depending on your child's understanding, position the hands to display time on the hour, half hour, or quarter hour.

Measuring Time

Include an assortment of items used to measure minutes and hours—digital clock, egg timer, hourglass, or stopwatch.

Directions: Compare the time displayed on or indicated by each of these time instruments. How many seconds does it take for the sand to go through the hourglass? Is the time shown on the stopwatch and the egg timer the same? Do these instruments measure time in the same way that a clock in your home does?

Units of Time

Make a series of two-piece puzzles from 5 ↔ 7-inch cards cut in half. When each puzzle is put together it should read:

60 seconds = 1 minute, 60 minutes = 1 hour, 24 hours = 1 day, 7 days = 1 week, 28 to 31 days = 1 month, 365 days = 1 year, 12 months = 1 year, 52 weeks = 1 year

Directions: Fit the puzzles pieces together to show equivalent times.

Beat the Clock

Provide a kitchen timer or stopwatch, a dry-erase marker, and a laminated chart that lists activities and has a column to write the number of things a child can do in one minute. Activities could include

⟨ Do jumping jacks
⟨ Bounce a ball
⟨ Sing the alphabet song
⟨ Pick up paper clips or pebbles, and put them in a container
⟨ Count playing cards
⟨ Touch the four corners of a room in your home

Directions: Ask your child how many times during one minute she can do each activity listed on the chart. Time her while she tries each activity, and count the number with her. Help her write the number on the chart.

Variation:

⟨ Ask your child to think of other things she and you can do in one minute. Take turns timing each other. Instead of one-minute activities, increase the time to two or five minutes.

Ready, Set, Bedtime!

Send home *Ten Minutes Till Bedtime* by Peggy Rathmann and a three-column chart with these headings: Bedtime Activities, Estimated Time, and Actual Time.

Directions: After reading *Ten Minutes Till Bedtime*, make a list of all the things you do to get ready for bed on the chart. In the next column, estimate the time it takes to do each thing. Ask someone in your family to time you and then record the actual time it took you to do each thing.

See "All in a Day" in Chapter 5.

Books

⟨ *And Sunday Makes Seven* by Robert Baden (Latino/bilingual)
⟨ *Bats Around the Clock* by Kathi Appelt
⟨ *The Berenstain Bears Catch the Bus* by Stan and Jan Berenstain
⟨ *Cookie's Week* by Tomie de Paola
⟨ *Five Minutes' Peace* by Jill Murphy
⟨ *The Grouchy Ladybug* by Eric Carle
⟨ *Just a Minute* by Teddy Slater
⟨ *On Monday When It Rained* by Carryl Kachenmneister
⟨ *Ten Minutes Till Bedtime* by Peggy Rathmann
⟨ *Time (Math Counts)* by Henry Arthur Pluckrose
⟨ *Today Is Monday* by Eric Carle
⟨ *The Very Hungry Caterpillar* by Eric Carle

Other Ways to Help Your Child Learn

⟨ How many clocks or signs that show time can you and your child find in your home or in the community?

⟨ Make a list with your child of all the things he does on a weekday. Then make a schedule listing the starting time of each activity.

⟨ Post a monthly calendar, write family activities on it, and encourage your child to write or draw his own activities. Talk about these activities as you point out today, yesterday, tomorrow, and next week. There is a monthly calendar template in the Resources.

Talk about time whenever possible. Ask your child to check clocks in your home to make sure they show the same time. In how many more minutes will the cake need to cook? For what time will we need to set the alarm? We need to leave in half-an-hour. What time will that be? On Tuesday, we will . . . Grandma's birthday is next month.

TANGRAMS

Grade Level: 1–3
Purposes

⟨ Recognize and name 2-D geometric shapes
⟨ Put shapes together and take them apart to form other shapes (See Figure 6.1.)
⟨ Recognize and apply flips and turns of geometric figures
⟨ Use problem-solving strategies

Activities

Tangram Puzzle

Use the pattern in the Resources to cut one or more tangrams out of card stock. Place each tangram in a zip-and-seal bag.

Directions: A tangram is made of seven puzzle pieces that fit into a square. They can also be made into a rectangle, a triangle, and many other shapes. What can you do with the tangram pieces?

⟨ Name the shape of each tangram piece.
⟨ Try to make a square using all seven pieces.
⟨ How many ways can you make a square using fewer than seven pieces?
⟨ Can you make a square without using any triangles?
⟨ Try to make a rectangle using all seven pieces.
⟨ Try to make a triangle using all seven pieces.

Making Pictures

Include a tangram puzzle and a set of tangram pattern cards. Create pattern cards by tracing shapes you make from the seven tangram pieces, cutting them out, gluing them onto card stock, and laminating them. Pattern cards can also be purchased.

Directions: Use the tangram pieces to make the shape on each of the cards. What other shapes can you and others in your family make? How many different ways can you make a boat using the tangram pieces?

Books

⟨ *Grandfather Tang's Story* by Ann Tompert (Chinese/Chinese American)
⟨ *The Greedy Triangle* by Marilyn Burns
⟨ *Sir Cumference and the First Round Table* by Cindy Neuschwander
⟨ *The Tangram ABC Book* by T. E. Foster
⟨ *Three Pigs, One Wolf, Seven Magic Shapes* by Grace Maccarone
⟨ *The Warlord's Puzzle* by Virginia Walton Pilegard

Other Ways to Help Your Child Learn

⟨ See how many shapes in a tangram your child can find in your home or neighborhood. How many triangles, squares, rectangles, and parallelograms?
⟨ Just as Grandfather Tang arranged tangram pieces to make animals as he told the story of the fox fairies, use tangram pieces with your child as you retell favorite stories.

Figure 6.1 Shapes Made With Tangram Pieces

NUMBERS MAKE SENSE

Grade Level: PreK–K

Purposes

⟨ Demonstrate one-to-one correspondence
⟨ Compare the quantity of two groups of objects
⟨ Recognize numerals

Activities

Sponge Numbers

Write numerals from 1 to 10 on ten sponges. Make the corresponding number of dots on each sponge with a permanent marker. Include a small bag of toothpicks.

Directions: Ask your child to poke a toothpick into the spots on each sponge to make the correct number. Help him count the spots as he does so.

Egg Carton Numbers

Write numbers 1 to 12 in each cup of an egg carton or a plastic ice cube tray. Provide a set of buttons or other small counters.

Directions: Ask your child to put the correct number of buttons in each cup of the egg carton. Help her count the buttons one-by-one as she does this.

Animal Dominoes

Make a set of dominoes from 28 three-inch by five-inch cards. Draw a line down the middle of each card. Draw, glue, or stick a picture of one of seven different animals on each side of the domino. Other domino sets might include colors, fruit, transportation vehicles, or other common objects.

Directions: Put a starter domino on the table. Take turns choosing a domino and placing one picture on it next to a matching picture on another domino.

Ten Black Dots

Send home *Ten Black Dots* by Donald Crews, a sheet of adhesive dots, several sheets of paper, and a few markers or crayons.

Directions: After reading the story, ask your child to count out 10 dots and then to make a picture using them.

Button, Button

Send home a small bag of different colored buttons or others counters and two rings. Rings can be made by cutting out the edge of a plastic lid.

⟨ *Directions:* Place fewer than 5 objects inside one of the rings. Ask your child how many there are. The eventual goal is for her to be able to recognize how many objects there are

without counting them. Put between 5 and 10 objects inside each of the rings and ask your child to point to and count how many there are. Then ask which ring has more and which has less. Ask her to put objects inside each of the rings and ask you the same questions.

Books

⟨ *1 Hunter* by Pat Hutchins
⟨ *Animal Numbers* by Bert Kitchen
⟨ *Five Creatures* by Emily Jenkins
⟨ *One Crow: Counting Rhyme* by Jim Aylsworth
⟨ *One Gorilla* by Atsuko Morozumi
⟨ *The Right Number of Elephants* by Jeff Sheppard
⟨ *Ten Black Dots* by Donald Crews
⟨ *Two of Everything: A Chinese Folktale* by Lily Toy Hong
⟨ *Two Ways to Count to Ten* by Ruby Dee (Liberian folk tale)

Other Ways to Help Your Child Learn

⟨ Give your child many opportunities sorting objects in your home. He can help you sort laundry, buttons and other small items, coins, or items in your "junk" drawer.
⟨ Use everyday experiences to talk with your child about numbers. For example, ask how many slices of bread you will need to make sandwiches for your family. Ask your child to set the table so that everyone has a spoon, plate, napkin, and so on. Ask him who has more (or fewer) crackers or crayons. Point out how numbers help you every day to cook, count change, or keep track of the exercises you've done.
⟨ Sing and act out songs and rhymes that include numbers with your child. Rhymes like "Ten Little Monkeys Jumping on the Bed" are children's favorites for a reason.

BIG NUMBERS

Grade Level: 1–3

Purposes

⟨ Count, read, and write whole numbers to 100
⟨ Understand the relationship between numbers, quantities, and place value in whole numbers (to 100 or to 1,000)
⟨ Estimate quantities

Activities

Counting Beans

Make a set of bean sticks to represent ones, tens, and hundreds. Glue ten dried beans onto 20 jumbo craft sticks. Tape 10 of these craft sticks together to make a raft of 100 beans. (Keep the others separate.) Make several of these rafts. Include a handful of loose beans. Alternatively, draw spots onto the sticks instead of gluing beans and then provide a handful of paper spots. Include a set of number cards.

Directions: Take turns drawing a card. Use the bean sticks to represent the number on the card.

What's Your Guess? (See Figure 6.2.)

Provide a clear plastic container filled with more than 100 small items (shells, buttons, pompoms, colored "gems," counting bears, wooden cubes, clothespins, bottle caps, nuts and bolts).

Directions: Estimate how many items are in the container. Write your estimate. Tell someone in your family what you based your estimate on. Empty out what you think is half (or one quarter) of the contents of the container. Count the number, and record your estimate. Empty out the rest of the contents, count them, and check your estimate for accuracy.

Variation:

⟨ Send an empty jar home. Children and families can choose something to put in the jar for the class to estimate.

Something Enormous

Send home *Something Absolutely Enormous* by Margaret Wild and one or more sheets of graph paper. If the graph paper is laminated, also include two or three dry-erase markers of different colors.

Directions: In the book, Sally knits 1,000 squares. Color or mark 1,000 squares on the graph paper. In how many different ways can you show 1,000? What can you do 1,000 times? How long do you think it will take you?

Figure 6.2	Estimation Jar

Lowest to Highest

Make several tables divided into 16 squares. Write a number from 0 to 100 in each square. Provide markers of two different colors.

Directions: Take turns spotting numbers from lowest to highest. Say each number out loud as you place your marker on it. You can also do the reverse and go from highest to lowest.

Make One Bigger

Provide two to four dice, depending on children's abilities, and paper and pencil for scoring.

Directions: Take turns rolling the dice. Line them up to make the biggest number possible. For example, if you role a two and a seven, the bigger number would be 72. If you roll a four, eight, and one with three dice, the biggest number would be 841. Tell your partner why you arranged the dice as you did, and use the paper to write down your answer. The goal is to roll the biggest number during each round, which can be from six to ten turns each.

Books

⟨ *The 100th Day of School* by Angela Shelf Medearis
⟨ *100th Day Worries* by Margery Cuyler
⟨ *The 500 Hats of Bartholomew Cubbins* by Dr. Seuss
⟨ *Anno's Mysterious Multiplying Jar* by Mitsumasa and Masaichiro Anno
⟨ *Emily's First 100 Days of School* by Rosemary Wells
⟨ *From One to One Hundred* by Teri Sloat
⟨ *Great Estimations* by Bruce Goldstone
⟨ *How Much Is a Million?* by David M. Schwartz
⟨ *A Million Dots* by Andrew Clements
⟨ *Millions of Cats* by Wanda Gag
⟨ *One Grain of Rice: A Mathematical Folktale* by Demi (East Indian)
⟨ *One Hundred Hungry Ants* by Elinor J. Pinczes

Other Ways to Help Your Child Learn

⟨ Encourage your child to make a collection of 100 items. These can be displayed in groups of 10 or bc used to create something of your child's choosing. Items to consider are pennies, shells, stones, marbles, stamps, leaves, or paper clips.
⟨ Make a chain with 100 paper clips, a necklace with 100 Cheerios, or think together and write down the names of 100 animals.
⟨ Start a pennies or spare change jar. Use the coins with your child to count to 100.
⟨ Ask your child to estimate numbers during daily routines. For example, how many raisins are there in a mini box of raisins? How many slices are there in a loaf of sandwich bread? How many pages in a book? Help her compare her estimate to the actual number.
⟨ Challenge your child to a friendly competition. See how many times each of you can bounce a ball or hop on one foot or hula-hoop. Count the number of times together. You might want to set a limit depending on your child's abilities.
⟨ Help your child find large numbers in a newspaper or magazine.

FRACTIONS ARE FUN

Grade Level: 1–2

Purposes

⟨ Recognize fractions of a whole and parts of a group
⟨ Recognize, name, and compare fractions
⟨ Explain reasoning used to solve problems

Activities

Making Fractions

Place a set of 10 to 20 cubes, counters, or chips in a zip-and-seal bag. Make a set of activity cards that ask players to count out a certain number of cubes, and then divide them so that each player has one-half, one-third, one-fourth, or one-eighth of the cubes.

Directions: Take turns drawing an activity card that tells how to divide the cubes. Tell each other how you decided to divide the cubes the way you did.

Pie Plate Puzzle

Make a fraction circle from a paper plate. Take other paper plates and cut them to make fractions of the whole. Cut plates to represent one-half/one-half, one-third/two-thirds, one-quarter/three-quarters, and so on. Make enough fraction pieces so that there are various ways to make one whole (e.g., two one-fourth pieces and one one-half piece). Write the fraction on each piece and laminate them.

Directions: Take turns choosing one fraction piece and placing it on the pie plate. The other person must select one or more fraction pieces to complete the circle. Say the names of each of the fractions you use.

Measuring Cup Math

Provide a set of measuring cups. Write *1 cup, 3/4 cup, 2/3 cup, 1/2 cup, 1/3 cup,* and *1/4 cup* on each cup. If the cups are not color-coded, mark each with different colored tape.

Directions: Ask your child to line the cups up from biggest to smallest. Then ask him to predict and then test equivalent amounts by filling the cups with water. (This can also be done in the bathtub!) For example:
⟨ How many of the smallest cups do you think it will take to fill up the biggest cup? Fill the smallest cup with water to test your estimate.
⟨ How many red cups does it take to fill the blue cup?
⟨ Fill the large cup with water. Predict first and then count how many 1/2, 1/3, or 1/4 cups it will fill.
⟨ Continue to ask similar questions with all the measuring cups.

Fraction Creatures

Send home Ed Emberley's *Picture Pie,* several sheets of colored construction paper, a glue stick, marker, and a pair of children's scissors.

Directions: Trace around a glass to make circles on the paper. Cut them out, fold them once, twice, three times, or four times to make different sized wedges. Cut along the folded lines. Use the fraction pieces to make your own pictures just like Ed Emberely did. Tell someone in your family about the shapes you used in your pictures.

Books

⟨ *Eating Fractions* by Bruce McMillan
⟨ *Ed Emberley's Picture Pie* by Ed Emberley
⟨ *Full House: An Invitation to Fractions* by Dayle Ann Dodds
⟨ *Give Me Half!* by Stuart J. Murphy
⟨ *When the Doorbell Rang* by Pat Hutchins
⟨ *The Wishing Club: A Story About Fractions* by Donna Jo Napoli

Other Ways to Help Your Child Learn

⟨ Use everyday opportunities to talk with your child about fractions. For example:
 • Let's give half the oranges to Grandma. How many should we put in a bag to take to her?
 • This pizza has 16 slices. Since there are four of us, we can each eat a quarter of it. How many pieces does each of us get?
 • Can you cut your sandwich into halves, thirds, quarters?
⟨ Show your child how coins represent fractions of a dollar. Use change to help him break a dollar in various ways (halves, quarters, tenths, etc.).
⟨ Give your child a sheet of paper, and ask him to fold it in half, into fourths, and so on. Is there more than one way to fold the paper into these fractions?

IT ALL ADDS UP!

Grade Level: 1–2

Purposes

⟨ Practice addition facts to 20
⟨ Record information on a graph
⟨ Use problem-solving strategies

Activities

Play 17

Remove the nines, tens, jacks, queens, kings, and jokers from a deck of cards. Include paper to be used as a scorecard.

Directions: For two to four players. Shuffle the cards, and put them face down. Each player draws five cards. The first player lays down one card and says its value (e.g., 5). The next player lays down a card but adds its value to the first card. (For example, if she lays down a four, the total value would be 9.) The next player plays a card and so forth. The goal is to get as close to 17 as possible. If one player makes 17, she gets 17 points. Players can also

score by going slightly over 17. In that case the player must subtract from 17 the amount she has gone over. (For example, if the final number is 20, which is 3 more than 17, the player must subtract 3 points from 17.)

Players help each other to add their total scores when the game is over.

Favorites Survey

Make a blank "Favorites" graph that children can use to record answers to their survey question.

Directions: Surveys help us answer questions. Ask your child to think of questions she is interested in asking other people. She might ask, "What is your favorite fruit (vegetable, cereal, snack, flavor of ice cream)?" or, "What is your favorite color (number, sport, pet)?" Then help her make a list of least 10 people she can ask. Ask her to use a graph to record responses to her questions.

⟨ What is the least favorite?
⟨ What is the most favorite?
⟨ How many more people chose the most favorite than the least favorite?

Spin and Add

Provide a game spinner, paper, and pencil.

Directions: Spin the spinner, and write down the number the spinner lands on. Spin again, and add this number to the last one. Keep spinning and adding. How high can you go? Take turns and check each other's addition.

Die Toss

Provide two large dice or make dice from wooden cubes.

Directions: Roll the dice, and add up the total.

Variation:

⟨ Use one die. Roll the die so that your child can see only three faces. Ask him to add the spots on these three faces. Then ask him to figure out the sum of three faces that he cannot see.

Number Tic-Tac-Toe

Laminate a tic-tac-toe grid, and provide a dry-erase marker.

Directions: Play tic-tac-toe, but instead of making Xs and Os, write a numeral from 0 to 9 in each of the squares. The first player must write her number in the center square. The goal is to complete a horizontal, vertical, or diagonal line so that two of the three numbers add up to the third number. For example, 3, 4, and 7. The order of the numbers does not matter.

Books

⟨ *12 Ways to Get to 11* by Eve Merriam
⟨ *Anno's Counting Book* by Mitsumasa Anno

⟨ *How Many Snails?* by Paul Giganti
⟨ *The Philharmonic Gets Dressed* by Karla Kuskin
⟨ *The Right Number of Elephants* by Jeff Shepard
⟨ *Two of Everything* by Lily Toy Hong
⟨ *The Wolf's Chicken Stew* by Keiko Kasza

Other Ways to Help Your Child Learn

⟨ *Make it Up!* Take turns making up math problems that you think are easy enough to do without using paper or a calculator. Tell each other how you are able to figure out the problems in your head.

⟨ Use an egg carton and a handful of beans or other small items to help your child practice adding numbers to 20. Choose a number between 12 and 20. Place fewer beans than the number you chose in one cup of the carton. Ask your child to count up from the number of beans in the cup by placing one bean in each of the other cups until she reaches the number you chose. Ask her how many beans she added to reach the chosen number.

SCIENCE KITS

ADVENTURE BACKPACK

Grade Level: PreK–2

Purposes

⟨ Understand that plants and animals share our world and live in their own environments
⟨ Conduct investigations based on individual interests
⟨ Record observations through drawing or writing

Activities

Furnish a small backpack with materials children can use to conduct investigations of their own choosing. Items can include an unbreakable magnifying glass, empty food containers, tweezers, notepad, and pencils.

Variations:

⟨ Add binoculars or a small fish net.
⟨ Add picture cards of common plants and animals in your environment to prompt children to look for and investigate these things.

Directions: Go on an outdoor "adventure" with your child. Your backyard, neighborhood, or a local park is filled with interesting things to explore and discover. Encourage your child to use the magnifying glass to look closely at plants and bugs, some of which might be underneath rocks. She can use the tweezers to carefully pick up insects to put in one of the containers for a closer look. Ask your child open-ended questions to encourage conversation about what she is seeing, feeling, hearing,

smelling, and touching. For example, instead of asking, "What color is that leaf?" ask her to describe what she is experiencing. Encourage her to draw or write about what she discovers.

Books

⟨ *Are You an Ant?* by Judy Allen
⟨ *Backyard Insects* by Millicent E. Selsam
⟨ *The Boy Who Drew Birds: The Story of John James Audubon* by Jacqueline Davies
⟨ *Eliza and the Dragonfly* by Elizabeth Kennedy
⟨ *Nature in the Neighborhood* by Gordon Morrison
⟨ *Under One Rock: Bugs, Slugs, and Other Ughs* by Anthony D. Fredericks
⟨ *What's Under the Log?* by Anne Hunter

Other Ways to Help Your Child Learn

⟨ Help your child make a map of the location of her adventure (your backyard, your neighborhood, or the park). Encourage her to include features related to her discoveries.
⟨ Help your child find information about plants, insects, or other things she discovered at your local library or on the Internet.

AMAZING MAGNETS

Grade Level: 1–3

Purposes

⟨ Investigate magnetism through direct experience
⟨ Understand properties of objects and materials
⟨ Make predictions based on observations and record results
⟨ Understand that magnets can be used to make some objects move without being touched

Activities

Magnetic Attraction

Gather together magnets of varying strengths (bar type magnets and horseshoe magnets with keeper bars) and assorted items, some of which will be attracted to magnets and some that will not (examples: a tin can, keys, paper clips, fasteners, steel ball bearings, metal nuts, steel wool, wire, wooden block, sponge, pennies, rocks, feathers, buttons, corks, shells, sandpaper, string, pencil, cardboard tube).

Note: As with other small items you send home, consider the safety of younger family members.

Directions: Experiment with the magnet and materials. Which materials are attracted to the magnet and which are not? Sort these into two groups. Talk with a family member about the similarities and differences these materials have. With your family, make a list of things in your home that are attracted to magnets. Place a piece of paper, plastic cup, or sheet of aluminum foil between a magnet and a paper clip. Does the thickness of the material or what the materials is made of change whether or not the magnet still attracts the paper clip? If possible, take a magnet with you when you and your family visit a park playground.

What parts of playground equipment will the magnet stick to? Drag the magnet through the sand. What do you notice?

Car Race

Provide two or three small metal matchbox-size cars and several strong magnets.

Directions: Each player chooses a car. Each player uses a magnet to race her car from a designated starting line to a finish line. Are there ways to make the car go faster or farther?

Make a Magnet

Provide a pair of scissors or a large nail, some paper clips, and a strong bar magnet.

Directions: Magnetize the scissors (or nail) to pick up paper clips by rubbing a magnet over the blades of a pair of scissors (or a nail) in one direction. Rub 5, 10, 15, and 20 times, and try to pick up a paper clip after each set of strokes. Questions: Does rubbing the magnet more times make it easier to pick up more paper clips? How can you demagnetize the magnet?

Mystery Magnets

Tape or glue several small magnets on the inside of two or three small, sturdy boxes. Tape the boxes shut so the magnets can't be seen and the boxes can't be opened.

Directions: Try to find the location and even the shape of each magnet without opening the box. Talk about how you figured this out.

Books

⟨ *What Is the World Made Of? All About Solids, Liquids and Gases* by Kathleen Weidner Zoehfeld
⟨ *What Magnets Can Do* by Allan Fowler
⟨ *What Makes a Magnet?* by Franklyn M. Branley
⟨ *The Wiener Dog Magnet* by Hayes Roberts

Other Ways to Help Your Child Learn

⟨ Attach a magnet to a string and tie the string to a yardstick or long stick to make a "fishing pole." Scatter small items in a box, and take turns fishing. Alternatively, attach paper clips to pictures of items that are and are not attracted to magnets.
⟨ Ask open-ended questions: "What do you notice?" "What do you think will happen?" "Why do you think that happened?"
⟨ Help your child find magnets around your home (a refrigerator door seal, cupboard latch, fancy buckle, etc.).

MY FIVE SENSES

Grade Level: PreK–K

Purposes

⟨ Observe common objects by using the five senses
⟨ Describe similarities and differences in appearance, sounds, tastes, smells, and textures

Activities

What's That Smell?

Place scented items (cinnamon stick, cloves, coffee, mothball, soap) or cotton balls soaked in liquid scents (vanilla, peppermint, or lemon extract; vinegar; rubbing alcohol; perfume) in 35 mm film canisters with pinholes poked in the top. Securely tape or glue tops shut. Label each canister on the bottom with a word, picture, or number that corresponds to an answer key with a picture and the word for the items that makes each smell.

Directions: Encourage your child to guess what each canister smells like and to use descriptive words to talk about them. Use the answer key to help him match the word or picture with its smell. Take turns choosing scents you like and don't like.

Feely Bag

Put several common objects (a pencil, nail brush, plastic cup, length of chain, etc.) or different textured materials (cotton balls, scraps of burlap and velvet fabric, ball of aluminum foil, sandpaper square) in a cloth bag.

Directions: Ask your child to identify the objects by using her sense of touch. Encourage him to use descriptive words like *smooth, hard,* or *bumpy* to describe how each item feels. Add objects from your own home to make this guessing game more fun.

Sandpaper Letters

Cut letters, numbers, or shapes from sandpaper. Glue these onto cardboard.

Directions: Ask your child to close his eyes and identify each with only his sense of touch. Lay a sheet of paper over the sandpaper letters, numbers, or shapes. Let your child use the side of a crayon to make rubbings.

Say What You See

Include one or more wordless picture books in the activity pack.

Directions: Ask your child to "Say what you see" to tell you the story in a wordless picture book.

Mirror, Mirror

Provide two small unbreakable mirrors.

Directions: Ask your child to use the mirror to look at his reflection, to see what's behind him, or around a corner. Face different directions, and try to see each other by looking in your mirror. Experiment with the mirrors together to see different objects in your home. Are there ways to make an object appear more than once by using two mirrors?

Sound Shakers (See Figure 6.3.)

Put a small number of items into opaque containers (6- to 8-ounce yogurt containers or film canisters work well). Possibilities include keys, sand, packing peanuts, popcorn

kernels, plastic beads, pebbles, marbles, rice, paper clips, and small rubber balls. Glue or tape the lids so the containers cannot be opened. On the bottom of each container, write the word or tape a picture of the items in the container. Alternatively, a symbol on each container can be tied to an answer key. Provide an extra empty container so families can add their own items.

Directions: Shake each container, listen for the sound it makes, and then guess what objects are inside. Take turns placing an object in the empty container and asking each other to guess what the object is.

Books

⟨ *Brown Bear, Brown Bear, What Do You See?* by Bill Martin, Jr.
⟨ *Do You Want to Be My Friend?* by Eric Carle (Wordless book)
⟨ *Good Dog Carl* by Alexandra Day (Wordless book)
⟨ *The Listening Walk* by Paul Showers
⟨ *Look! Look! Look!* by Tana Hoban
⟨ *Mis Cinco Sentidos* by Aliki (Spanish)
⟨ *My Five Senses* by Aliki
⟨ *Pancakes for Breakfast* by Tomie de Paola (Wordless book)
⟨ *Squishy, Squishy: A Book About My Five Senses* by Cherie B. Stihler
⟨ *You Can't Smell a Flower With Your Ear!* by Joanna Cole

Other Ways to Help Your Child Learn

⟨ Give your child small samples of several different foods to taste (a lemon wedge, potato chip, unsweetened cocoa, honey on bread). Ask him to predict how the items will taste. Alternatively, you can blindfold him or ask him to cover his eyes to do a "blind tasting." Talk with him about the four major tastes: sour, salty, bitter, and sweet.

| Figure 6.3 | Sound Shakers With Answer Key On Back Side of Card |

⟨ Play "I Spy" with your child. Take turns saying, "I spy with my little eye . . . ," and then describe the characteristics of an object in your immediate environment. The other player will try to guess what you see. For example, saying, "I spy with my little eye something that is fuzzy, round and yellow."

⟨ Play "What's Missing?" Remove one item from a room or table, and ask your child to solve the mystery of what is missing.

⟨ Make a texture collage together from scrap materials found around your home.

⟨ Go on a "listening walk" with your child. Talk about what kinds of sounds you hear.

WEATHER

Grade Level: 1–3

Purposes

⟨ Identify changes in weather from day to day
⟨ Use simple tools to measure and record weather conditions
⟨ Communicate observations orally and through drawings

Activities

What's the Temperature?

Provide an unbreakable thermometer and a "What's the Temperature?" recording sheet divided into four parts.

Directions: Use the thermometer to check the temperature in four different locations in and around your home. Draw a picture of where you put the thermometer, and record the temperature on one square of the recording sheet. Talk with your family about what might cause the temperatures to be different in the different locations.

What Makes the Wind?

Put several tissue paper strips in a zip-and-seal bag along with the directions.

Directions: Hold a strip of tissue paper above a table lamp. Then turn the lamp on, and let it warm up. How does the air feel above the lamp? What happens to the paper strip when you hold it above the lamp now? Talk with your family about what you observe and what causes what you see.

Windy Weather

Place a tissue paper or crepe paper streamer, a chiffon scarf, and a plastic pinwheel in a zip-and-seal bag.

Directions: Test how air movement from the wind, a fan, a hair dryer, or by blowing affects a crepe paper streamer, scarf, and plastic pinwheel. In what other ways can you create air movement?

Variations:

⟨ Include a pattern for making a pinwheel from heavy paper, a pin, and a pencil with an eraser top.

⟨ Include directions for making a weather vane. (Find directions online at www.pbs.org, or see Neil Ardley's *101 Great Science Experiments.*)
⟨ Record the wind direction on a weather calendar.

Track the Weather

Provide a copy of the blank monthly calendar in the Resources that families can use to document weather conditions.

Directions: Record the weather conditions on the calendar for a month. You can write words to describe the weather (sunny, cloudy, overcast, foggy, rainy, hot, warm, cool) and/or draw a picture of the weather on the calendar for each day of the month. Talk together about how the weather has changed during the month.

Books

⟨ *The Cloud Book* by Tomie de Paola
⟨ *Gilberto and the Wind* by Marie Hall Ets
⟨ *Just a Thunderstorm* by Gina Mayer and Mercer Mayer
⟨ *The Kid's Book of Weather Forecasting* by Mark Breen
⟨ *Like a Windy Day* by Frank Asch
⟨ *Peter Spier's Rain* by Peter Spier
⟨ *Weather Detectives* by Mark Eubank
⟨ *What Color Was the Sky Today?* by Melia Ford

Other Ways to Help Your Child Learn

⟨ Ask your child to make predictions at breakfast about what the weather will be like in the afternoon.
⟨ Become a sky and cloud watcher with your child. Notice how the sky and clouds change during the day and from one season to another. Talk about what you see in the clouds.
⟨ Trace the edge of a puddle of water outside. Observe it to see how long it takes to dry up.
⟨ Help your child observe the changes throughout the seasons in a plant or tree in your yard or neighborhood. Encourage him to draw and write about what he sees and knows.

SHAPES AND SHADOWS

Grade Level: PreK–1

Purposes

⟨ Identify and match common geometric shapes in the environment
⟨ Describe the properties of common objects
⟨ Conduct investigations

Activities

Shape Sorts

Provide a set of geometric shapes (e.g., 4 circles, 4 squares, 5 rectangles, 6 triangles).

Directions: Ask your child to sort the shapes into groups (sets) and then to make a pattern or arrange the shapes to make figures. Encourage her to name the shapes she uses.

Living Room Geometry

Provide a dry-erase marker and laminated tally sheet with geometric shapes (circle, square, rectangle, triangle) drawn or glued on one side.

Directions: Look for shapes with your child in one room of your home. Look at the floor, ceiling, doors, windows, furniture, and objects in the room. For each object in the room, ask her to make a tally mark on the sheet next to the shape it resembles. Count how many shapes of each kind she spotted.

Shape Bingo

Make six bingo-type cards, each one different than the others, a spinner card that includes all the same shapes, and enough small paper markers to cover the squares on all the cards.

Directions: For two to six players. Each player takes a turn spinning the spinner. If the arrow points to a shape he has on his card, he can cover the shape with a marker. When any player has covered all his shapes, he calls, "Bingo!"

Shape Shadows

Bag together a flashlight and several sturdy geometric shapes.

Directions: Shine a light on a wall in a darkened room. Encourage your child to hold each shape in front of the light to make a shadow. What happens when he moves the shape closer to or farther from the light? How can he make the biggest or the smallest shape shadow? What happens to the shadow when the shape is turned? Can he use a square shape to make a rectangle or a line?

Books

⟨ *I Spy Shapes in Art* by Lucy Micklethwait
⟨ *Light and Shadow* by Myra C. Livingston
⟨ *Moonbear's Shadow* by Frank Asch
⟨ *Nothing Sticks Like a Shadow* by Ann Tompert
⟨ *Round Is a Mooncake: A Book of Shapes* by Roseanne Thong (Chinese American)
⟨ *Shadow Night* by Kay Chorao
⟨ *The Shape of Me and Other Stuff* by Dr. Seuss
⟨ *Shapes, Shapes, Shapes* by Tana Hoban
⟨ *What Makes a Shadow?* by Clyde Robert Bullo
⟨ *When a Line Bends . . . A Shape Begins* by Rhonda Gowler Greene
⟨ *A Wing on a Flea: A Book About Shapes* by Ed Emberley

Other Ways to Help Your Child Learn

⟨ Have fun together by shining a light in a darkened room on familiar objects (a fork, stuffed animal, vase) and by making hand shadows.

〈 On a sunny day, draw a chalk outline around your child's shadow in the morning, at noon, and in the afternoon as she stands in the same place. Talk about what makes the shape of her shadow's outline change.

〈 Draw a target on a wall. Take turns trying to toss a ball into the air so that its shadow touches the target.

〈 Point out different shapes and shadows in your neighborhood.

〈 Play shadow tag on a sunny day. Try to tag each other's shadow rather than actually tagging each other.

SINK AND FLOAT

Grade Level: Kindergarten

Purposes

〈 Identify objects that sink and float

〈 Make predictions based on past experience with a particular material or object

〈 Classify objects according to whether they sink or float

〈 Describe physical properties of materials

Activities

Will It Sink or Float?

Provide an assortment of items, some that will sink and others that will float (a pencil, rubber band, toothpick, marbles, cork, plastic spoon, rock, eraser, aluminum foil, coin, sponge, small ball, wooden block, Styrofoam tray, or plastic containers of different sizes and shapes), picture cards of these items, and a laminated sheet divided into two columns, one labeled for "sink," the other for "float."

Directions: Ask your child to predict which items will float and which will sink, and then allow her to test her predictions in the sink, bathtub, or a bucket full of water. Ask her why she thinks each item floats or sinks. Afterwards, ask her to place the picture cards in either the "sink" or "float" column. Find other items around your home for her to test.

Sink It in the Sink

Include two containers of different sizes and a bag of marbles or other small items that will sink.

Directions: Float the containers in a sink or bathtub. Count the number of marbles that it will take to sink each container. What do you notice?

Books

〈 *Christopher Columbus* by Stephen Krensky

〈 *Let's Try It Out in the Water: Hands-On Early-Learning Science Activities* by Seymour Simon and Nicole Fauteux

〈 *Rub a Dub Dub* by Kin Eagle

〈 *Who Sank the Boat?* by Pamela Allen

〈 *Will It Float or Sink?* by Melissa Stewart

Other Ways to Help Your Child Learn

⟨ Make a boat from materials found in your home. Float it during bath time.

⟨ Take two equal-size sheets of aluminum foil. Crumple and pound one sheet to make it into a small, hard ball. Ask your child to predict whether or not the shape affects whether something floats or sinks. Let him test his predictions.

⟨ Add a cup of salt to a sink or bucket full of water. Retest items that floated or sunk in plain water. Talk with your child about his observations.

SHELLS

Grade Level: 1–2

Purposes

⟨ Identify and classify objects according to their attributes

⟨ Compare and contrast attributes of objects

⟨ Describe observations and reasoning orally

Activities

Shell Discovery

Provide an assortment of sturdy shells—the more varied, the better—a hand-held magnifying lens, and a ruler. Make task cards with activities that children can do at home. Suggestions:

⟨ Arrange the shells from smallest to largest. Measure the length of the smallest and largest shell. How much bigger is the largest shell?

⟨ Decide how to organize the shells. Explain to someone in your family why you grouped them the way you did.

⟨ Group shells by patterns.

⟨ Choose a shell and draw a picture of the animal that might have lived in it.

⟨ Pick your favorite shell, and write why you like it best.

⟨ Try to find some of the shells in one of the books. How many can you find?

⟨ Tell someone who has not read the books three things you have learned about shells.

Directions: Explore the shells. Choose a card and follow the directions.

Variation:

⟨ Add small plastic representations of sea life. Make similar kinds of task cards for these materials.

Shell Attribute Game

Place an assortment of shells in a bag.

Directions: For two or more players. Place any shell in the center of the table. The first player chooses another shell that shares at least one attribute with the "starter" shell and describes what that attribute is. (Examples: It is the same size. It has two connected shells.) She then places it next to the starter shell. The next player picks a shell that shares an attribute with the last shell placed.

Animals That Live in Shells

Make an "Animals That Live in Shells" chart that has columns with these labels:

⟨ Draw the animal
⟨ Write the animal's name
⟨ Where does it live?
⟨ Mollusk or crustacean?
⟨ How many shells does it have?
⟨ Does it have a head?
⟨ How many legs or feet does it have?
⟨ Does it have a backbone?

Directions: Read one of the information books with a family member. Then choose five shells, and complete the chart for them.

Books

⟨ *Crab Moon* by Ruth Horowitz
⟨ *Eyewitness Explorers: Shells* by DK Publishing
⟨ *A House for Hermit Crab* by Eric Carle
⟨ *Peterson First Guide to Shells of North America* by Jackie Leatherbury Douglass, John Douglass, and Roger Tory Peterson
⟨ *The Shell Book* by Barbara Hirsch Lember
⟨ *Shells! Shells! Shells!* by Nancy Elizabeth Wallace
⟨ *What Lives in a Shell?* by Kathleen Weidner Zoehfeld

Other Ways to Help Your Child Learn

⟨ Take your child to the beach or a natural history museum to look for shells.
⟨ Ask your child open-ended questions about what she observe and thinks. These are questions that have many answers and encourage your child's critical thinking. For example, ask, "How would you describe this shell?" rather than, "What is it?"
⟨ After reading one of the information books, talk with your child about differences between mollusks and crustaceans.
⟨ Visit the American Museum of Natural History Online Field Journal http://www.amnh.org/nationalcenter/online_field_journal/cp/cpsh/cpshmain.html.
⟨ Make a list of all the different kinds of shells (e.g., egg) you and your child can think of.

TREES

Grade Level: K–1

Purposes

⟨ Understand that different types of plants share our environment
⟨ Identify external features of trees
⟨ Describe the properties of common objects
⟨ Distinguish and classify items based on their attributes

Activities

Parts of a Tree

Make two sets of cards, one with names of tree parts, the other with corresponding pictures of these parts, for example: bark, blossom, branch, bud, compound leaf, cone, needles, root, simple leaf, stem, seedling, seeds, root, twig.

Directions: Spread the picture cards on a table. Take turns drawing a word card and matching it to its picture.

Seed Search

Provide an assortment of sturdy seeds (acorns, pinecones, nuts) and picture cards of the trees that produce them.

Directions: Match the seed to the tree from which it comes. Can you find other seeds in your neighborhood? Collect the seeds, and draw a picture of the tree they came from.

Leaf Sort

Draw different leaf shapes onto green, red, yellow, and brown card stock. Laminate. Add three or four plastic sorting circles or hoops. These can be made by cutting around the edges of coffee can lids.

Directions: Sort the leaves by color, shape, size, or number of leaves on a stem. Can you think of a different way to sort the leaves?

Secret Leaf Game

Draw different leaf shapes onto green, red, yellow, and brown card stock. Laminate. Alternatively, laminate real leaves.

Directions: Play a leaf guessing game. Spread all the leaves on a table. Take turns giving each other clues to find a "secret" leaf. For example, a clue may be, "This leaf is yellow and has a smooth edge." The guesser chooses a leaf and asks, "Is this the secret leaf?" Continue until all the leaves are eliminated.

Tree Products Search

Provide several sheets of blank paper or a small notebook and a pencil.

Directions: Take an indoor tree walk in your home. Look for things that are made from trees. Starting with this pencil and paper, list or draw a picture of each thing you find. How many are there?

Books

⟨ *Autumn Leaves* by Ken Robbins
⟨ *The Giving Tree* by Shel Silverstein
⟨ *Leaf Man* by Lois Ehlert
⟨ *The Life Cycle of a Tree* by Bobbie Kalman
⟨ *Nature in the Neighborhood* by Gordon Morrison

⟨ *One Small Place in a Tree* by Barbara Brenner
⟨ *Our Tree Named Steve* by Alan Zweibel
⟨ *Tell Me, Tree: All About Trees for Kids* by Gail Gibbons
⟨ *A Tree Is a Plant* by Clyde Bulla

Other Ways to Help Your Child Learn

⟨ Take a neighborhood walk with your child to look for different kinds of trees. Help her notice tree and leaf shapes, trunk colors, and bark textures. Collect leaves or other tree parts. These items can be sorted into categories once you get home or taped or glued onto paper to create a tree collage.

⟨ Let your child make crayon rubbings of leaves or the bark of a tree. Talk with her about the features that are revealed in the rubbings (e.g., leaf shapes and veins).

⟨ Grow an avocado tree. Poke three toothpicks in the middle of an avocado so that it can be suspended in a glass of water. Submerge the largest end. Change the water about once a week. After the stem and roots are several inches long, transplant the avocado into a pot.

BIRDS

Grade Level: PreK–2

Purposes

⟨ Understand that each animal needs its own type of food
⟨ Describe similarities and differences among birds
⟨ Identify body parts of birds
⟨ Record observations

Activities

Puzzle Parts

Copy the illustration of the bird in the Resources. Glue it onto card stock and laminate. Cut out each labeled body part to form a puzzle.

Directions: Put the bird back together. Talk about why each of the bird's body parts is important for its survival.

Birding Safari

Directions: Go on a nature walk to look for and collect items birds might use to build a nest. Try to make a nest with the items you collect.

Feed the Birds!

Furnish a pinecone, a small bag of birdseed, some string, a small notebook, and a pencil.

Directions: Make a bird feeder by smooshing peanut butter into the pinecone. Roll the cone in birdseed, tie a string to the top end and hang it in an outdoor location where it is easy to observe birds. Watch for birds that come to this feeder. Draw, dictate, or write about what you see.

Variation

〈 Provide a plastic bowl or half of a milk carton instead of a pinecone so families can make a "dish" feeder by punching evenly spaced holes around the top edge, suspending the bowl by strings passed through the holes, and filling the bowl with birdseed.

Life Cycles

Provide a set of laminated cards that show the life cycle of birds.

Directions: Put the cards in order and talk together about each stage in a bird's life.

Books

〈 *Beaks!* by Collard Sneed
〈 *Birds Build Nests* by Yvonne Winer
〈 *Birds' Nests* by Eileen Curran
〈 *Birdsong* by Audrey Wood
〈 *The Boy Who Drew Birds: A Story of John James Audubon* by Jacqueline Davies
〈 *Catching the Wind* by Joanne Ryder
〈 *DK Eyewonder: Birds* by Samantha Gray
〈 *The Life Cycle of a Bird* by Bobbie Kalman and Kathryn Smithyman
〈 *Little Green* by Keith Baker
〈 *No Roses for Harry* by Gene Zion
〈 *Owls* by John Becker
〈 *Paisano, the Roadrunner* by Jennifer Dewey

Other Ways to Help Your Child Learn

〈 Close your eyes and listen for birds in your neighborhood or local park. How many different songs do you hear? Can you make sounds like the birds you hear?
〈 Help birds in your neighborhood build their nests in the early spring. Weave or poke pieces of yarn or string, long strands of dried grass, dryer lint, pet hair, and short twigs through a strawberry basket or mesh onion bag. Hang the basket outdoors near a birdfeeder if you have one. Encourage your child to check the basket everyday to see what materials the birds have taken.
〈 Observe birds in your neighborhood with your child. Are they ground feeders? Do they eat seeds, or fruit, or insects? Help your child create a bird feeder of her own design.
〈 Visit the Cornell Lab of Ornithology's Web site (http://www.birds.cornell.edu/) for information and images about many different bird species and to listen to recordings of birds' songs.
〈 Start a list of birds that you and your child see together.

INSECTS AND BUGS

Grade Level: PreK–2

Purposes

〈 Observe and describe similarities and differences in characteristics and behavior of animals
〈 Identify basic needs of insects and spiders
〈 Understand that insects and spiders have predictable life cycles

Activities

Insect Knowledge Game (See Figure 6.4.)

Write questions about insects and spiders on 1 1/2-inch paper squares. Tailor the questions to the content in the book or books you send home. Glue the squares side by side to make a path inside a file folder. Draw an arrow to indicate where to place game markers to start the game. Draw a garden as the finish. Decorate spaces around the path with drawings of insects. Include four game markers and a numbered cube with the numerals 1 to 4, *roll again*, and *lose a turn* on its sides.

Questions can include What does a caterpillar eat? What do bees make? How many legs do insects have? Where do ants live? What do ladybugs eat?

Directions: Test your insect knowledge! Choose a game marker. Decide who will go first. Role the cube and move your marker. Read the question on the square where you land out loud. Tell your partners the answer.

Variation:

⟨ Include a question answer sheet.

Insect and Spider Puzzle (See Figures 6.5 and 6.6.)

Tape six jumbo craft sticks together to make a raft. On the opposite side, draw a ladybug in the center of the raft. Write *insect*, one letter per stick, on the top end. On the bottom end, write *has* on the first stick and *6 legs*, one character per stick. Remove the tape and place it on the other side so that you can make a double-sided puzzle. On the reverse side, draw a spider. Write *spider* at the top, and *has 8 legs* at the bottom.

Directions: No directions are necessary.

Insects' Life Cycles

Make individual picture cards showing the four stages of the life cycles of several insects (egg, larva, pupa, adult). Consider including a moth or butterfly, a beetle, a bee, and a dragon-fly or fly. Pictures can be drawn or download from the Internet.

Directions: Place the cards in a sequence that shows each insect's life cycle.

Books

⟨ *Are You a Spider?* by Tudor Humphries
⟨ *Bugs Are Insects* by Anne Rockwell
⟨ *Bugs, Bugs, Bugs* by Catherine Daly
⟨ *Diary of a Spider* by Doreen Cronin
⟨ *From Caterpillar to Butterfly* by Deborah Heiligman
⟨ *Insect Soup: Bug Poems* by Barry Louis Polisar
⟨ *Insects and Bugs* by Amanda O'Neill
⟨ *The Life and Times of the Honeybee* by Charles Micucci
⟨ *Mealworms: Raise Them, Watch Them, See Them Change* by Adrienne Mason

Figure 6.4 Insect Knowledge Game

Figure 6.5 One Side of Craft Stick Puzzle

Figure 6.6 The Other Side of Craft Stick Puzzle

Other Ways to Help Your Child Learn

⟨ Take a walk with your child to look for insects and spiders. Spend time observing the insects' or spiders' behavior and talking about what you see. After you get home, encourage your child to draw what he saw.

⟨ Raise mealworms with your child. Mealworms are inexpensive and can be purchased at pet stores. (They are often used to feed pet reptiles.) Keep the mealworms in two to three inches of wheat bran, wheat germ, or whole-wheat flour in a sealed container with air holes poked in the top. Add a small piece of cabbage or potato for moisture. Observe what happens over several weeks to a month. Do not assume that the mealworms are dead if they don't move!

⟨ Take a trip to a natural history or science museum, a zoo, or a pet store to observe insects and spiders up close.

THE NIGHT SKY

Grade Level: 1–3

Purposes

⟨ Recognize that different objects appear in the day and night sky
⟨ Observe that the phases of the moon occur in a predictable pattern
⟨ Document observations through writing and illustrations

Activities

Day or Night?

Make two file folder felt boards, one with light blue felt, the other with dark blue felt, and each with a horizon line. Cut out felt shapes of objects that can be seen in the sky from the horizon upwards, for example, sun, moon, stars, clouds, flag on pole, butterfly, bat, airplane, lightning bolt, rocket ship, bird, tree, kite, balloon, hot air balloon, tree, house, or building.

Variation:

〈 Use laminated card stock for the day and night backgrounds and shapes.

Directions: After reading one or more books together, talk about what we can see in the sky. Place objects onto the "day" or "night" felt board.

Moon Watching

Provide a small notebook or composition booklet entitled "My Moon Journal."

Directions: Look for the moon every night or day. Keep a journal to record your observations. Draw pictures of what the moon looked like. Write about where and when you saw it, or any other things you wonder or know about the moon. Be sure to date each entry. Talk with your family about when and where you think you will see the moon the next day.

Books

〈 *Goodnight Moon* by Margaret Wise Brown
〈 *Happy Birthday, Moon* by Frank Asch
〈 *Hello, Harvest Moon* by Ralph Fletcher
〈 *How the Stars Fell Into the Sky: A Navajo Legend* by Jerrie Oughton
〈 *I Took the Moon for a Walk* by Carolyn Curtis
〈 *If You Decide to Go to the Moon* by Faith McNulty
〈 *Kingdom of the Sun: A Book About the Planets* by Jacqueline Mitton
〈 *The Milky Way: A Cherokee Tale* by Joseph Bruchac and Gayle Ross (Native American)
〈 *The Moon Book* by Gail Gibbons
〈 *Papa, Please Get the Moon for Me* by Eric Carle
〈 *Why the Sun and the Moon Live in the Sky* by Elphinstone Dayrell (African folktale)
〈 *Zoo in the Sky: A Book of Animal Constellations* by Jacqueline Mitton

Other Ways to Help Your Child Learn

〈 Take your child to a local planetarium.
〈 When you can see the moon in the sky, let your child call a friend or relative who lives far away to talk about the moon's appearance and location in both places. Does the moon look the same or not?
〈 Look up answers to your child's questions on NASA's Web site (www.nasa.gov).

Creative Arts Kits 7

The learning-at-home activities included in this chapter invite children and family members to engage together in making music, dancing, drawing, playing active games, and other learning experiences. Activities such as these help parents recognize the value of creative arts activities as learning opportunities. These kits include suggestions for a few basic materials that can be combined with common household items to encourage creative problem solving and expression as well as physical development. As in other areas of the curriculum, you can also include many of the materials you use in your classroom in a take-home kit. Children and their families will be eager to use art materials or musical instruments at home. But if you add expendable materials, carefully consider the practicality and expense of replenishing them after the kit is returned.

You will notice that these activities also encourage skill and concept development in other areas of the curriculum, underscoring the integrated nature of creative learning experiences.

THE MUSIC IN ME

Grade Level: K–2
Purposes

⟨ Practice listening skills
⟨ Develop musical concepts and appreciation
⟨ Identify common instruments and use musical terminology
⟨ Compose and improvise rhythms

Activities

Making Music

Include a variety of musical instruments such as bells, rhythm sticks, sand blocks, maracas, and finger cymbals.

Directions: Experiment with different ways to play the instruments. Play each slow and fast, quiet and loud, and with different rhythms. Ask your child to close her eyes. Play each of the instruments, and ask her to identify which one it is. Play the instruments together as you sing a favorite song or listen to music on the radio.

Music Concert

Provide a microphone (a real but broken one or one made from a paper tube and Styrofoam ball), a few articles of clothing for musician or vocalist costumes (a vest, shirt, or pull-on skirt), and tickets.

Directions: Find a spot in your home where your child can put on a concert. He can sell tickets, be the announcer, play music, or sing. Alternatively, other family members can assume these roles as well as that of the appreciative audience.

Music Instrument Memory Game

Provide a book about the orchestra, such as *Tubby the Tuba* by Paul Tripp or *Meet the Orchestra* by Ann Hayes. Make duplicate 3" ↔ 5" cards with labeled pictures or photocopies of musical instruments. These can be drawn, downloaded from the Internet, or photocopied from a book (be sure to credit your source). Instruments can include a cello, clarinet, cymbals, flute, French horn, harp, kettle drum, trombone, trumpet, and violin.

Directions: For two players. Lay cards face down. Take turns flipping over pairs of cards. If the two cards match, the player keeps the cards and takes another turn. If they do not match, the cards are turned back over, and it is the other player's turn. The object is to match the most cards.

Music Group Number Match

Zin! Zin! Zin! A Violin by Lloyd Moss not only introduces children to instruments in an orchestra but it also is a musical group counting book. To reinforce concepts introduced in this book, make pairs of cards that represent the number of people in a musical group and the name for that number. For example, make a card with one person and another with the word *solo*, or a card with two people and another with the word *duet*. Words for other music group compositions are *trio, quartet, quintet, sextet, septet, octet, nonet, chamber group* (of ten).

Directions: Take turns with your child matching the number of people in each musical group.

Books

⟨ *Ah, Music!* by Aliki
⟨ *Fiestas: A Year of Latin-American Songs and Celebrations* by Jose-Luis Orozco
⟨ *Hip Cat* by Jonathan London
⟨ *How Music Came to the World: An Ancient Mexican Myth* by Hal and Carol Ober (Hispanic)
⟨ *M Is for Music* by Kathleen Krull
⟨ *Max Found Two Sticks* by Brian Pinkney (African American)
⟨ *Mi Música/My Music* by George Ancona (Spanish-English bilingual)
⟨ *Music, Music for Everyone* by Vera B. Williams
⟨ *My Family Plays Music* by Judy Cox (African American)
⟨ *The Bat Boy and His Violin* by Gavin Curtis (African American)
⟨ *Tubby the Tuba* by Paul Tripp
⟨ *Zin! Zin! Zin! A Violin* by Lloyd Moss

Consider adding a CD or tape of music related to one or more of the books you send home.

Other Ways to Help Your Child Learn

⟨ Listen and dance to different kinds of music with your child: classical, reggae, jazz, country, folk, hip-hop, and others.

⟨ Help your child tap the beat of music with two pencils, two chopsticks, two spoons, or a shaker of some sort.

⟨ Make music shakers (maracas) from empty soda cans, paper rolls, or two plastic cups. Fill with sand, beans, or pennies and securely tape openings.

⟨ Encourage your child to experiment with sounds she can make with her body—slapping her thighs, rubbing her feet together, snapping fingers, and making mouth sounds.

⟨ Go on a safari around your home to collect objects that can be used to make music. Create a family orchestra.

⟨ Take your child to a concert or performance that includes music.

⟨ Teach your child songs related to your own cultural heritage.

⟨ Sing with your child (even if you can't carry a tune)!

LET'S PRETEND

Grade Level: PreK–1

⟨ Engage in fantasy play, recreating situations in familiar settings
⟨ Use body, voice, and imagination to represent concepts related to other content areas
⟨ Retell or dramatize stories

Activities

Act it Out! (See Figure 7.1.)

Put *Amazing Grace* by Mary Hoffman, a length of fabric in a gender-neutral pattern (approximately 45" ↔ 18"), and these directions in a zip-and-seal bag.

Directions: In the story *Amazing Grace*, Grace used pieces of cloth to help her act out stories she heard and read. Sometimes, she made hats, scarves, belts, and capes from scraps of materials. Use the material in the bag to act out some of your favorite stories for your family.

Story Plays

Send home a familiar storybook that has several characters, along with simple props connected to those characters. Props can include hats, household items, or masks with attached sticks. Alternatively, include sturdy puppets instead of props.

Directions: Read the book together. Encourage your child to use the props in a play he creates about the story.

To Market, To Market

Gather several props that children can use in a dramatic play grocery store. These might include a laminated shopping list and dry-erase marker (or a pad of paper), a cloth shopping bag, a wallet or billfold, and a moneybox (cash register).

Directions: Let your child play grocery story with items in your kitchen and home. Take turns being the customer and the storekeeper. Mark prices on items. Use actual bills and coins in these transactions. Help him read information on the packaging.

Figure 7.1	Act It Out! Directions With a Simple Length of Fabric

Variation:

⟨ Send home collections of props to encourage children to engage in other thematic dramatic play: post office, shoe store, restaurant, and others.

Books

⟨ *All the World's a Stage* by Rebecca Piatt Davidson
⟨ *Amazing Grace* by Mary Hoffman (African American)
⟨ *Not a Box* by Antoinette Portis
⟨ *The Squiggle* by Carole Lexa Schaefer (Chinese/Chinese American)

Other Ways to Help Your Child Learn

⟨ After looking at the cover illustration of a book and reading the first page of the story aloud, ask your child to predict what will happen in the story. Afterwards, ask him to tell how the story differed from his prediction.
⟨ Dramatic play encourages language development. Give your child many opportunities to pretend and act out stories or experiences he has had.
⟨ Encourage your child's language, literacy, and imagination by asking him to tell a story about
 • What the family pet did when no one was home;
 • What he would do if he could fly;
 • What would happen if it rained something besides raindrops; or
 • What if he were a musician.
⟨ Take your child to a children's theater performance.

DANCE!

Grade Level: PreK–1

Purposes

⟨ Increase coordination and balance
⟨ Respond spontaneously to different types of music, rhythms, and sounds
⟨ Develop body awareness
⟨ Engage in movement activities with family members

Activities

Provide a tape or CD of a variety of instrumental music with different tempos and props associated with dance. These can include a ribbon streamer or silk-like scarves, a pull on "tutu" made with netting, a sash, a "magic" wand, or any items associated with the books you include.

Dancing Animals

(Optional: a tape or CD of "Carnival of the Animals" by Camille Saint-Saëns or "Peter and the Wolf" by Sergei Prokofiev.)

Directions: Encourage your child to experiment with dance movements. Ask her to wiggle like a snake, swim like a fish, flap like a bird, or hop like a frog. What other animal movements can she invent?

I've Got Rhythm

Directions: Listen to the music together and clap, stomp, or sway to the rhythm of the music with your child. Encourage him to move in a variety of other ways to the music and combine movements into his own dance steps.

Copy Cats

Directions: Take turns moving to music in a particular way. The other person can try to copy the movement. Begin with simple movements and then combine two or more moves. Use words to describe the way you are moving (e.g., swaying, stepping, turning, twisting, twirling, bouncing, etc.).

Let's Dance!

Directions: Turn the music on, and let your child stage a dance performance in your living room. He can use the props provided or other articles of clothing in his dances.

Books

⟨ *Color Dance* by Ann Jonas
⟨ *Dance* by Bill Jones and Susan Kuklin (African American)
⟨ *The Dance* by Richard Evans
⟨ *Dance, Tanya* by Patricia Lee Gauch

⟨ *Giraffes Can't Dance* by Giles Andreae
⟨ *Presenting Tanya, the Ugly Duckling* by Patricia Lee Gauch
⟨ *Rainbow Tulip* by Pat Mora (Mexican American)
⟨ *Tallchief: America's Prima Ballerina* by Maria Tallchief and Rosemary Wells (Native American)
⟨ *Ten Go Tango* by Arthur Dorros and Emily Arnold McCully

Other Ways to Help Your Child Learn

⟨ Play different kinds of music and dance together! Music that is upbeat and that is easy to clap or jump to works best.
⟨ Give your child a balloon, and encourage him to bounce the balloon up in the air to the rhythm of music you play for him.
⟨ Encourage your child to act out movements in front of a mirror.
⟨ Teach your child dances related to your own cultural heritage.
⟨ Take your child to a dance performance.

SOMETHING BEAUTIFUL

Grade Level: K–2
Purposes

⟨ Understand one's own thoughts and feelings as well as those of others
⟨ Recognize how peoples' thoughts and feelings are similar and different
⟨ Appreciate beauty in others, in their creations, and in the natural world

Activities

Something Beautiful Puzzle

Make a puzzle by taping nine jumbo craft sticks together and, on them, drawing a picture related to one of the books you send home. Write "something"—one letter per craft stick across the top—and "beautiful"—one letter per craft stick across the bottom. Retape the puzzle so that you can draw a picture and write the words on the other side. Remove the tape, and place the puzzle in a zip-and-seal bag.

Directions: Put the puzzle together to create "something beautiful."

Variation:

⟨ Provide nine extra craft sticks so that children can create and keep their own puzzles.

Happy Hearts

Put the book *Something Beautiful* by Sharon Dennis Wyeth and a journal or several sheets of paper in a zip-and-seal bag.

Directions: The little girl in the book *Something Beautiful* learns that something beautiful "makes your heart happy." Talk about things that make your heart happy. Draw or write about these in the journal.

My Favorites

Make cards with words to describe "favorites:" color, animal, friend, food, dessert, book, song, toy, game, place, thing to do together, day of the week, shirt, time at school, sport, and so forth.

Directions: Take turns drawing a card. Read the word, and tell your partner what your favorite one of those is. Alternatively, you can ask the other person to guess your favorite before you tell him or her.

Books

⟨ *Abuela's Weave* by Omar S. Castaneda (Latin American)
⟨ *The Art Lesson* by Tomie dePaola
⟨ *Eddie's Kingdom* by D. B. Johnson
⟨ *Fireflies* by Julie Brinckloe
⟨ *Something Beautiful* by Sharon Dennis Wyeth (African American)
⟨ *The Story of Jumping Mouse* by John Steptoe (Native American)

Other Ways to Help Your Child Learn

⟨ Help your child make his or her own puzzle of "something beautiful." The easiest way to do this is to tape the craft sticks together before your child draws and writes on them. Your child may keep this puzzle.
⟨ Do something with your child to help someone else or to make your house, apartment building, or neighborhood more beautiful. Ask your child to draw a picture or write about the beautiful thing you have done together.

COLOR MY WORLD

Grade Level: PreK–K

Purposes

⟨ Reinforce basic color concepts
⟨ Introduce vocabulary words related to color (e.g., *shade, hue, tint*)
⟨ Match words with the colors they represent

Activities

Color Match

On the inside of a file folder, draw and label colored circles for red, orange, yellow, green, blue, purple, brown, and black. Onto equal-size circle shapes (or dye cuts), draw items in those colors—for example, a red leaf, yellow bee, orange butterfly, green frog, brown gingerbread man, and black rabbit. Draw two items of each color. Put these in a resealable sandwich bag. Label and decorate the front of the file folder, and laminate. Staple the bag to the inside.

Directions: Activity is self-explanatory. No directions are needed.

Color Sort and Sequence

Collect paint samples of different shades of basic colors from a hardware store.

Directions. The term *value* refers to the lightness or darkness of a color. Light blue has a higher value than navy blue because it has more white in it. Sort colors into color families. Talk about the different shades of colors. Order paint samples of the same color from lightest to darkest, and talk about their different values.

Water Color Pictures

Provide a set of watercolor paints, a paintbrush, and several sheets of white paper.

Directions: No directions are needed; however, consider requesting that the paints and paintbrush are cleaned before they are returned to school.

Optional materials to send home

⟨ A square of red, yellow, and blue cellophane or a set of color paddles
⟨ Regular crayons or Crayola Multicultural Crayons

Books (See ACEI Focus on PreK spring 2008)

⟨ *Color Dance* by Ann Jonas
⟨ *The Color of Us* by Karen Katz (Multicultural)
⟨ *Colors Everywhere* by Sam McBratney
⟨ *The Deep Blue Sea: A Book of Colors* by Audrey Wood
⟨ *Duckie's Rainbow* by Frances Barry
⟨ *Farm Life* by Elizabeth Spur
⟨ *Flyaway Katie* by Polly Dunbar
⟨ *Lemons Are Not Red* by Laura Vaccaro Seeger
⟨ *White Is for Blueberry* by George Shannon

Others Ways to Help Your Child Learn

⟨ Refer to the color of things during everyday activities. For example, Would you like to wear your brown shirt or your blue one? This squash is yellow just like the corn.
⟨ Name something in your home that is a certain color. Ask your child to find other things that are the same color. How many can he find?
⟨ Play a guessing game with your child. Say, "I'm thinking of something green that is part of a tree. What is it?" or, "I'm thinking of something in the sky that is white. What is it?" Invite your child to ask you a color riddle.
⟨ Give your child some old magazines to look through for items of a specific color (maybe their favorite color). He can cut or tear the pictures out and use them to make a collage of that color. Talk with him about the different shades of color in the pictures he used.
⟨ Purchase yellow, red, and blue food coloring. Fill several glasses half full with water. Let your child experiment with mixing colors in the water. Ask him what he notices when he mixes two colors together.

LET'S GET PHYSICAL

Grade Level: PreK–1

Purposes

⟨ Practice and enhance basic locomotor skills
⟨ Increase balance and coordination
⟨ Develop body awareness
⟨ Engage in physical activities with family members

Activities

Send home items needed for the activities in a small gym bag. Add other equipment you may have that encourages children to move.

Jump Over the River

Include a roll of masking tape and a measuring tape.

Directions: Use the masking tape to make a six- to eight-foot V-shaped "river" that is about three feet across at the top. What is the widest part of the river you can jump across? Mark and measure this distance.

Sidewalk Games

Include several pieces of sidewalk chalk.

Directions: Use the sidewalk chalk to draw paths to follow. For example, draw a long line to make a "tightrope." Walk on the tightrope and try not to fall off! You can make this more challenging by balancing a beanbag on your head or carrying something. Ask your child to invent and use the chalk to draw an obstacle course for everyone in the family to navigate. Use the chalk to draw a hopscotch pattern with eight numbered sections.

Sharks

Include a roll of masking tape. (Poly-spots are optional.)

Directions: Use the masking tape to create series of "islands" at least 24 inches in diameter and close enough together so that your child can jump from one island to another. You can also make "stepping stones" between the islands. Ask your child to pretend there are sharks in the ocean. To avoid the sharks, she will need to jump from one island to another. Ask her to go back and forth from the starting point to a particular island. Play background music to make this activity even more exciting.

Variation:

⟨ A tamer version of this is to make "puddles," and ask your child to pretend she is a frog jumping from one puddle to the next. Ask her to hop up and down inside her puddle, jump in front of, around, or over her puddle.

Cup Catch

Include several sturdy plastic cups and a foam or tennis ball.

Directions: Try to catch the ball in the cup when it is tossed, bounced, or rolled.

Cup Bowling

Include 5 to 10 sturdy plastic cups and a foam or tennis ball.

Directions: Set the cups up like bowling pins, or use them to build a cup structure. Try to knock it down by rolling or bouncing the ball.

Paper Plate Skate

Include 6 to 8 paper plates. Each family member will need 2.

Directions: Use the paper plates to skate across the kitchen or living room floor. Skate or dance with your child to music. Do the twist together.

Bean Bag Toss

Include several beanbags, a laminated target, and a roll of masking tape.

Directions: Tape the target on the wall (either indoors or out) or on the floor. Tape a line for players to stand on. Take turns throwing the beanbags at the target. Make this even more fun by using one or more boxes or wastebaskets as targets.

Streaming Ribbons

Include a ribbon streamer made by taping or hot gluing a two- to four-foot length of ribbon to a shower curtain ring. Ribbons can also be glued onto a wooden paint stirrer.

Directions: Ask your child to stand in one place and make ribbon shapes above, in front of, or around his body. Ask him to make a snake, a rainbow over his head, and figure eights. Then, ask him to make shapes (a river, waves on the ocean, a tornado) with the ribbon as he moves around. What other shapes can he make?

Paddle Ball

Include two short-handled foam paddles and a foam or tennis fall.

Directions: Toss the ball, so your child can hit it with the paddle. Bounce the ball to her. Encourage her to hit it back to you, up in the air, or against a wall and to vary how hard she hits it.

Books

⟨ *Animal Action ABC* by Karen Pandell
⟨ *The Animal Boogie* by Debbie Harter
⟨ *Jumping Day* by Barbara Juster Esbensen
⟨ *My Amazing Body: A First Look at Health and Fitness* by Pat Thomas
⟨ *Over in the Jungle: A Rainforest Rhyme* by Marianne Berkes
⟨ *The Three Little Fish and the Big Bad Shark* by Will Grace

Other Ways to Help Your Child Learn

⟨ Play animal charades with your child. Write the names of animals on small slips of paper, and put them in a hat or basket. Take turns drawing a slip of paper from the hat and moving like the animal written on it. The other player or players guess what animal each of you is pretending to be.

⟨ Pretend to be each other's mirror image or shadow. Take turns copying the movements each of you do while standing either face-to-face, as if looking in a mirror, or following behind one another to create a shadow.

⟨ Play an outdoor game like tag or red light/green light with your child.

⟨ Make an obstacle course using items in and around your home that children can move over, under, around, and through.

MY CRAYONS TALK

Grade Level: PreK–K

Purposes

⟨ Use lines, forms, and colors to express ideas and feelings
⟨ Discuss own works of art
⟨ Experiment with colors through drawing
⟨ Create a self-portrait and draw everyday objects

Activities

Self-Portrait (See Figure 7.2.)

Provide a regular box of crayons and a box with multicultural skin tones and several sheets of paper.

Directions: Ask your child to look in the mirror and create a self-portrait. He can draw his face on one sheet and his whole body on another. Reinforce the uniqueness of all the features he includes in his drawings.

Picture Puzzle

Send home one or more pieces of card stock (5" ↔ 7" or 8" ↔ 10") and safety scissors.

Directions: After your child draws a picture onto the card stock, cut it into 8 to 12 pieces. He can make two puzzles if he draws on both sides of the card stock. Be sure to ask him to tell you about his picture.

Variation:

⟨ Each family member makes a picture puzzle and then trades with someone else who can try to put the puzzle together.

My Book of Favorites

Send home an unlined journal (handmade or purchased) and a box of crayons. Other art materials, such as Crayola Multicultural Crayons, markers, or colored pencils can also be included.

Directions: Your child can use the journal to make a book about her favorite things. Make sure you talk with her about what she has drawn and written (or dictated to you) and why they are her favorites.

Figure 7.2	Five-Year-Old Nathan's Self-Portrait

Partner Art

Provide a box of crayons or markers and several sheets of unlined paper.

Directions: Draw one or more shapes (e.g., circle, triangle) on paper. Ask your child to finish your drawing. Then it's his turn to start a drawing for you.

Books

- ⟨ *David's Drawings* by Cathryn Falwell
- ⟨ *Harold and the Purple Crayon* by Crockett Johnson
- ⟨ *In the Leaves* by Huy Voun Lee (Chinese)
- ⟨ *Ish* by Peter H. Reynolds
- ⟨ *Marianthe's Story: Painted Words and Spoken Memories* by Aliki
- ⟨ *My Crayons Talk* by Patricia Hubbard
- ⟨ *No Good in Art* by Miriam Cohen
- ⟨ *No One Saw: Ordinary Things Through the Eyes of an Artist* by Bob Raczka
- ⟨ *What Is an Artist?* by Barbara Lehn

Other Ways to Help Your Child Learn

⟨ Turn on different kinds of music, and suggest that your child make his crayons dance on paper as he listens.

⟨ Ask your child to make a card for a friend or family member.

⟨ Take a small box of crayons or a few markers and some paper when you go places. Your child will be occupied creatively while you are waiting in line or at a restaurant or office.

TWISTING AND TURNING

Grade Level: 1–3

Purposes

⟨ Apply artistic processes and problem-solving strategies to represent ideas

⟨ Develop perceptual motor skills

⟨ Experiment with artistic media

⟨ Create a representational sculpture of people, animals, or buildings

Activities

Straw Structures

Provide a small box of drinking straws (about 2 dozen) and an equal number of small paper clips.

Directions: Open each paper clip to make an S shape. Insert each end into the ends of two straws. You can change the angle of the straws by bending the paper clip. You can also insert the ends of more than one paper clip into a straw to attach several straws together.

⟨ What can you build?

⟨ Can you make a letter of the alphabet?

⟨ Can you make a box?

⟨ What is the tallest or widest structure you can build?

⟨ What can you and someone in your family make together?

Pipe Cleaner Creatures

Provide 10 to 20 pipe cleaners (chenille stems), some one-inch strips of scrap fabric, and a permanent marker.

Directions: Twist the pipe cleaners to make a person, animal, or something else you imagine. Use the fabric scraps to wrap around the pipe cleaner base. Draw features on your creature. If you wish, add other materials you have around your home. Tell your family a story about your creature.

Milk Carton Toys

Provide at least one 1/2-pint milk carton and a small zip-and-seal bag containing a few rubber bands, pieces of yarn, straws, paper clips, and other scrap materials.

Directions: Create a toy for a younger child from the milk carton. You might make a puppet, boat, car, or house. If you wish, you can also use other materials you have in your home. Ask an adult to make sure it is safe before giving it to a younger child.

Books

⟨ *The Dot* by Peter H. Reynolds
⟨ *Ecoart!: Earth-Friendly Art and Craft Experiences for 3- to 9-Year-Olds* by Laurie Carlson
⟨ *Good Earth Art: Environmental Art for Kids* by MaryAnn F. Kohl
⟨ *Not a Box* by Antoinette Portis
⟨ *The Red Book* by Barbara Lehman (wordless book)
⟨ *Seen Art?* by Jon Scieszka

Other Ways to Help Your Child Learn

⟨ Collect recycled materials that your child can use to create something of her own choosing. Good materials include empty food containers, bottle tops and caps, cardboard, egg cartons, cardboard tubes, fabric scraps, and aluminum foil. Ask her to tell you about her creation.
⟨ Encourage your child to think about alternative uses for common materials by asking, "What else could this be used for?" You are encouraging creative thinking problem solving.
⟨ Let your child use commercially packaged bread dough to make and bake creations of his own.

IMAGINATION CREATIONS

Grade Level: K–3

Purposes

⟨ Apply artistic processes and problem-solving strategies to represent ideas
⟨ Develop perceptual motor skills
⟨ Experiment with artistic media
⟨ Create a representational sculpture of people, animals, or buildings
⟨ Practice

Activities

Retooling

Provide several sheets of construction paper and markers or crayons.

Directions: Help your child trace around several common household tools, like a spatula, pair of scissors, spoon, or hairbrush. Then encourage him to use his imagination to create something from this outline. Can it become a person, an animal, an object, or an invention of some sort?

What If?

Punch holes into the corners of 3" ↔ 5" cards, so they can be put onto a ring binder. Write on several 3" ↔ 5" inch cards *what if* questions that encourage children's imaginative thinking. Questions might include

⟨ What would happen if it really did rain cats and dogs?

⟨ If a dollar bill could speak, what would it say?

⟨ What else could you do with a hat besides wear it on your head?

⟨ What would you do if you had 1,000 bars of soap?

⟨ Where would you go if you could fly?

⟨ What might happen if everything in the world was blue?

⟨ If you could invent something that would do work for you or your family, what would it be, and how would it work?

⟨ What if everybody looked the same?

⟨ What would happen if there weren't any cars?

⟨ What if the sun didn't rise in the morning?

⟨ What would you do if you were in charge of the world?

Directions: Take turns asking each other *what if* questions. There are no right or wrong answers. It's OK to build on someone else's idea as you talk together about what might happen. Choose your favorite idea, and draw a picture and/or write a story about it.

Thumb Print Drawings (Figures 7.3 and 7.4.)

Send home one of Ed Emberley's books, an inkpad, several sheets of paper, and a black marker.

Directions: Make your own thumb or fingerprint drawings. Tell someone in your family a story about the drawings you've made.

Figure 7.3 Thumb Print Dinosaur

Figure 7.4 Thumb Print Ladybug

Books

⟨ *Animals Should Definitely Not Wear Clothing* by Judi Barrett
⟨ *Cloudy With a Chance of Meatballs* by Judi Barrett
⟨ *Ed Emberley's Complete Fingerprint Drawing Book* by Ed Emberley
⟨ *Ed Emberley's Drawing Book of Animals* by Ed Emberley
⟨ *The Giant Jam Sandwich* by John Vernon Lord and Janet Burroway
⟨ *If I Were in Charge of the World and Other Worries: Poems for Children and Their Parents* by Judith Viorst
⟨ *Katie's Picture Show* by James Mayhew
⟨ *Michelangelo* by Mike Venezia
⟨ *Spencer Makes Circles* by Crista Chevalier
⟨ *The Young Artist* by Thomas Locker

Other Ways to Help Your Child Learn

⟨ Take a small notebook and crayons or markers when you and your child go places together. He can draw while you are waiting for an appointment or at a restaurant.
⟨ A package of pipe cleaners (chenille stems) can encourage your child to use his imagination to create things during car or bus trips.
⟨ Ask relatives and friends to give your child open-ended art materials as gifts instead of conventional toys.
⟨ Encourage and show your child you value his imagination and creative expression.

JOLLY JUNK

Grade Level: PreK–3

Purposes

⟨ Create a 3-D form
⟨ Represent ideas through an original creation
⟨ Use problem-solving strategies
⟨ Refine perceptual motor skills

Activities

Trash to Treasure

Place an assortment of reusable items in a zip-and-seal bag. These can include a toilet tissue tube, cardboard box, egg carton, torn ends of computer paper, scrap wrapping paper and ribbon, meat tray or aluminum pie plate, buttons, bottle caps, knobs, string, discarded CDs/DVDs, and so on.

Directions: Ask your child, "What can you do with these materials?" or, "What could you make with them?" Encourage him to brainstorm several ideas. After he has decided his favorite, be available to provide additional recyclable items you may have around your home.

Baubles and Bangles

Provide several clear plastic lids from deli-style containers, a pair of safety scissors, a hole punch, and several permanent markers. Buttons, sequins, small craft materials, and glue can also be included.

Directions: Ask your child how he can use the materials in the bag to make an ornament or a piece of jewelry. Talk with him about his ideas and help as needed, but be sure to follow his lead. He can keep his creation or give it as a gift.

Sound Off!

Place an assortment of items in a zip-and-seal bag. These can include an aluminum pie, one or more spools, a piece of corrugated cardboard, two small plastic flowerpots, a wooden dowel or spoon, and several bottle caps.

Directions: Let your child experiment with the materials in the bag to make sounds. Ask her in how many different ways she can make sounds. What else would she need to turn these materials into one or more musical instruments?

Books

⟨ *A Is for Art* by Marjorie Moon
⟨ *I Am an Artist* by Pat Lowery Collins
⟨ *Not a Box* by Antoinette Portis
⟨ *Olivia Forms a Band* by Ian Falconer
⟨ *The Wonderful Towers of Watts* by Patricia Zelver

Other Ways to Help Your Child Learn

⟨ Encourage your child to think of alternative uses for items you would ordinarily discard. What can those Styrofoam packing materials be used for? What can she make with that warped spatula? How about tin can lids or even dryer lint?
⟨ Keep a "beautiful junk" box in a handy place, and add discarded items to it so that your child has a ready supply of materials to use for her creations.
⟨ Give your child a box of straws and some glue, tape, and string. Ask her to design a house for one of the three little pigs.

FIESTA!

Grade Level: PreK–3

Purposes

⟨ Experiment with artistic media
⟨ Develop perceptual motor skills
⟨ Participate in creative expression associated with Hispanic cultures

Activities

Yarn Painting

Provide a piece of sturdy cardboard approximately 5" to 8" on a side, bits of colored yarn, a small bottle of school glue, and a pencil.

Directions: Draw a simple picture or design on the cardboard. Spread a small amount of glue on top of it and fill it in with yarn, pressing the yarn into the glue.

Song and Dance

Directions: Choose a song in *Fiestas: A Year of Latin-American Songs and Celebrations,* and act it out or dance to it with others in your family.

Variation:

⟨ Include CD or tape with Latin American music for children to dance to.

Ring Toss

Provide three to six rings at least 6 inches in diameter plus a handful of small items the size of counters or bottle caps. The rings can be purchased or made from cardboard or large coffee can lids.

Directions: Spread the small items on the floor about two feet apart. Take turns tossing the rings. You win an item when your ring encircles it. Talk with your child about which techniques make it easier to win an item.

Fiesta Float

Send home a zip-and-seal bag filled with assorted scrap paper, fabric and craft materials, along with a piece of card stock.

Directions: Give your child a shoebox or box of similar size. Encourage him to use the materials in the bag to create a fiesta float. Other items you have at home can be added to these materials. Ask him to name and tell about his float and to write, draw, or dictate this information on the sheet provided.

Books

⟨ *Around the World in 80 Tales* by Saviour Pirotta
⟨ *Birthdays Around the World* by Mary D. Lankford
⟨ *Celebrate! It's Cinco De Mayo / Celebremos Es El Cinco De Mayo* by Janice Levy
⟨ *Family Pictures / Cuadros de Familia* by Carmen Lomas Garza
⟨ *Fiesta!* by Ginger Foglesong
⟨ *Fiestas: A Year of Latin-American Songs and Celebrations* by Jose-Luis Orozco
⟨ *Mexico ABCs: A Book About the People and Places of Mexico* by Sarah Heiman
⟨ *The Piñata Maker / El Piñatero* by George Ancona

Other Ways to Help Your Child Learn

⟨ Make a piñata with your child. Blow up a round balloon. Cover it with about four layers of newspaper strips that have been dipped in either two ounces of glue mixed with three cups of water, or a flour and water paste. After the balloon is dry, encourage your child to decorate or paint it. Then, cut a small hole in the piñata, fill it with small treats and surprises, and cover the hole with paper. Make two holes in the top to thread a cord through so you can hang the piñata from the ceiling or a tree branch. It's now ready for your child and others to take turns trying to break the piñata with a stick while they're blindfolded.

⟨ Plan a party with your child. Encourage him to make invitations and to participate in making preparations for the party. Let him write or dictate captions for the photos you take during the party, and save them in a purchased or homemade album.

ARTISTS EVERYWHERE!

Grade Level: K–3

Purposes

⟨ Describe and discuss works of art
⟨ Tell a story based on a painting
⟨ Compare similarities and differences in two works of art
⟨ Create a picture in the style of a famous work of art

Activities

Alike and Different

Provide prints of two works of art and cards with short sentences that describe them and a file folder with a Venn diagram drawn on the inside. Label the diagram with the names of the works of art.

Directions: Take turns drawing a card. Place it in the portion of the diagram to show whether it describes one work or art, the other, or both. Tell your partner why you made the decision you did.

Variation:

⟨ Include cards with adjectives that describe the works of art (*cheerful, gloomy, amusing, rosy, comforting, harsh*).

This Is Me!

Place materials and paper in a zip-and-seal bag that children can use to create a self-portrait. These materials can include pens, paints, and/or scrap materials for collage. Include a book with artistic portraits.

Directions: Talk with your child about the portraits of people in the book. Then, ask her to look in a mirror and tell about the features that make her special. Encourage her to create a self-portrait using the materials in the bag.

Picture Stories

Send home prints or postcards of works of art that include people, several sheets of paper, and a few pens or pencils.

Directions: Choose a picture of a work of art that has people in it. Write or dictate a story about what you think it shows. Read or act out your story for or with other family members.

Just Like Picasso!

Provide one or more prints by abstract artists like Pablo Picasso, Joan Miro, or Wasilly Kandinsky, and provide art materials for children to create their own piece of art in the style of the artist. Depending on the prints you include, you might include paints or scrap paper and scissors and pens.

Directions: Talk with your child about how the artist created the work in the print. Invite your child to use the art materials to create his own work of art in the style of that artist.

Art Talk

Place several postcards of works of art in a zip-and-seal bag.

Directions: Look at the postcards with your child. Use artistic terms like *shape, pattern, design, color,* and *line* to talk with your child about what he sees. Ask him to order the pictures in different ways, for example, from brightest to darkest to lightest or from most to least favorite.

Books

⟨ *A Is for Art Museum* by Katy Friedland and Marla K. Shoemaker
⟨ *Discovering Great Artists: Hands-On Art for Children in the Styles of the Great Masters* by MaryAnn F. Kohl and Kim Solga
⟨ *Looking at Faces in Art* by Joy Richardson
⟨ *Painting With Picasso* by Julie Merberg and Suzanne Bober
⟨ *Visiting the Art Museum* by Laurene Krasny Brown and Marc Brown

Other Ways to Help Your Child Learn

⟨ Take your child to an art museum. Ask him to look for three favorite works of art.
⟨ Check out books of fine art from the library.
⟨ Cut out pictures of fine art from magazines with your child (they're often used in advertisements), and help him glue them into a notebook to make his own book.
⟨ Create a "gallery" in your home of your child's own works of art.
⟨ Check out Web sites of museums and art galleries such as the National Gallery of Art in Washington, D.C., the Museum of Modern Art in New York, the Louvre in Paris, the Art Institute of Chicago, or the Museum of Fine Arts in Boston. These sites have visual tours, kids pages, and other art appreciation experiences to share with your child.
⟨ Help your child use the Internet to find out more about a favorite artist.

More Learning Activities 8

No Materials Required

The suggestions in this chapter can be included as Other Ways to Help Your Child Learn activities with any other interactive homework materials you send home. They also can be added to school newsletters, posted on classroom Web sites, or listed on a Day-by-Day Calendar of Family Activities for vacation or summer learning. Similar to other interactive homework, they encourage intellectual dispositions as well as academic skills and knowledge. Most of the activities integrate content areas and are easily adapted for children of different ages.

The activities described below do not depend on your sending home materials. They either require no materials at all or make use of basic items most families already have on hand. There is also a list of Family Fieldtrips in the community that offer many opportunities for learning together.

75 FAMILY ACTIVITIES

1. Puppetry (Language, Literacy, Expressive Arts)

Make puppets from empty food containers, toilet tissue rolls, socks, or paper bags. You can also cut off the fingers of old gardening or dishwashing gloves to make finger puppets. Encourage your child to use materials you have on hand to personalize her puppets. Put on a puppet show together.

2. Collections (Mathematics, Science)

Help your child start a collection of interesting, noncommercial items. These might be rocks, seeds, keys, buttons, or stamps. Talk with him about the similarities and differences in the items. Help him think of ways to display his collection.

3. Label the Table (Language, Literacy)

Encourage your child to make labels for things around your home. Small sticky pads work well for this purpose. If she is a dual- or second-language learner, help her label items in both

languages. Alternatively, write names of objects around the house (bed, closet, radio, etc.) on 3" ↔ 5" cards and encourage your child to find and place them on those objects.

4. Finger Writing (Language, Literacy)

Fill a cookie sheet that has sides or a shallow tray with salt, sand, or cornmeal. Encourage your child to write his name or other words in the tray. As a variation, let your child write and draw in shaving cream in a tray or on a tabletop.

5. Feed the Birds
(Mathematics, Science, Language, Literacy, Expressive Arts)

Make a bird feeder with your child. Give him a small notebook to draw and write about the birds that come to the feeder. Bird feeders can be made by

⟨ Covering a pinecone with peanut butter and rolling it in birdseed;
⟨ Filling a half grapefruit rind or cupcake wrapper with peanut butter, birdseed, raisins, and apply bits;
⟨ Stuffing a mesh onion or other vegetable bag with suet;
⟨ Stringing Cheerios on a string;
⟨ Filling a plastic flowerpot with birdseed;
⟨ Poking a straw through the middle of a heel (crust) of bread, letting it dry out, and then looping a string through the straw; or
⟨ Cutting openings on opposite sides and several inches from the bottom of a milk carton, poking a straight stick or dowel underneath the openings for a perch, and filling this feeder with birdseed.

6. Backyard Bird Count
(Mathematics, Science, Language, Literacy)

Watch and count birds in your yard or a nearby park during a certain period of time. Make a tally of the number of different kinds of birds you saw. As an alternative, participate in the Cornell Lab of Ornithology's Great Backyard Bird Count in February or Project FeederWatch by entering your bird list online (www.birdsource.org).

7. Kitchen Vegetable Sprouts (Science, Language, Literacy)

⟨ Stand a carrot top (a 1-inch cut from the thick end of a carrot) in a shallow container. Add water about halfway up the side of the carrot. Replenish and change water as needed and keep in sunny place.
⟨ Cut the pointed end off a sweet potato. Poke toothpicks into 3 or 4 sides of the potato so that it can be suspended with the pointed end up in a tall jar. Add water to the jar so that about half the potato is covered. Replenish and change water as needed and keep in a sunny place.
⟨ Help your child record through drawing and writing what he observes happening.

8. Shopping for Dinner
(Language, Literacy, Mathematics, Science)

Plan a dinner menu with your child. Ask your child to make a list of the ingredients you will need for this meal. He can drawn, dictate, or write the items. Let him find the items on the list at the store, help put them away at home, and participate in preparing the meal. Older children can look for newspaper coupons for these ingredients, read nutritional information on food packaging, estimate the total cost of the groceries beforehand, and compare this to the final cost on the receipt.

9. Surprise Box (Language, Literacy)

Place a common item in a box. Give your child three clues that describe the item and encourage him to guess what it is. If your child is reading, write these clues on a slip of paper. For example, clues may be, It is made of metal. You can hold it in your hand. We use it to eat cereal. What is it? (Answer: a spoon.)

10. Secret Messages (Language, Literacy)

Hide "secret messages" for your child. Leave notes under pillows, in pockets, or in a backpack. Stick one on the bathroom mirror or in her shoes.

11. Name Puzzle (Literacy)

Write your child's name on a strip of cardboard. Make wavy or jagged cuts between the letters to make a name puzzle. You can also make phone number or address puzzles.

12. Household Items Sorting
(Mathematics, Science, Language)

Ask your child to help you sort things in your home (laundry, dishes, toys, recyclables, etc.). Talk with him about similarities and differences in these items as he sorts them.

13. Alike and Different (Language, Mathematics, Science)

Name two things and ask your child to tell one way they are alike and one way they are different. Begin with items that are easy to compare—socks and shoes, for example—and then make it more challenging—for example, a horse and a kite—according to your child's responses.

14. Concept Book
(Language, Literacy, Mathematics, Science, Expressive Arts)

Give your child a small notebook or make a book by fastening together sheets of paper. Talk with him about the kind of book it will be, for example, a book of colors, shapes, animals, transportation, or favorite things. On each page, he can draw or paste pictures related to the topic. Encourage him to talk about each picture. Write his words verbatim or help him write a description of each picture.

15. Newspaper Collages (Literacy, Expressive Arts)

Let your child cut or tear shapes from a newspaper or magazine. Glue onto paper to make a collage. The collage can be decorated with other scrap materials and markers.

16. Prop Box (Language, Literacy, Expressive Arts)

Place several items of clothing, shoes, and hats in a box or basket. Encourage your child to dress like a character in a favorite story and act out or retell the story from the character's point of view. Add other items related to your child's favorite stories. (See Figure 8.1.)

17. Shape Walk (Mathematics)

Go on a neighborhood "shape walk." Look for and count how many circles, squares, rectangles, and triangles you can find on your block.

18. Find It! (Language, Mathematics, Science)

Ask your child to find 5 or 10 things that are yellow, round, smooth, cold, and so forth.

19. Treasure Box (Expressive Arts)

Give your child a shoebox to collect and keep his favorite items. He can decorate and label this "Treasure Box."

Figure 8.1 Prop Box Items That Encourage Learning Through Dramatic Play

20. Newspaper Letters (Literacy)

Write a word or a name on a piece of paper. Help your child find the letters in a newspaper or do a "word search" for the same word.

21. Favorite Food Collage (Language, Literacy, Expressive Arts)

Save boxes and labels from your child's favorite foods. Help him cut out words he recognizes to make a food collage.

22. Bilingual Puzzles (Language, Literacy)

Glue magazine pictures onto sheets of heavy paper or cardboard. Cut the image in half in a wavy or jagged pattern. On one half of the picture, write the name of it in English; on the other half, write the name in a different language. Encourage your child to match the two pieces of the puzzle and name the picture (or read the words) in both languages.

23. Cooking by the Box (Language, Literacy, Mathematics, Science)

Read and follow the directions on a muffin or gelatin box with your child. Let him gather ingredients and do as much of the cooking as possible.

24. Picnic Planning (Literacy, Mathematics)

Help your child make a list of items to take on a picnic or special outing. Assemble and pack the items together.

25. Calendar Chronicle (Language, Literacy, Expressive Arts)

Give your child his own calendar so that he can draw pictures of the weather, how he feels, or what he did on each day's square.

26. Paper Plane Distances (Mathematics, Science, Expressive Arts)

Make and fly paper airplanes. Measure the distance each plane flew in paces, using a string, or a tape measure. Record and compare the distances.

27. Paint With Water (Expressive Arts)

Give your child a paintbrush and a bucket of water to "paint" your house, building, or the sidewalk.

28. Silly Book (Language, Literacy, Expressive Arts)

With a digital or disposable camera, take photos of your child acting silly or doing silly things. Your child can also take silly photos of family members or friends. Glue pictures into a

blank book or "album" you have made from fastening several sheets of paper together. Encourage your child to caption or tell or write a silly story based on the picture.

29. Nature Poster
(Science, Language, Literacy, Expressive Arts)

Take a bag with you as you walk around your neighborhood or visit a nearby park, so your child can collect natural items (pine cones, feathers, leaves, twigs). Help your child glue these items onto poster paper (or brown paper bags). Talk with her about each of these items, and label them together.

30. Message Board (Language, Literacy)

Place a small cork or magnetic board at your child's eye level. Leave messages there for him. Post photos and interesting pictures to talk with him about. Provide sticky notes or other note-paper for him to leave messages for family members.

31. What's in the Bag? (Language)

Put a familiar household item in a small bag or pillowcase. Ask your child to feel the item either inside or outside the bag and guess what it is. Ask questions that encourage your child to describe how it feels, what it's made of, and how it's used.

32. Scavenger Hunt (Language, Literacy)

Hide alphabet letters, notes, school supplies, or other items around your home. Give your child a bag or basket to collect the items he finds.

33. Personalized Gift Wrap (Expressive Arts)

Wrap a present in plain white paper or a paper grocery bag. Ask your child to decorate it.

34. Creation Box (Expressive Arts, Language, Literacy)

Keep a box of scrap materials (cardboard, Styrofoam trays, junk mail, used gift ribbon, egg cartons, buttons, fabric scraps, toothpicks, straws, foil wrappers). Keep scissors, a paper punch, tape, glue, and writing materials handy. Encourage your child to create whatever he wants. Talk with him about his creation, find a prominent place to display it.

35. What's Missing? (Mathematics, Language)

Take turns lining up several items. One player covers her eyes and the others remove one or more items. The guesser tries to figure out what's missing. This is a good game to play while you're waiting to be served at a restaurant.

36. Neighborhood Map
(Mathematics, Science, Expressive Arts)

Help your child make a neighborhood "map" out of empty boxes and food containers.

37. Eat the Alphabet (Language, Literacy, Expressive Arts)

Ask your child to list or draw items she eats that begin with each letter of the alphabet (apple, bread, carrot, dill pickle, etc.).

38. Shoebox Diorama (Language, Literacy, Expressive Arts)

Save a shoebox for your child to use to create a 3-D scene from a book that you have read together. She can draw on the inside of the box and then use materials to make other features in her diorama. Scrap paper and cardboard, aluminum foil, play dough, twigs, and other natural items work well.

39. Estimation Jar (Mathematics)

Fill a clear container or jar (plastic peanut butter jars work well) with a number of small identical items such as marbles, shells, crayons, cotton balls, macaroni, or pennies. Ask your child to estimate how many items are in the jar and then to count them by making groups of 10. As her guesses become more accurate, increase the number of items in the jar.

40. Favorite Character (Language, Literacy, Expressive Arts)

Ask your child to choose a character from a favorite book. Talk with him about how that character would dress and act. Invite him to dress up and act like the character. Encourage him to "read" the book or tell a story about the character to other family members.

41. Patterning (Mathematics)

Give your child a handful of colored cereal, colored pasta, nuts, or rocks. Make a pattern with them (ABAB or AABAA) and ask her to make a similar one. Take turns making patterns for each other to copy.

42. Coin Caterpillar (Mathematics)

To help your child count by fives, make a "caterpillar" by lining up several coins in a row. As you help your child count the value of each coin by fives, ask her to draw one leg of the caterpillar beneath each coin for each five she counts. For example, a dime will have two legs, while a quarter will have five legs.

43. Hidden Words (Language, Literacy)

Write a word on a piece of paper that has more than one syllable, such as *operation*, *calculator*, *friendship*, or *beautiful*. Ask your child to make a list of all the words he can think of using only the letters in this word. Try this at a restaurant by choosing a word on the menu. It's a great waiting game.

44. Listening to Sounds (Language)

Ask your child to close his eyes and listen while you use common items to make a sound. Ask him to tell you what object made that sounds. Try turning on the faucet, opening a door, shaking keys, or stacking plates.

45. Surprise Jar (Language, Literacy, Expressive Arts)

On slips of paper, write messages of things for family members to do. These can be things to act out (wiggle like a worm), an exercise (do 20 jumping jacks), a special chore (empty the trash), or a trick to try (touch your tongue to your nose). Put these in a jar, and take turns drawing a message from the jar.

46. Put It in Order (Language, Literacy, Mathematics)

Place several objects in a row on a table or on the floor. After your child looks at them, ask her to leave the room. Rearrange the objects. When she returns ask her to try to put the objects back in their original order. Take turns.

47. Top 10s (Language, Literacy)

Help your child make one or more Top 10 lists. Ask her about her top 10 favorite foods, things to do, places to go, or reasons to hug someone.

48. Moon Journal
(Language, Literacy, Science, Mathematics, Expressive Arts)

Look for the moon every night or day. Ask your child to draw what the moon looks like and to dictate or write what he sees, wonders about, or knows. Help him investigate answers to his questions. Keep the journal for a month.

49. Bedtime Storytelling (Language, Literacy)

Invite your child to read a bedtime story (or tell about the pictures) to a sibling or stuffed animal.

50. Picture Storytelling (Language, Literacy, Expressive Arts)

Let your child cut out several pictures from a magazine. Ask her to arrange the pictures however she wants and then to tell a story about what is happening in the pictures. Now it's your turn to rearrange the pictures and to tell her a story you make up. You can also tell a story together and write it down.

51. Letter Game (Language, Literacy, Mathematics)

Write each letter of the alphabet on a piece of paper or index card. Take turns choosing a card and trying to name (or write) an animal or object that begins with the selected letter. Older children may enjoy earning and adding up points for each word. For example, 10 points for correctly spelled words, 5 points for words that are named but incorrectly spelled.

52. Categories (Language, Literacy, Mathematics, Science)

Take turns thinking of a subject (animals, vehicles), and take turns naming as many things as you can in that category. Challenge older children to name a new word that begins with the

last letter of the previous word. Alternatively, write the names of categories on slips of paper and put them in a plastic container. The categories can include girls' or boys' names, foods, places in your home, colors, or others that you think of. Take turns drawing a slip of paper and then naming items.

53. Job Chart (Language, Literacy, Mathematics)

Help your child think of five things he can do to help out at home. Make a chart that lists these jobs, and make a check or draw a happy face next to the job every time your child does it. Be sure to let him know how much he is helping your family.

54. Paper Towel Quilt (Expressive Arts, Language, Mathematics)

Fold squares of sturdy paper towels in half, quarters, and then eighths. Dip each corner into a bowl of water with food coloring mixed into it. Open the squares, let them dry, and then lay them together to make a quilt. They can also be glued onto newspaper. Talk with your child about the colors and patterns he sees.

55. What's in a Face? (Language, Literacy, Expressive Arts)

Help your child find and cut out pictures of faces from magazines or newspapers. Talk with him about the expressions on these faces and what the people might be feeling. Do they look happy, afraid, surprised, worried, or angry? Talk together about why they might feel this way. Encourage your child to glue the faces onto paper and add speech balloons with words each person might say or think.

56. Photo Album (Language, Literacy)

Paste photos or magazine pictures onto construction paper (or into a purchased notebook or photo album). Staple the pages together. Help your child write captions for the pictures, or take dictation as he tells you a story about one or more of them.

57. Family Traits (Language, Mathematics, Science)

Choose a family trait, such as hair or eye color. Ask your child to count the number of people in your family who have variations of that trait. For example, how many people have black, brown, or gray hair? Help her make tally marks on a graph to record the results.

58. Favorite Recipes (Language, Literacy, Mathematics, Science)

Cook something with your child, letting him participate as much as possible. Read recipe directions together. Talk with him about measurements, fractions, and proportions. Encourage him to notice changes as ingredients are combined or heated.

59. Doubling a Recipe (Mathematics)

Help your child figure out the quantities of ingredients that will be needed to double a simple recipe. He can use one-fourth, one-third, one-half, and two-thirds measuring cups filled with water or corn meal to find out.

60. Silly Rhymes (Language, Literacy)

Make up words that rhyme with the names of each member of your family. You can make up silly rhymes and use them in songs or poems you invent. Help your child make a list of these words, and point out how different letters can make the same sound. For example, words that rhyme with Mary are *berry, carry, hairy,* and *wary.* Words that rhyme with Juan are *gone, lawn,* and *wan.*

61. Writing Box (Language, Literacy, Expressive Arts)

Make a writing box for your child. Fill it with paper, pens, markers and crayons, scissors, glue, and old envelopes or greeting cards. Invite him to decorate it and to use the materials inside to make lists, write notes, create cards, draw pictures, and tell stories.

62. Beautiful Junk Box (Expressive Arts)

Keep a box in a handy place for collecting discarded or recycled items your child can use to make 3-D structures or other assemblages. Cleaned out food containers, packaging, scraps from family craft or fix-it projects, and parts from broken household items are wonderful materials to inspire your child's imaginative thinking and problem solving as she creates something new from discarded items.

63. License Plate Games
(Language, Literacy, Mathematics)

Use license plates to help your child read or count numbers and letters, look for particular numbers (their age or the ages of other family members), or find the next number in a series.

64. Memory Game (Language, Literacy, Mathematics)

Write a number or draw a shape on one side of the paper. Flip the paper over and ask your child to write or draw the same number or shape. This is a good way to pass the time waiting in the doctor's office or other places.

65. Who Am I? (Language, Literacy)

Pretend you are a person your child knows or a character from a story with which your child is familiar. Invite him to ask you *yes-no* questions to try to figure out who you are. For example, "Are you younger than I am?" or, "Do you wear a tall, black hat?" Now, it is your child's turn to pretend and your turn to ask questions.

66. Dividing Crackers (Mathematics)

Give your child a handful of crackers. Ask her to divide the crackers so that each person in your family (or at the table) gets the same amount. How many are left over? Ask her to decide what can be done with the remainder.

67. Play Dough
(Language, Literacy, Mathematics, Science, Expressive Arts)

Make play dough with your child. In a skillet, mix 1 cup flour, 1/2 cup salt, 2 teaspoons cream of tartar, 1 cup water, and 4 tablespoons vegetable oil. Stir well. Cook over medium-high heat until the texture changes into dough. Remove from the heat and, when cool, knead to finish mixing. It's fun to make letter and other shapes with play dough. Keep it in a covered container for reuse.

68. From My Window (Language, Science, Expressive Arts)

Look out a window in your home with your child. Ask her to describe what she sees. How many shapes can she spot? What do the clouds tell her about the weather? What has changed since the last time she looked? Encourage her to draw what she sees. You and she can also record seasonal or other changes over time.

69. Nim (Mathematics)

Gather 21 small items (toothpicks, beans, marbles, paper clips) and arrange them in a row. Take turns picking up 1, 2, or 3 items. The player who picks up the last item loses.

70. Add-On Game (Language, Literacy)

To encourage listening and recall, begin a word series of foods, animals, or objects, and take turns adding to it. For example, say, "On our walk, we saw a dog and. . . ." Your child will then say, "On our walk, we saw a dog and a blue house and. . . ." Try this with shopping lists: "At the store we will buy milk and. . . ."

71. Storytelling (Language, Literacy)

Tell your child a story—one that is true or one you make up—and then ask your child to tell you a story.

72. Scarf Dancing (Expressive Arts)

Give your child one or more scarves. Turn the music on and encourage him to use the scarves to experiment with dance and movement. Dance with your child!

73. Newspaper Numbers (Mathematics, Language, Literacy)

Encourage your child to hunt for and circle numbers on one page of a newspaper. Talk about what the numbers tell. Are they page numbers, prices for items, dates? How many numbers are less than 10 or more than 100?

74. Bubble Magic (Mathematics, Science, Language)

Make a bubble solution with your child from 1 quart of water and 2/3 cup dishwashing liquid. (Optional: Add 1 tablespoon glycerin, available at drug stores, to make the bubbles

sturdier.) Make bubble wands from twisted pipe cleaners, old fly swatters, plastic berry baskets, cookie cutters, or plastic lids with the centers cut out. Encourage your child to experiment making bubbles. Talk about what works best and why.

75. Personalized Magnet Board
(Language, Literacy, Mathematics)

Apply stickers, photos, or other pictures to small pieces of cardboard, and affix magnetic tape to the back of each. You can also write letters, numbers and math symbols, or words directly onto the cardboard. A cookie sheet or metal baking pan makes a perfect magnet board.

FAMILY FIELDTRIPS

Family outings are excellent opportunities for children to learn. These experiences encourage children's concept development and broaden their views of the world around them and the people in it. Trips can be taken to sites that consciously cater to family activities—zoos, amusement parks, and the like. However, visits to typical neighborhood locations or shops can also be wonderful learning adventures for children who are often fascinated by everyday activities that adults take for granted. The way dough is prepared for a pizza crust, the machinery in a shoe repair shop, and the way plumbing parts are categorized in a hardware store offer children many things to think and talk about with an adult guide. Helping families to see things through children's eyes will enable them to capitalize on the informal learning opportunities these experiences provide. There are many possibilities:

⟨ Airport, train, or bus station
⟨ Animal rehabilitation centers
⟨ Aquariums
⟨ Bakeries
⟨ Bank
⟨ Beach
⟨ Bookstore
⟨ Botanic gardens
⟨ Building centers
⟨ Cemetery
⟨ Construction site
⟨ Doctor's office or medical clinic
⟨ Fabric store
⟨ Farm centers
⟨ Fire station
⟨ Garage or service station
⟨ Grocery stores
⟨ Hair or barber salon
⟨ Hardware stores
⟨ Health club
⟨ Hike or camping trip

⟨ Laundromat
⟨ Local library
⟨ Monuments
⟨ Museums (natural history, history, art, transportation, science, children's)
⟨ Nature centers or ecological preserves
⟨ Nursery or flower shop
⟨ Optometrist or optical store
⟨ Paint store
⟨ Parks
⟨ Pet shop
⟨ Planetariums
⟨ Polling sites (for voting)
⟨ Post office
⟨ Restaurants
⟨ Shoe stores
⟨ Travel agency
⟨ Vegetable or farmers' markets
⟨ Veterinary clinic
⟨ Water parks
⟨ Zoos

Use the outing as an opportunity to point out and talk about the jobs people do, the tools and clothing they need to do their work, and those things you and your child experience. Take photographs to capture images to help children revisit and talk later about their experiences.

Family Walks

Just like fieldtrips to locations in your community, the world right outside your doorstep is full of interesting and exciting things for children to learn and experience. They can be spur-of-the-moment educational opportunities. They require little planning, cost nothing, and can be as short or long as you wish. Take a walk in your neighborhood

- ⟨ In the snow, rain, or when it's windy;
- ⟨ To look for different kinds of animals, trucks, license plates, trees, signs, shapes in buildings and houses, flowers, letters, or numbers;
- ⟨ To collect natural items to be used to create collages or assemblages; and
- ⟨ To talk about your home's location in relation to other places in your neighborhood. (For example, Our house is behind . . . , to the left of . . . , or four blocks from . . .)

9 Family Projects

Like other types of interactive homework, family projects are tangible bridges between home and school; they directly link children's at-home and at-school experiences. These informal projects are engaging and non-intimidating. They highlight family strengths and relationships because their open-ended nature enables every family to participate in their own way. Indeed, originality is encouraged because family projects are based on each family's unique characteristics.

The process of creating something together provides many opportunities for shared learning. The simple act of spending time together with a joint focus is a benefit for parents and children alike. Projects inspire discussions that further children's language development. They can be the basis for parents and other adults to recount stories and share family lore. They also provide contexts for joint problem solving and for parents to model and to encourage creativity.

Parents who have participated in family projects have felt closer to their children as a result (Barbour, 2002). Even though process over product is emphasized, finished products can reinforce children's family and cultural identify. Children are proud of projects they complete with their families and usually are enthusiastic about sharing them with others.

Family projects can take a week or even longer to complete. Therefore, it's important to tell families well in advance, so they can plan accordingly. Another reason for advanced notification is that some family projects require families to provide materials—rather than relying on teachers to supply them. This allows adequate time for gathering these materials. Notification might take the form of a letter at the beginning of the year previewing the kinds of projects children will bring home and general expectations for completing them. Some teachers try to send home family projects on a regular basis, particularly if they have a seasonal theme or coincide with thematic units or classroom activities. For example, families can be asked to create a sculpture out of recycled items for a curricular focus on Earth Day or recycling.

Choose family projects based on their mutual benefit for all concerned. As in other interactions with families, it is important to be sensitive to each family's characteristics, circumstances, and needs. This may mean tailoring requirements and expectations accordingly or even supplying materials for those families who will find it challenging to provide them on their own.

TIME CAPSULE

Planning together and assembling items to put in a child's time capsule is a fun project that gives families many things to consider and talk about. It also validates each child's uniqueness and reinforces his sense of self.

Materials

None

Directions:

No matter how old your child is, and no matter what he is like right now, he won't be the same tomorrow. While you can't bottle him to keep him from growing and changing, you can capture what he is like right now in a time capsule. You'll not only have fun putting the time capsule together now, you and your child may be surprised when you open it next year to see how much he's grown.

Help your child record through drawing, writing, or dictation things he especially likes (friends, foods, books, games, toys, colors) and dislikes, things he has done, or places he has gone, or special birthday or family events. Items that may be especially meaningful are electronic recordings, such as a tape of his voice (perhaps reading a book, telling a story, or singing a song) or video tapes, original artwork or handwriting samples, written anecdotes of what he says about his experiences or thoughts, a tracing of his hand or foot, and a string that is as long as he is tall. Be sure to encourage your child to add anything that represents who he is at this moment in time. Photos or other scrapbook memorabilia (postcards, event tickets, etc.) can also be included.

Put all the items in an airtight container. Bury the time capsule if you wish, or simply tuck it in away to be opened next year.

OUR FAMILY CUBE

Making a family cube is a collaborative family project that children can display at school and use to talk about who is in their families and what makes their family special.

Materials

A pattern for a cube copied onto card stock. A brief fill-in-the-blank questionnaire can also be included that asks questions (e.g., Who is in your family? With whom do you live? What languages do you speak at home? Do you have pets?) Information on this survey can be used in charting and graphing activities as well as in expanding children's understanding of family diversity.

Directions:

Make a family photo cube. Cut out the outline of the cube. Glue family photos onto each side of the cube, making sure there's at least one photo of every member of your family. Alternatively, your child can draw pictures of family members. After each side is complete, glue or tape the cube together.

TIMELINE

With families' help, children can create a timeline of their lives, giving them an understanding of personal history and reinforcing their own unique experiences. After timelines are returned home, they can be hung up and added to. They make wonderful keepsakes.

Materials

Send home several strips of paper at least four inches wide that have a vertical line with equidistant marks beginning with "I was born," "1 year," "2 years," and so on up to the age of the oldest child in class.

Directions:

A timeline shows when thing happened. Help your child make a timeline of her life beginning with her birth date. Add special dates and important events you and she remember, such as when she began to walk and talk, when siblings were born, and when she started school. Encourage your child to illustrate each event and to glue photos onto her timeline. Talk together about your memories and what your child wants to do or be when she is older.

ALL ABOUT ME

Not only will children be able to share their booklets with the class, the information in them can be used for comparisons and extension activities. For example, children's favorite colors can be graphed. If this project is sent home at the beginning of the year, information can be collected at the end of the year to show children how they've grown and changed. Families will also treasure completed booklets as keepsakes.

Materials

Make booklets by stapling together several forms with spaces for children and their families to fill in information and add illustrations and photographs. Forms can elicit information, such as this:

I was born on _____ in _____.

I live at _____. Here is a picture of my home.

My phone number is _____.

The people in my family are _____. Here is a picture of my family.

One special thing about my family is _____.

I am _____ tall, and I weigh _____ pounds.

I have _____ hair and _____eyes.

I am good at _____.

My best friends are _____.

The thing I like best about school is_____.

My least favorite things about school is _____.

My favorite book is _____.

My favorite color is_____.

My favorite things to eat are _____.

After school, I like to _____.

When I grow up, I want to _____.

One funny thing I did when I was little was _____.

Here's a picture of what I look like now.

Directions:

Help your child write information about himself to create an "All About Me" book. Encourage him to write as much as he can and to draw pictures. Include photos if you wish. Add other information and drawings on the blank pages.

FAMILY CALENDAR

A 12-month family calendar can help children focus on time concepts as they relate them to important family occasions. It can also inspire conversations about family events and traditions and help children plan ahead. Family members can participate in personalizing the calendar. They can draw pictures, attach photographs, or even glue or tape mementos, such as an invitation or ticket, onto the calendar to commemorate special days.

Materials

Use the template in the Resources to duplicate 12 monthly calendar pages for each child in your class. Alternatively, use computer software to create month-by-month calendar pages or download them from Internet sites such as Education World (http://www.education-world.com). If desired, punch holes in the top and include three brass fasteners, so families can create a wall-type calendar.

Directions:

Make a calendar page for each month of the year by writing the month and the days on each of these sheets. Use the calendar to mark family events. Fill in birthdays, family trips or events, religious or cultural celebrations, and any other days that are important to members of your family. Talk together about what makes these occasions special. Encourage your child (or your children) to draw pictures on the calendar. You can also attach photographs or small mementos of past or future events, such as tickets or an invitation. Help your child mark the passage of time as she looks forward to or recalls special family events.

CLASS COOKBOOK

A class cookbook that includes one or more recipes submitted by each family is a welcome family keepsake. To introduce the activity, read *The Edible Pyramid* by Loreen Leedy or show children a cookbook ahead of time, such as *Pretend Soup and Other Real Recipes: A Cookbook for*

Preschoolers & Up by Mollie Katzen and Ann Henderson. A cookbook will help them understand the kind of information that is important to include in a recipe and how directions are written.

Materials

Send home the Family Recipe Form in the Resources, or create your own, making sure there is space for children's comments and illustrations. Once children bring back their recipes, duplicate them to create cookbooks for each family.

Variations:

Take dictation, or ask each child to write and illustrate the recipe for their favorite dish prior to requesting the actual recipe from his or her family. Include both recipes side-by-side in the cookbook.

To celebrate diversity, encourage families to submit recipes for traditional foods from their culture. There can be a separate space on the recipe form for family members to add a little information about the dish, such as its origin or when it's eaten. This way, families provide two recipes: one from their heritage and one that is the children's favorite. These can be duplicated and bound into a "Family Heritage Cookbook."

Directions:

We are creating a "Class Cookbook." Please print your child's favorite recipe on the form, and encourage him or her to illustrate and write a comment about it. After all recipes have been turned in, your child will bring home a completed cookbook with directions for many favorite dishes you and your child can read about and cook together. (Adapt instructions for a "Family Heritage Cookbook.")

100-ITEM CREATION

To coincide with the 100th day of school, families can make something together using 100 items. This open-ended project enlists family support of children's understanding of number concepts, grouping, and counting to 100.

Materials

None

Directions:

We are learning about the number 100. Help your child create something using 100 items—no more or no fewer than 100. Think of the possibilities. Will it be 100 popsicle sticks, shells, stamps, pennies, paper clips, toothpicks, buttons, seed pods, or something else entirely?

NEIGHBORHOOD MAP

This mapping activity provides family members the opportunity to talk with children about special features of their neighborhood while reinforcing positional words. It expands children's understanding of spatial relationships and of the geography of a familiar neighborhood.

Materials

Provide an 11" ↔ 14" sheet of construction paper or card stock. Roll it up and rubber band directions to it.

Directions:

Take a walk around your block or neighborhood with your child. Point out what makes your neighborhood different from other neighborhoods—the streets, buildings, trees, signs, and other features. During your walk, talk with your child about how these features are related. Use positional terms like *next to, across from, to the left of,* or *behind.* After you return home, help your child draw a map of your neighborhood that includes the features she remembers. Encourage her to show and describe her map to other family members.

HERE'S WHERE I LIVE

Introduce the activity by reading *A House Is a House for Me* by Mary Ann Hoberman. Post or hang from the ceiling drawings that children make of their homes. Attach name and address streamers to the bottom of each.

Materials

Paper or card stock on which children can draw and decorate pictures of their homes. If a blank label is included, family members can write their addresses and phone numbers.

Directions:

Talk with your child about the features of your home, for example, where the door and windows are, what kind of a roof it has, and what if any trees are outside of it. Then, ask him to draw and decorate your home so that others can see what it looks like. Write your address and phone number on the label and help your child memorize these.

MILK CARTON CREATIONS

This family project focuses attention on recycling materials by challenging families to create something from a milk carton or milk jug. It can be sent home in April to coincide with Earth Day.

Materials

Collect enough half-gallon milk cartons or gallon plastic milk jugs for every child in class. (Enlist the support parents in saving these items.) Send a milk jug home with each child.

Directions:

Create something out of this recycled milk jug. Brainstorm ideas together but follow your child's lead in settling on what you will turn this milk jug into. Add items from around your home to your creation.

RECYCLED JUNK SCULPTURE

Another project based on recyclable materials is for families to create a sculpture from materials they would otherwise discard. Be sure to allow enough time for completion of this project so that families will have accumulated an adequate array of recyclable materials to inspire their creativity.

Materials

None

Variation:

⟨ Ask families to help their child create something related to the unit of study. For example, they can make a dinosaur from household trash. They can then name the dinosaur, and write where it lived, what it ate, and how it behaved.

Directions:

Look around your home and neighborhood to find materials that would otherwise be discarded but that can be used to create a 3-D sculpture of some sort. Your finished sculpture should be of a manageable size for your child to carry.

WORD RINGS

This personalized family project begins with words that individual children know or are learning. Each child's word ring will be different. Send word rings home on a regular basis—say every Friday—so families come to expect them.

Materials

Print words for each child on 3" ↔ 5" cards. These can be sight words, spelling words, or words from a classroom word wall. Make or ask each child to make a name card. Write directions on the back of the name card. Punch a hole near the top of each card, and put them on a ring fastener. Determine the number of words on the ring, and adapt directions as appropriate for each child. Remove cards as children master the words on them, and replace them with new word cards.

Variations:

⟨ Make a word bank instead. Send home a recycled container (an oatmeal or shoe box), or ask families to save one. Cut a slit in the top.
⟨ Word cards can be sent home, or families can add ones themselves.

Directions:

Your child has brought home words he is learning. Help him read the words and use each word in a sentence. Ask him to spell the words. Point out these words in signs, food packaging, books, and other print material.

Take the cards out of the ring fastener and help your child

⟨ Sort them by the number of letters in each word;
⟨ Arrange them alphabetically; and
⟨ Make silly sentences out of them.

MYSTERY BAG

On a rotating basis, send home a drawstring cloth bag or a sturdy opaque box. Throughout the year, send home different sized bags or different shaped boxes.

Materials

Write "Mystery Bag" or "Mystery Box" and a big question mark on a drawstring cloth bag or a sturdy opaque box. Tie a ribbon around the box or rubber band it, so the lid doesn't fall off.

Directions:

Help your child choose one thing to put in the bag. It is your child's turn to choose one item for the mystery bag. His friends in class will try to guess what's inside. Since they will hold it and shake it, please make sure the item has no sharp edges and is unbreakable.

FAMILY DECORATE AND DRESS-UP PROJECTS

Children and their families work together to brainstorm ideas and to complete the projects together. Once they bring their creations back to school, children have opportunities to share them with the class and to develop oral language skills as they describe what they have done. The projects reinforce the integral role home-school collaborations play in children's learning and sense of continuity between their in-school and out-of-school experiences.

These projects can be sent home individually or on a monthly basis. Either way, it is important to plan ahead, decide whether they are optional, and explain the projects to families in advance. Start-of-year planning will make it easier to send them home regularly. Parents themselves can be recruited early on to assemble materials, so they are ready to go throughout the year.

Most decorate or dress-up projects begin with an outline of a shape copied onto 11" ↔ 14" card stock, although different sizes of heavy paper or cardboard can work well too. Consider asking printing and copying businesses to donate leftover paper. Families use any materials they wish to embellish the outlines that are sent home. Paper or fabric scraps, beads, buttons, feathers, paint, yarn, items from nature, or recycled materials work well. However, it is a good idea to caution against using food items, such as Cheerios, because of their perishability and attractiveness to insects. Depending on your school's population or individual children's circumstances, it may be wise to include basic items, such as markers, along with the outlines or cutouts you send home.

Projects with seasonal themes are described below.

⟨ September: Family Quilt or Mini Me

⟨ October: Pumpkins
⟨ November: Turkeys
⟨ December: Gingerbread Boy or Girl, Evergreen Tree, or Ornament
⟨ January: Snow People
⟨ February: Mailboxes for Valentines
⟨ March: Leprechaun Trap
⟨ April: Hat or Piñata
⟨ May: Flower

Family Quilt

A family quilt not only provides a welcoming, family-friendly component to a classroom or school, it can be the focus on spin-off activities related to counting, graphing, and cultural celebrations. String decorated squares together with ribbon or yarn pushed through holes punched in the corners.

Materials

Send home a "quilt square" made from 12" ↔ 12" piece of card stock (oak tag).

Directions:

We are making a family quilt. Please decorate this "quilt square" any way you wish to represent your family. You might wish to draw, write, glue photos or other items to it—whatever your family agrees upon. After your child brings it back to school, we will add it to our classroom quilt to show that we are all members of a school family too.

Mini Me

Creating representations of themselves reinforces children's uniqueness and provides opportunities for them to describe and compare their characteristics with those of others.

Materials

A gender-neutral outline of a child drawn on 11" ↔ 14" card stock. Alternatively, trace the outline of each child onto butcher paper, or send a small roll of butcher paper home for family members to do this so that their child can make a Big Me.

Directions:

Please help your child decorate this cutout to make it look like himself or herself. You may want to help him find materials in your home to use, for example, markers, crayons, magazine pictures, yarn, or buttons. Encourage your child to be creative as he personalizes the cutout and uses the space around it to add other things that represent special things about your family or what he likes to do or eat or play.

Pumpkins

Children and their families create pumpkin faces or pumpkin people to display in the classroom.

Materials

Send home either a pumpkin shape drawn on 11" ↔ 14" card stock (oak tag) or a paper plate (orange plates are easy to find in the fall) with an optional sheet of card stock to make the pumpkin-head's body.

Directions:

As a family, decorate this pumpkin anyway you would like. Brainstorm ideas with your child, and follow his lead as much as possible.

Disguise the Turkey

Read *Sometimes It's Turkey, Sometimes It's Feathers* by Lorna Balian, *'Twas the Night Before Thanksgiving* by Dav Pilkey, or *A Turkey for Thanksgiving* by Eve Bunting to introduce this project. Families will then decorate or dress-up a turkey to keep it safe during Thanksgiving.

Materials

Send home an outline of a turkey on 11" ↔ 14" card stock.

Directions:

Disguise Tom or Tina Turkey so that it won't be caught for Thanksgiving dinner.

Gingerbread Boy or Girl or Evergreen Tree

Gingerbread people or evergreen trees can be displayed around the classroom or in the hall. They will add a festive and welcoming atmosphere to your school.

Materials

Send home an outline of a gingerbread person on 11" ↔ 14" card stock or an outline of an evergreen tree.

Directions:

Use materials around your home to decorate this gingerbread boy or girl (or this evergreen tree).

Snow People

Introduce the idea of dressing a snow person by reading *Snowballs* by Lois Ehlert to the class.

Materials

Send home an outline of a snow person for children to dress up.

Directions:

Use materials around your home to dress up the snow person.

Valentines Mailboxes

Children create mailboxes to bring to school on Valentine's Day.

Materials

Ask families well ahead of this project to save a shoebox. Collect a few extras to send home with children who indicate they don't have one.

Directions:

Cut a slit in a shoebox or a similar-size box to turn it into a mailbox. Decorate it for Valentine's Day, making sure your child's name is on it in big letters.

Leprechaun Trap

Children can write directions for catching a Leprechaun. After they have returned their creations to school and set their traps before going home, the "Leprechaun" drops a piece of gold (rocks sprayed painted gold or chocolate gold coin) near their traps.

Materials

None need to be sent home.

Directions:

A Leprechaun is a tiny Irish "elf" that, according to legend, makes shoes; they are cobblers. Each Leprechaun has a pot of gold. They are tricky and very hard to catch, but if you catch one, he will lead you to his pot of gold. Use items you have around your home to create a trap that will outsmart a Leprechaun. Be sure to bait your trap.

Hats

Read *A Three Hat Day* by Laura Geringer to introduce the activity. In addition to the opportunity children will have to model and talk about their creations in class, using recycled materials provides an example to families about conserving resources.

Materials

Send home either a brown paper grocery bag or several pieces of newspaper. Alternatively, ask families to supply these items.

Directions:

(1) Make a hat by rolling down the top of the grocery bag until there is enough of a brim to fit your child's head. Or (2) unfold several double sheets of newspaper and place them on your child's head, fanning them out in different directions. With masking tape, make the hatband by taping it tightly in a circle just above your child's eyes. Remove the hat and roll up the edges to shape the brim however big your child wants it to be. Tape the brim in place. Now decorate the hat using any materials you have on hand.

Piñatas

Read a book to the class about fiestas, such as *Fiesta!* by Ginger Fogleson Guyor, or a book about Cinco de Mayo, such as *Celebrate! It's Cinco de Mayo/Celebremos! Es El Cinco de Mayo* by Loretta Lopez.

Materials

Send home an outline of a piñata.

Directions:

Decorate this piñata and use the space around it to draw or glue items you would put inside your piñata.

Flowers

Introduce the variety of flowers by reading *Planting a Rainbow* by Lois Ehlert, *The Reason for a Flower* by Ruth Heller, or *Jack's Garden* by Henry Cole to the class. After children bring their finished flowers to school, add stems and arrange them on the bulletin board in a "vase," or plant them in a bulletin board "garden."

Materials

Send home an outline of a flower with several petals on 11" ↔ 14" card stock. A sturdy paper dinner plate can be a good alternative.

Directions:

It's spring! Help your child decorate this flower to add to our classroom garden.

Resources

FAMILY SURVEY

Please help me get to know your child and family. I will use the information you share to plan learning activities that are best suited to your child's needs and interests.

With whom does your child live?

Who are your child's legal guardians?

What is the best way to contact you?

When is the best time to reach you?

How does your child get to and from school?

What languages are spoken at home?

Which adults in your family know how to read in English or in your native language?

What is your country of origin?

If you were born in another country, how long have you been in the United States?

Who in the family is most likely to help the child with homework?

Is your child enrolled in afterschool programs?

What are your goals for your child this year?

What are your child's special interests?

What other special things would you like me to know about your child?

SAMPLE FAMILY LETTER 1

Dear Family Partner,

Your child has brought home a literacy backpack with activities for you to do together. Please read to or help your child read the books in the backpack and help your child do the activities. Before returning the backpack to school on Monday, please write a comment in the Parent Journal about your experiences with the materials, and ask your child to do the same in the Child's Journal. He or she can write, draw, or dictate.

Please help your child take good care of these materials and make sure that all the items are returned. This will ensure that your child is able to bring home another backpack.

We hope you and your child enjoy the books and activities together. Remember, **you** are your child's first and most important teacher.

Thank you for your help!

Your child's teacher

SAMPLE FAMILY LETTER 2

Dear Family Partner,

Your child has brought home the _____ learning kit this week. It includes books for you and your child to read and fun activities for you to do together. These activities are designed to enhance your child's learning and to give you opportunities to support it. I encourage you to do all the activities together, but it is not a requirement.

Before returning the kit, please share your experiences with this kit on the response forms. There is one form for you and one for your child. He or she can draw, dictate, or write about what he or she learned or liked best from the kit.

Please return the kit with everything in it on Monday.

Have fun!

Your partner in helping your child learn,

Sample Literacy Bag Agreement

For the Parent:

❑ I promise to read with my child and do the activities with my child.

❑ I will sign the journal after we have read the books and done the activities in the bag.

❑ I will make sure my child takes good care of the bag and everything in it.

❑ I will make sure that the books and activities in the bag are returned.

Parent's Signature/Date

For the Child:

❑ I promise to treat the books and activities with care.

❑ I promise to spend time with the books in the bag.

❑ When someone asks to read with me, I will look, listen, and ask questions.

❑ I will do the activities with someone in my family.

❑ I will write about the books and activities in the journal.

❑ I will return each bag I take home with everything in it.

Child's Signature/Date

For the Teacher:

❑ I promise to do all I can to instill a love of reading in your child.

❑ I will discuss this agreement with your child.

❑ I will give your child time in school to talk about the books and activities in the bag.

❑ I will not allow your child to take home another bag until he or she has returned the previous one in good shape and with everything in it.

POETRY AWARD CARDS SAMPLE 1

THIS AWARD GOES TO THE **happiest** POEM

THIS AWARD GOES TO THE SADDEST POEM

THIS AWARD GOES TO THE MOST beautiful POEM

THIS AWARD GOES TO THE SILLIEST POEM

POETRY AWARD CARDS SAMPLE 2

THIS AWARD GOES TO THE MOST **SERIOUS** Poem

THIS AWARD GOES TO THE

THIS AWARD GOES TO THE **FUNNEST** Poem

THIS AWARD GOES TO MY **FAVORITE** Poem

The Neighborhood Walk Game

- For 2–4 players

- Directions
 - Roll the number cube to see who will go first. The player whit the highest number begins.
 - Take turns. Roll the number cube and move your marker that many spaces. Read the question out loud and answer it.
 - Continue playing untill all players have crossed the finish line.

START

Tell about a time you visited a neighbor.

Describe what you see out your front window.

Tell what you like to do best with your family.

Do you live in the country or in the city?

What is the tallest thing in your neighborhood?

What plants do you see in your neighborhood?

Close your eyes. What do you smell in your neighborhood?

How do you travel to school?

What is your address?

What is your favorite place in your neighborhood?

Who else lives in your neighborhood?

Describe some of your chores.

What is the noisiest place in your neighborhood?

Describe what you see on your street.

Where do you play in your neighborhood?

Close your eyes. What do you hear in your neighborhood?

The Neighborhood Walk Game

What does the wind sound like in your neighborhood?

What can you do to help keep your house clean?

How long have you lived where your live now?

Describe what you see from the window in your room?

Where do you see the most people in your neighborhood?

Finish

Who is your best friend?

What are some jobs that people do in your neighborhood?

Who would you like to invite for dinner?

What is the quietest place in your neighborhood?

What is the sunniest spot in your neighborhood?

What is your favorite place in your neighborhood?

Who lives next door to you?

Where can you walk in your neighborhood?

What can you do to help keep your neighborhood clean?

How do people travel in your neighborhood?

What do you like to do with friends in your neighborhood?

Where is your mail delivered?

What was the last animal you saw in your neighborhood?

What is your neighborhood like at night?

Making Progress Game

2–4 Pieces
Need dice and game pieces.

Directions

1. Roll the die. Move that number of spaces
2. A ladder means you move up. A slide means you move down.
3. The winner is the first player that gets to number 56.

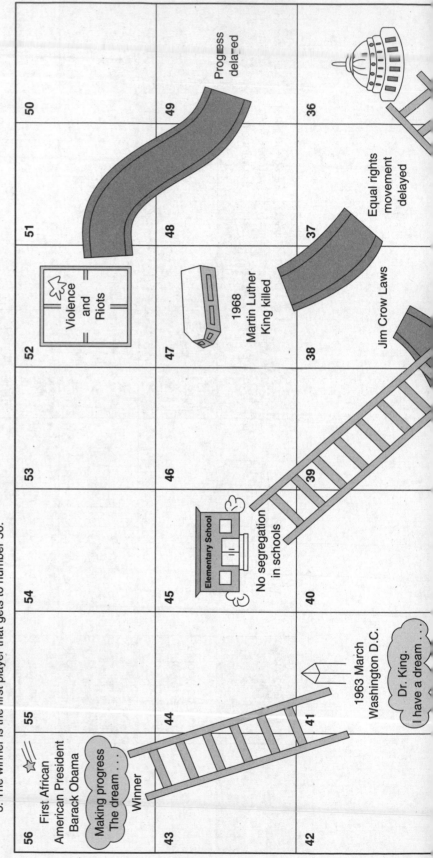

50	51	52	53	54	55
49 Progress delayed	48	47	46	45 Elementary School	44
36	37	38	39	40	41
	Equal rights movement delayed	Jim Crow Laws		No segregation in schools	Dr. King. I have a dream . . .

Violence and Riots

1968 Martin Luther King killed

56 First African American President Barack Obama

Making progress The dream . . .

Winner

43 42

1963 March Washington D.C.

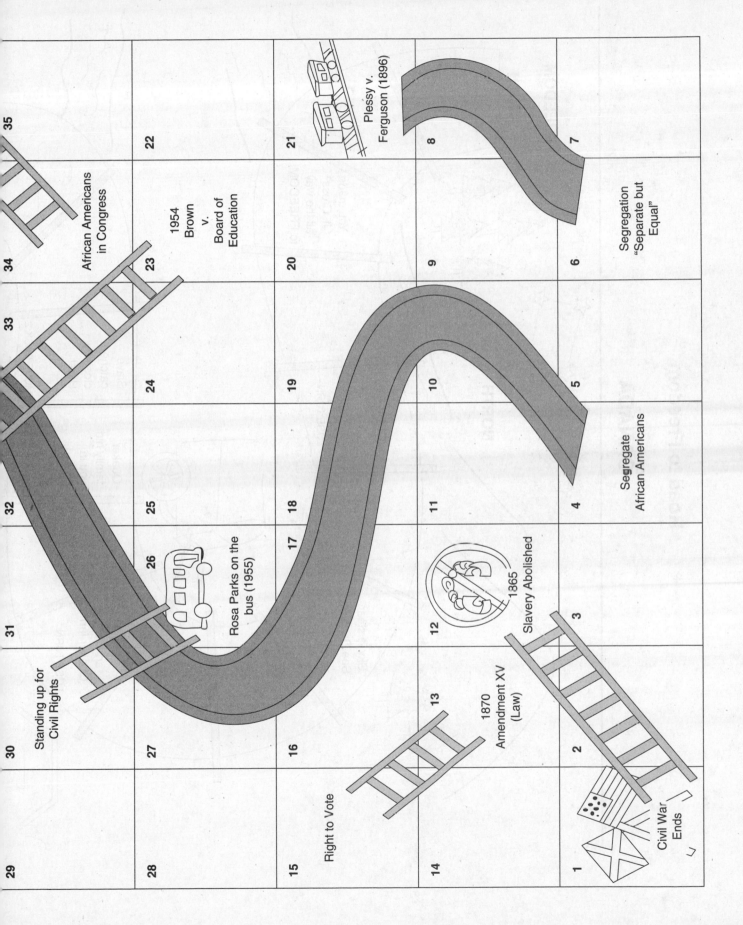

Road to Freedom

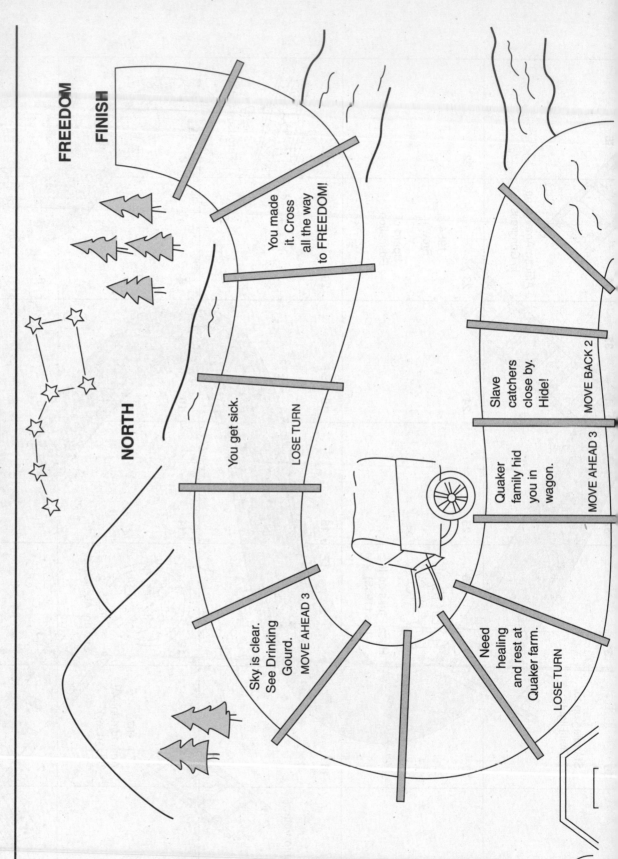

CANADA

FREEDOM

FINISH

NORTH

You made it. Cross all the way to FREEDOM!

You get sick.
LOSE TURN

Sky is clear.
See Drinking Gourd.
MOVE AHEAD 3

Need healing and rest at Quaker farm.
LOSE TURN

Quaker family hid you in wagon.
MOVE AHEAD 3

Slave catchers close by. Hide!
MOVE BACK 2

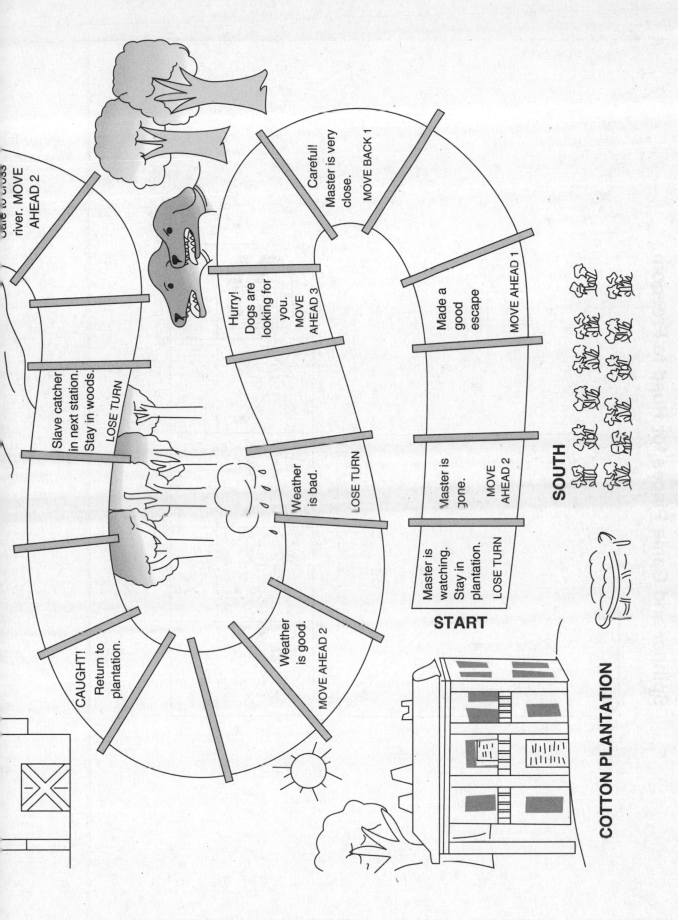

Safe to cross river. MOVE AHEAD 2

Slave catcher in next station. Stay in woods. LOSE TURN

CAUGHT! Return to plantation.

Weather is good. MOVE AHEAD 2

Hurry! Dogs are looking for you. MOVE AHEAD 3

Weather is bad. LOSE TURN

Careful! Master is very close. MOVE BACK 1

Made a good escape MOVE AHEAD 1

Master is gone. MOVE AHEAD 2

Master is watching. Stay in plantation. LOSE TURN

START

SOUTH

COTTON PLANTATION

Spinner and Game Pieces for Road to Freedom

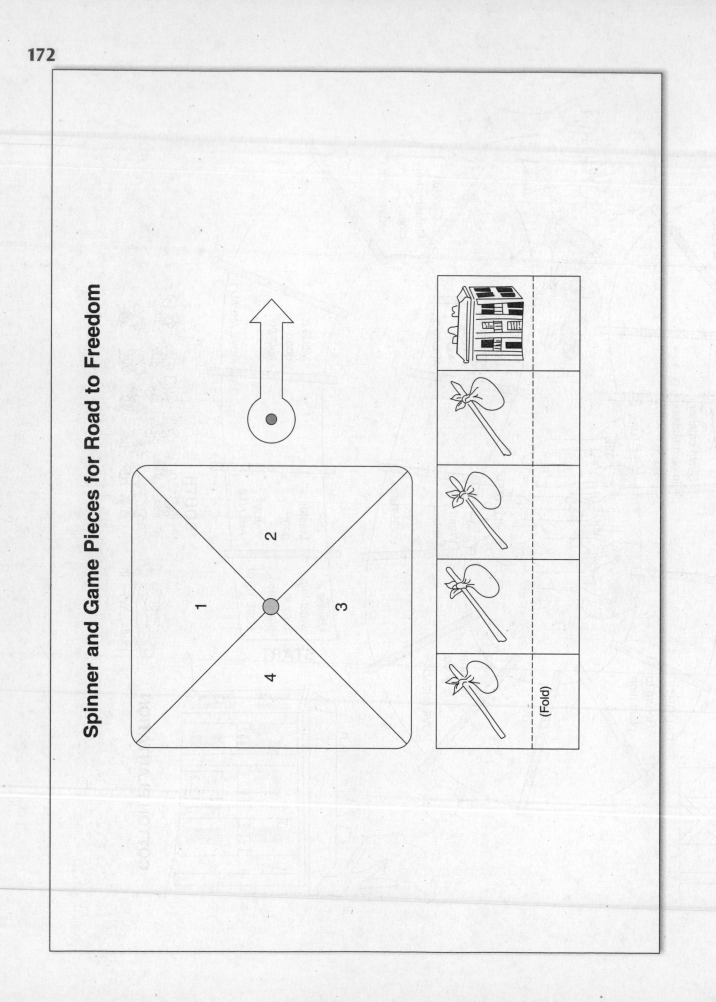

Cake Walk

2-4 players

1. Place your marker anywhere on the cake walk.
2. Roll dice.
3. Move the number of spaces.
4. If you land on a number space, go forward or back.
5. If you land on a cake, pick a card.
6. The first person to win three cake cards is the winner!

Endureza la Caminata

2-4 jugadores

1. Coloque su marcador dondequiera en la caminata de bizcocho.
2. Arrolle dados.
3. Mueva el número de espacios.
4. Si usted aterriza en un espacio del número, avance o atrás.
5. Si usted aterriza en un bizcocho, escoja una tarjeta.
6. ¡La primera persona para ganar tres tarjetas de bizcocho son el ganador!

Cake Walk

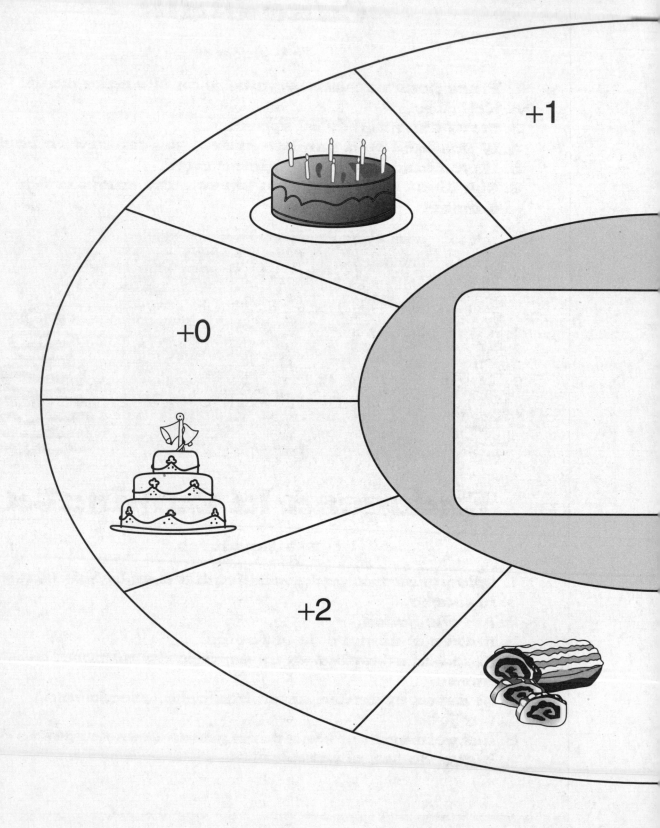

Endureza la Caminata

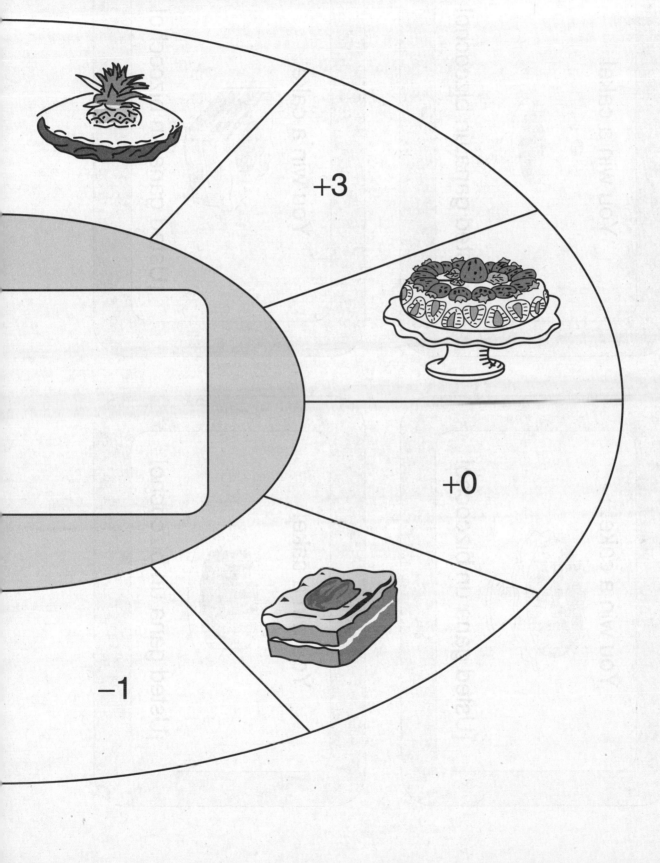

Cake Walk Game Cards

You win a cake!

¡Usted gana un bizcocho!

You win a cake!

¡Usted gana un bizcocho!

You win a cake!

¡Usted gana un bizcocho!

You win a cake!

¡Usted gana un bizcocho!

Cake Walk Game Cards

You just brushed your teeth.
No cake!

Usted acaba de cepillar los dientes.
¡Ningún bizcocho!

The dog ate the cake!

¡El perro comió el bizcocho!

No more sweets for you!
Sorry, no cake.

¡No más dulces para usted!
Arrepentido, ningún bizcocho.

The cake fell!
No cake.

¡El bizcocho cayó!
Ningún bizcocho.

Cake Walk Game Cards

Sorry, you ran out of flour.
No cake!

Arrepentido, usted se quedó sin harina ¡Ningún bizcocho!.

Grandpa ate all the eggs first.
No cake!

El abuelito comió todos los huevos primero.
¡Ningún bizcocho!

Oh, no!
The cake burned!

¡Ah, no!
¡El bizcocho quemó!

The ants got to the cake first!
Sorry!

¡Las hormigas llegaron al bizcocho primero!
¡Arrepentido!

Calendar Template

Month of _____

Sunday	Monday	Tuesday	Wednesday	Thursday	Friday	Saturday

Family Recipe Form

Child's Name _____

Name of Recipe _____

Number of people it serves _____

Ingredients and quantities needed:

Cooking Directions:

Please draw and write about this recipe on the reverse side.

GRAND-PERSON OR GRANDPARENT INTERVIEW QUESTIONS

Ask one of your grandparents or another special older person these questions. This is just the beginning of a grand conversation!

⟨ How old are you? Where were you born?

⟨ Do you have any brothers or sisters?

⟨ Did you have any pets when you were a child?

⟨ What did your home look like? Is it still the same?

⟨ What was your mother or your father like?

⟨ Where did you go to school? What do you remember most about it?

⟨ Did you have chores?

⟨ What were your favorite things to do when you were my age?

⟨ What was your first job?

⟨ How do you think we could make the world better?

More questions to ask if you are interviewing one of your grandparents:

⟨ Where did you meet grandpa (or grandma)?

⟨ Tell me about my mom or dad when she or he was my age.

⟨ How do I remind you of her or him?

⟨ What makes you proud of my mom or dad?

Tangram Pattern

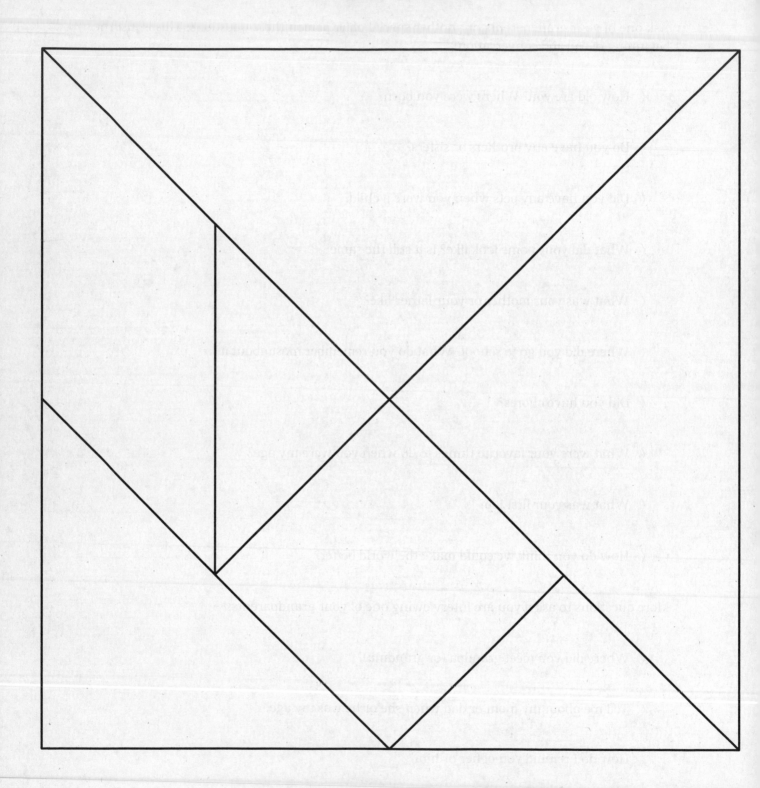

Bar Graph Template

How many _____?

15				
14				
13				
12				
11				
10				
9				
8				
7				
6				
5				
4				
3				
2				
1				
0				

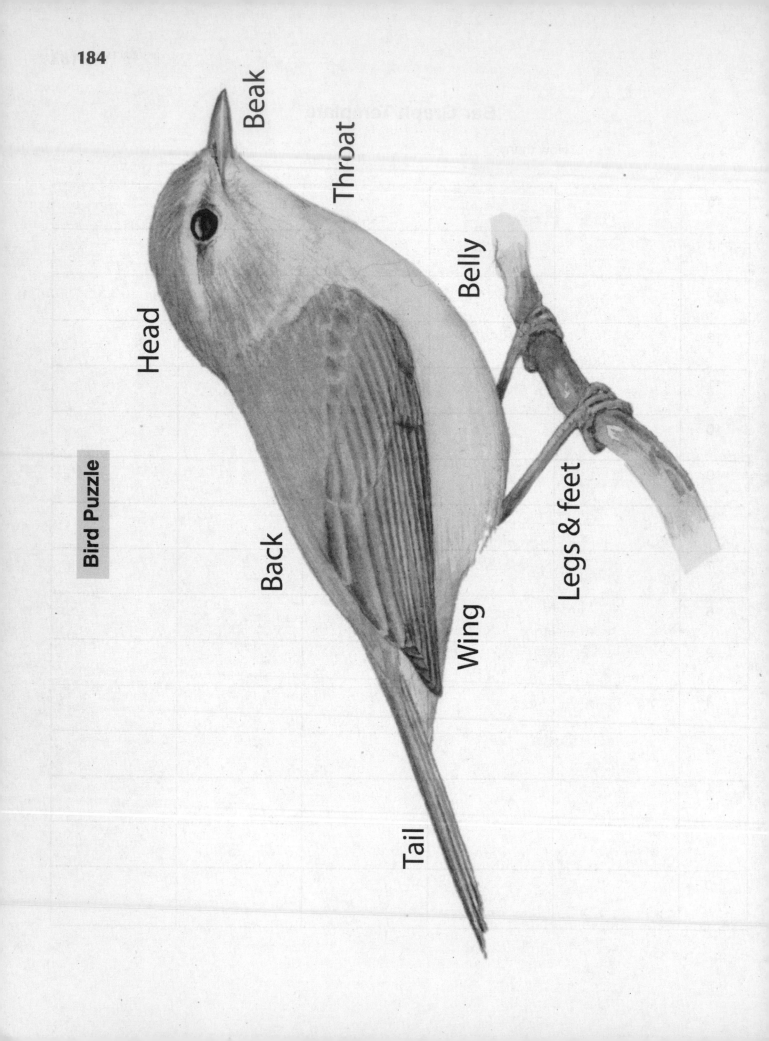

184

Bird Puzzle

Beak

Throat

Belly

Head

Back

Legs & feet

Wing

Tail

ONLINE RESOURCES

There is an overwhelming amount of information online for families, children, and teachers. To save you time wading through it all, here are some recommended Web sites and search engines listed in alphabetical order. These sites are family- and child-friendly, easily searchable, and replete with timely and appropriate information. The Web sites of regional museums and cultural institutions are also valuable resources for families, children, and teachers and should not be overlooked. Be sure to judge any activities for children on these sites for their age and individual appropriateness. Not all are equally appropriate.

Sites for Teachers

Association for Childhood Education International (ACEI). Includes Parent's Page with information about development, learning, and schooling.
www.acei.org

Can Teach. Lesson plans for K–6 along with links to activities, songs, poems and fingerplays, recipes, and games that are appropriate to share with families.
www.canteach.ca

Cornell Lab of Ornithology. Resources for educators as well as resources for kids and families. Includes a wealth of information about birds, backyard bird counts, citizen science projects, views from nest cameras, and sound recordings of animals.
www.birds.cornell.edu

Education World. Searchable site for lesson plans, professional development for teachers and administrators, technology integration, and discussion of school issues.
www.educationworld.com

Enchanted Learning. Printable activities, charts, and graphic organizers by subscription.
www.enchantedlearning.com/graphicorganizers/chart

Everything Preschool. Features thematically organized activities, games, song lyrics, and more.
www.everythingpreschool.com

National Association for the Education of Young Children (NAEYC). The world's largest professional organization dedicated to the education and development of children from birth through age eight. Includes resources especially for families, such as activities to do at home and brochures for families and children.
www.naeyc.org

National Atmospheric and Space Administration (NASA). Information about space and space exploration for educators and students, including videos. Free teaching materials.
www.nasa.gov

National Kindergarten Alliance. The only national organization dedicated to the needs of kindergarten children and teachers. The Web site includes curriculum ideas, position papers, and information about applying for small grants to support best practices.
www.nkateach.org

PBS Teachers. The Public Broadcasting Service site includes standards-based teacher resources, information about how to use PBS videos to encourage learning at home and at school, and a teachers' newsletter.
www.pbs.org/teachers

Project Wild. Environmental education curriculum and resources, plus opportunities to attend instructional workshops.
www.projectwild.org

Scholastic. Teaching resources, parent information, and children's activities organized by grade level, subject, and theme.
www.scholastic.com

Teachers Involve Parents in Schoolwork (TIPS). National Network of Partnership Schools' guidelines and templates for designing interactive homework assignments.
http://www.csos.jhu.edu/P2000/tips/index.htm

Sites for Parents and Caregivers

A Place of Our Own / Los Niños en Su Casa. Fully searchable companion Web sites to the award-winning television series for parents and caregivers of young children. Includes abundant information about learning at home, activities based on everyday materials, and active learning features for parents.
www.aplaceofourown.org and www.losninosensucasa.org

Kids in the Kitchen. Online cooking and recipe site for children and families, including recipes for arts and crafts materials.
www.kidscooking.freewebsitehosting.com

National Wildlife Federation. Activities to help children discover the wonder of nature.
www.nwf.org

PBS Parents. Plentiful information about child development, educational activities, and games for children.
www.pbs.org/parents

Sid the Science Kid. PBS preschool science program's Web site has information and activities parents and teachers can do with children to encourage them to investigate and learn science concepts. There are also songs, video clips, and interactive games for children.
www.pbskids.org/sid

U.S. Department of Education. Publishes the *Helping Your Child Series* in English and Spanish. The booklets and brochures listed below include information and simple activities families can do at home and in the community to encourage learning. They can be downloaded or mail ordered.

⟨ Helping Your Preschool Child
⟨ Helping Your Child Become a Reader

⟨ Helping Your Child Learn Science
⟨ Helping Your Child Learn Mathematics
⟨ Helping Your Child Succeed in School
⟨ Helping Your Child With Homework

www.ed.gov/parents/academic/help/hyc.html

Zero To Three. Child development information by topic with tips to encourage development.
www.zerotothree.org

Sites and Search Engines for Children

Ask Kids. Includes "Schoolhouse" subject areas and learning resources, games filtered by age, an image search feature, and movie and game reviews.
www.askkids.com

Canadian Kids. Links to hundreds of Web sites, both from Canada and elsewhere in the world, suitable for children, as well as their parents and teachers.
www.canadiankids.net

CyberSleuth Kids. A topically organized Internet search guide for K–12 students.
www.cybersleuth-kids.com

Fact Monster. Searchable by subject area or keyword. Includes homework help as well as factual information found in an atlas, dictionary, and encyclopedia.
www.factmonster.com

Google Safe Search for Kids and Teens. The most popular search engine filtered for use by students.
www.google.com/Top/Kids_and_Teens

Internet Public Library KidSpace. Includes topically organized reference materials, Web sites, and activities and games, along with resources for parents and teachers. Children can also ask a librarian a question.
www.ipl.org/div/kidspace

Kid Linx. Recommended links to "cool sites" for children as well as games and activities.
www.kidlinx.com

KidsClick! Annotated searchable directory of Web sites created for kids by librarians. Content is searchable by content, reading level, and key words.
www.kidsclick.org

Kids.Gov. The official U.S. Government portal for kids with links to games and activities as well as topical information.
www.kids.gov

PBS Kids. Public Broadcasting Service online learning service tied to its children's television programs. Includes games and music.
www.pbskids.org

Story Place. English and Spanish versions of interactive stories for preschool and elementary age children.
www.storyplace.org

Yahooligans. Yahoo for kids. The site is indexed by category and includes games, music, movies, jokes, sports, and e-cards. There are also interactive features.
www.kids.yahoo.com

References

Allen, B. A., & Boykin, A. W. (1992). African American children and the educational process: Alleviating cultural discontinuity through prescriptive pedagogy. *School Psychology Review, 21*(4), 586–596.

Bailey, L. B., Silvern, S. B., Brabham, E., & Ross, M. (2004). The effects of interactive reading homework and parent involvement on children's inference responses. *Early Childhood Education Journal, 32*(3), 173–178.

Barbour, A. C. (1998). Home literacy bags promote family involvement. *Childhood Education, 75*(2), 71–75.

Barbour, A. C. (2002). Using literacy backpacks in central Los Angeles to lower barriers to academic achievement. *Journal of Urban Learning, Teaching, and Research 2002 Yearbook* (American Educational Research Association Special Interest Group), pp. 54–61.

Berger, E. H. (2008). *Parents as partners in education: Families and schools working together.* Upper Saddle River, NJ: Pearson Prentice Hall.

Carlisle, E., Stanley, L., & Kemple, K. M. (2005). Opening doors: Understanding school and family influences on family involvement. *Early Childhood Education Journal, 33*(3), 155–162.

Caspe, M., Lopez, M. E., & Wolos, C. (2007). *Family involvement in elementary school children's education.* Cambridge, MA: Harvard Family Research Project. Retrieved May 7, 2009, from http://www.gse.harvard.edu/hfrp/projects/fine/resources/research/elementary.html

Cohen, L. E. (1997). How I developed my kindergarten book backpack program. *Young Children, 52*(2), 69–71.

Coleman, M., & Churchill, S. (1997). Challenges to family involvement. *Childhood Education, 73*, 144–148.

Cooper, H. (2007). *The battle over homework: Common ground for administrators, teachers, and parents.* Thousand Oaks, CA: Corwin.

Delgado-Gaitan, C. (1990). *Literacy for empowerment: The role of parents in children's education.* New York: Falmer Press.

Edge, D. (2000). *Involving families in school mathematics: Readings from* Teaching Children Mathematics, Mathematics Teaching in the Middle School, *and* Arithmetic Teacher. Reston, VA: National Council of Teachers of Mathematics.

Epstein, J. L. (1995). School/family/community partnerships: Caring for the children we share. *Phi Delta Kappan, 76*(9), 701–712.

Epstein, J. L. (2001). *School, family, and community partnerships: Preparing educators and improving schools.* Boulder, CO: Westview Press.

Epstein, J. L., & Van Voorhis, F. L. (2001). More than minutes: Teacher's roles in designing homework. *Educational Psychologist, 36*, 211–222.

Gardner, H. (1993). *Multiple intelligences: The theory in practice.* New York: Basic Books.

Gill, B. P., & Schlossman, S. L. (2003, December 11). My dog ate my argument. *Los Angeles Times*, p. B17.

Gill, B. P., & Schlossman, S. (2004). Villain or savior? The American discourse on homework, 1850–2003. *Theory Into Practice, 43*(3), 174–181.

Helm, J. H., & Katz, L. (2001). *Young investigators: The project approach in the early years.* New York: Teachers College Press.

Henderson, A. T., & Berla, N. (1995). *A new generation of evidence: The family is critical to student achievement.* Washington, DC: Center for Law and Education.

Henderson, A. T., & Mapp, K. L. (2002). *A new wave of evidence: The impact of school, family, and community connections on student achievement: Annual synthesis.* Austin, TX: National Center for Family & Community Connections with Schools.

Hoover-Dempsey, K. V., Walker, J. M., Sandler, H. M., Whetsel, D., Green, C. L., Wilkins, A. S., et al. (2005). Why do parents become involved? Research findings and implications. *The Elementary School Journal, 106*(2), 105–130.

Institute for Educational Leadership in Washington, D.C. (1995). *Study of attitudes among the parents of primary-school children.* EDRS 39 968.

International Reading Association. (1998). Learning to read and write: Developmentally appropriate practices for young children. A joint position statement of the International Reading Association (IRA) and the National Association for the Education of Young Children (NAEYC). *The Reading Teacher, 52*(2), 193–216.

Izzo, C. B., Weissberg, R. P., Kasprow, W. J., & Fendrich, M. (1999). A longitudinal assessment of teacher perceptions of parent involvement in children's education and school performance. *American Journal of Community Psychology, 27,* 817–839.

Jimerson, S., Egeland, B. E., & Teo, A. (1999). A longitudinal study of achievement trajectories: Factors associated with change. *Journal of Educational Psychology, 91,* 116–126.

Jones, I., White, C. S., Aeby, V., & Benson, B. (1997). Attitudes of early childhood teachers toward family and community involvement. *Early Education and Development, 8*(2), 153–163.

Kahn, P. H., Jr., & Kellert, S. R. (Eds.). (2002). *Children and nature: Psychological, sociocultural, and evolutionary investigations.* Cambridge: MIT Press.

Katz, L. G. (1993). *Dispositions: Definitions and implication for early childhood practice.* Champaign, IL: ERIC Clearinghouse on Elementary and Early Childhood Education. ED 360104.

Kindler, A. L. (2002). *Survey of the state limited English proficient students and available educational programs and services, 2000–2001.* Washington, DC: National Clearinghouse for English Language Acquisition & Language Instruction Educational Programs.

Kohn, A. (2007). Rethinking homework. *Principal, 86*(3), 35–38.

Ladson-Billings, G. (2001). The power of pedagogy. Does teaching matter? In W. Watkins, J. Lewis, & V. Chou (Eds.), *Race and education* (pp. 73–88). Boston: Allyn & Bacon.

Los Angeles Unified School District. (1998). *Academic English Mastery Program overview and instructional framework.* Los Angeles: Author.

Miller, S. A., & Cantor, P. (2008). Worksheets in preschool: Too much, too soon. *ACEI Speaks.* Olney, MD: Association for Childhood Education International.

Moll, L. C., Amanti, C., Neff, D., & Gonzalez, N. (1992). Funds of knowledge for teaching: Using a qualitative approach to connect homes and classrooms. *Theory Into Practice, 31*(1), 132–41.

Morton, I. (1992). *Increasing the school involvement of Hispanic parents.* New York: ERIC Clearinghouse on Urban Education. ED350380.

National Association for the Education of Young Children (NAEYC) and National Council for Teachers of Mathematics (NCTM). (2002). *Position statement. Early childhood mathematics: Promoting good beginnings.* Washington, DC: National Association for the Education of Young Children.

National Committee on Science Education Standards and Assessment. (1996). *National science education standards.* Washington, DC: National Academy Press.

National Education Association and National Parent Teacher Association. (n.d.). *Help your student get the most out of homework.* Retrieved May 7, 2009, from http://www.nccpta.org/uploads/Homework__9-25_.pdf

National Network of Partnership Schools at Johns Hopkins University. (2009). *Teachers involve parents in schoolwork.* Retrieved May 7, 2009, from www.csos.jhu.edu/P2000

National PTA. (2000). *Building successful partnerships: A guide for developing parent and family involvement programs.* Bloomington, IN: National Educational Service.

Ou, S. (2005). Pathways of long-term effects of an early intervention program on educational attainment: Findings from the Chicago longitudinal study. *Applied Developmental Psychology, 26*(5), 578–611.

Ratnesar, R. (1999, January 25). The homework ate my family. *Time,* pp. 55–63.

Richgels, D. J., & Wold, L. S. (1998). Literacy on the road: Backpacking partnerships between school and home. *The Reading Teacher, 52*(1), 18–29.

Sheldon, S. B., & Van Voorhis, F. L. (2004). Partnership programs in U.S. schools: Their development and relationship to family involvement outcomes. *School Effectiveness and School Improvement, 15*(2), 125–148.

Strickland, D. S. (2002). Bridging the gap for African American children. In B. Bowman (Ed.), *Love to read: Essays in developing and enhancing early literacy skills of African American children* (pp. 63–72). National Black Child Development Institute.

U.S. Department of Education, National Center for Education Statistics. National Household Education Surveys (NHES). (1996). Parent and family involvement in education survey. Available from http://nces.ed.gov/nhes/

U.S. Department of Education, National Center for Education Statistics. National Household Education Surveys (NHES). (1999). Parent interview survey. Available from http://nces.ed.gov/nhes/

U.S. Department of Education, Office of Communications and Outreach. (2005). *No Child Left Behind: What parents need to know.* Washington, DC.: Education Publications Center, U.S. Department of Education. Retrieved May 7, 2009, from www.ed.gov/nclb/overview/intro/parents/index.html

Van Voorhis, F. L. (2003). Interactive homework in middle school: Effects on family involvement and science achievement. *Journal of Educational Research, 96*(6), 323–338.

Viadero, D. (2008, February 20). Survey on homework reveals acceptance, despite some gripes. *Education Week, 27*(24), 10.

Walker, J. M. T., Hoover-Dempsey, K. V., Whetsel, D. R., & Green, C. L. (2004). *Parental involvement in homework: A review of current research and its implications for teachers, after school program staff, and parent leaders.* Cambridge, MA: Harvard Family Research Project. Retrieved May 7, 2009, from http://www.hfrp.org/publications-resources/browse-our-publications/parental-involvement-in-homework-a-review-of-current-research-and-its-implications-for-teachers-after-school-program-staff-and-parent-leaders

Walters, T. (2002). Images, voices, choices: Literature to nurture children's literacy development. In B. Bowman (Ed.), *Love to read: Essays in developing and enhancing early literacy skills of African American children* (pp. 73–81). National Black Child Development Institute.

Weiss, H., Caspe, M., & Lopez, M. E. (2006). *Family involvement in early childhood education.* Cambridge, MA: Harvard Family Research Project. Retrieved May 7, 2009, from http://www.gse.harvard.edu/hfrp/projects/fine/resources/research/earlychildhood.html